PARANORMAL
LANCASHIRE

Daniel Codd

AMBERLEY

First published 2011
Reprinted 2012

Amberley Publishing
The Hill, Stroud
Gloucestershire, GL5 4EP

www.amberleybooks.com

British Library Cataloguing in Publication Data.
A catalogue record for this book is available from the British Library.

ISBN 978 1 4456 0658 3

Typesetting and Origination by Amberley Publishing.
Printed in Great Britain.

Contents

Acknowledgements

In many ways this book concerns an 'outsider's' journey of discovery around Lancashire's most mysterious and paranormal locations. As such, this non-Lancastrian is extremely indebted to his many friends in this part of the world who have helped enormously, and to the many people who have quoted some vague story to me in one form or another, which I have subsequently attempted to trace to its origin. Among the many to whom I owe my gratitude in this journey of exploration are: Christine Goodier, Lancaster Castle Manager (for more information on this historic castle, please see www.lancastercastle.com); Ellie Singleton, Theatre Manager, Lancaster Grand, St Leonardgate, Lancaster (www.lancastergrand.co.uk); and many thanks to Angela Hunt-McDonagh, Wedding and Events Coordinator, Samlesbury Hall, for arranging permission for me to draw upon some of the personal anecdotes concerning the multiple ghosts there; also, the desk operator at the hall on 2 March 2011. More information on the ghosts and history of Samlesbury can be viewed at www.samlesburyhall.co.uk. Further thanks to Richard Roberts of Hoghton Tower, for sparing the time to furnish me with a look at the Ghost File, (for further information on their events and Ghost Tours please see www.hoghtontower.co.uk); Frank Walsh, Friend of Pendle Heritage Centre, and Susan, Visitor Services Advisor at Pendle Heritage Centre (further info on the Centre can be found on the Heritage Trust, North West website); Katie Duxbury; Adrian Paling at Witches Galore, Newchurch in Pendle; Christine Hunter Hughes, of Preston Playhouse Theatre (for more information on this amateur dramatics establishment, please refer to www.prestonplayhouse.com), and Janet Wood of Stock Photography, Licensed and Royalty Free Photographs.

Many thanks must go to Janet, whose website can be found at www.worldthroughthelens.com; Shaun Smith, Whalley Parish Administrator, for information on Abbot Paslew's grave, Whalley church; Phil, at www.rossallbeach. co.uk; Mick Pye of Old Clitheroe, please see www.oldclitheroe.co.uk (thank you for your interest and information); Ian Murphy and Tilly for taking the experimental trip up Pendle Hill; and to Elizabeth G. N. Sleaford, BSc (Hons) for allowing me to relate some of the Croston tales told to her by her father, see her family website for further information on Croston genealogy www.cowellfamily.org.uk. Further thanks to Dorothy MacLeod, Assistant Librarian, Lancashire Records Office, Preston, for her

invaluable assistance; Lynn Harrison, of Heskin Hall Antiques, Wood Lane, Heskin, Chorley (www.heskinhallantiques.co.uk); Rebecca Clarke of Browsholme Hall; Al Heffron, formerly of Euxton and manager of www.Euxton.com; Richard Woffenden, Turton Tower; Lisa Woods, Boars Head at Great Marton; Ian Robinson at Chorley Little Theatre (performance information available at www.chorleylittletheatre.com); staff at Clitheroe Castle's Museum; staff at Lancaster Castle; and staff at Lancaster Priory (many thanks for the soup and information in possibly the worst weather seen that month!)

Also thank you to Jason Deen, manager of the Boars Head, 38 Preston Old Road, Great Marton, Blackpool, for sparing the time to talk to me; N. O. for information on 'football ghosts'; owners of Malkin Tower Farm, for their info on Hobstones; parish councillors at Whalley; staff at Pendle Heritage Centre; Philip S. Evans, for useful historical depictions of Lancashire towns (for further information, see www.oldukphotos.com). Also to the owners of Thorneyholme Farm, Blacko, for putting me up and putting up with my incessant questions!

Thank you to Irene McIntosh, administrator, St Andrews Church, Leyland; David Briggs, for agreeing to talk to me about his 1983 UFO encounter; Andrew Mather, Karen Doyle of Preston Historical Society, whose good work can be observed at www.prestonhistoricalsociety.org.uk; Andy at the Black Horse, Long Lane, Limbrick, the second-oldest pub in Lancashire, and holder of the longest unbroken drinks license in the county! To Merrily Harpur; Mark Fraser of Big Cats in Britain (www.bigcatsinbritain.org); Tony Sharkey, Local History Librarian, Central Library, Blackpool, for allowing me access to archive copies of the *West Lancashire Evening Gazette* in my ghost hunt. All photographs and images are copyright Daniel Codd, except: Fleetwood ghost (private source); Carry Bridge 'ghost lamp', Chorley railway yard, Up Holland ghost house, Blackpool pleasure flight, Blackpool tram, Old Demdike @ Roughlee, Preston market with the permission of Lancashire Record Office, Lancashire County Council, Preston PR1 2RE. Photograph of St Walburge's church, Preston, courtesy of GeorgeGreen/shutterstock.com (www.shutterstock.com).

Foreword

The place of Lancashire – Red Rose county – in British history is most definitely assured. So much has happened here that is symbolic and definitive – even changing the course of history. Robert the Bruce's Scottish army raided the county, the deposed King Henry VI was captured near Clitheroe in 1465, and Preston has twice been the dramatic setting for decisive conflicts in British history, in 1648 and 1715. The proliferation of cotton mills and textile factories brought huge influxes of workers to the region, changing the landscape forever in the early 1800s and bringing with it the innovation, ingenuity and radicalism that always accompanies such leaps forward in progress.

However, this book is concerned with another dimension of Lancashire's history: its paranormal mysteries, its eerie secrets and its supernatural legends. The proud and beautiful county of Lancashire has for generations been a land of storytelling, folklore and the supernatural; a tradition not lost in the twenty-first century. Even in spite of the industrialisation of its southern borders and the modern escapism of its eastern coastline, Lancashire's sometimes unsettling folk belief is to this day repeated in modern and well-attested tales of the paranormal.

We learn from early sources, such as John Roby's *Traditions of Lancashire* (1829), just what a fertile place for myths, stories, superstitions and folklore the north-west of England was: of how, for instance, Sir Lancelot of the Lake, who ruled western Lancashire in Arthur's time, overthrew Sir Tarquin, a cruel and treacherous knight of gigantic stature who lived in a fortified castle near Manchester and reputedly dined on the carcasses of slain children. Lancelot du Lac had been, as an infant, kidnapped by a nymph called Vivian, the mistress of Merlin, and raised at her court in subterranean caverns beneath a great expanse of inland water. By Roby's time some identified this location with Martin Mere, north-west of Burscough. Until it was drained in the nineteenth century, this was reputedly the largest body of fresh water in England.

Maybe the region had its own Atlantis, too. There was a widespread belief in the nineteenth century that at one time there had existed a primitive city on Mellor Moor, north of Mellor, which had centuries earlier been engulfed by an earthquake. Some claimed that on certain evenings phantom echoes of this lost community could be heard: bells ringing, festivities and the like.

We also learn of such beloved Lancashire legends as the story of 'The Eagle and the Child', associated with the dynasty of Sir Thomas Lathom of Lathom House, from whom descended the Stanley line thanks to the intervention of an eagle. There are numerous popular versions of this tale, some varying wildly in their details, with the most familiar placing events as occurring in the 1300s. In his *History of Lancaster* (1870), Edward Baines posited that he had traced this story back to its origins in the ninth century:

> Of the many humane traits in his (Alfred the Great's) character, one is mentioned which serves to show that our popular Lancashire tradition of the *Eagle and Child* is of the date of several centuries earlier than the time of the De Lathoms: "One day, as Alfred was hunting in a wood, he heard the cry of a little infant in a tree, and ordered his huntsmen to examine the place. They ascended the branches, and found at the top, in an eagle's nest, a beautiful child dressed in purple, with golden bracelets, the marks of nobility on his arms. The king had him brought down, and baptised and well educated; from the accident he named the foundling Nestingum.

Centuries later one Bishop Thomas Stanley composed a poem in which he ascribed the event as occurring in 'Terleslowe wood – a portion of the Lathom domain.' The Lord of Lathom, in this version, believed a miracle had occurred, and took the boy as though his own: in due time the boy became the father of Isabella Lathom, who married Sir John Stanley, and this was the explanation for the Stanley's crest of the Eagle and Child. As with many Lancashire legends, there are many versions of this fabled story, with some claiming the discovery was a ruse to explain the fruits of the lord's infidelity to his wife.

And we have legends concerning the semi-mythical bandit Robin Hood, too. Stones on Blackstone Edge Moor are designated Robin Hood's Bed, and from here there is a spectacular panoramic of Rochdale. Robin is said to have thrown a quoit from this point in the direction of Spotland, some 6 miles distant, which became the huge stone on Monstone Edge that acted as a boundary marker.

It is interesting to speculate on the 'truth' of such stories. Roby's original narratives were for the most part embellishments padded out into full short stories, with attendant dialect and in some respects more akin to the storytelling of the Brothers Grimm, for instance, than the more substantiated folklore of later decades that comprised of anecdotal half-truths, twice-told tales, sincere beliefs and genuinely mystifying events. It is this that largely concerns us here, rather than the ballad-like storytelling of Roby's work (interesting though this is as a template for later research).

Roby lost his life by drowning in the *Orion* disaster of 18 June 1850, when that steamer was wrecked with the loss of many lives off the coast of Portpatrick. But his legacy was embraced by others: following Roby's work came James Bowker's *Goblin Tales of Lancashire* (1883), and also what many consider to be the definitive work on the county's supernatural heritage, *Lancashire Folk-lore* by John Harland and T. T. Wilkinson (1867).

Our book is concerned with all that falls under the broad umbrella term of the 'paranormal' in Lancashire and will hopefully allow the reader to observe the different

forms that the strange and mysterious has taken in the past, in comparison with the stories that are reported and repeated throughout Lancashire these days.

There are many elements of Lancashire's mysterious heritage that we have had to, by necessity of content space, gloss over. For instance, criminal riddles are not featured in any great depth, although I am tempted to mention one odd episode worthy of a Sherlock Holmes tale. This concerns an incident in 1826, when on 1 October a coach was stopped at Lancaster on account of an offensive smell emanating from a box it had been carrying from Manchester to Edinburgh. A constable who opened the box found within the decomposing bodies of a woman and a male infant, and at an inquest the following day it was stated that no marks of violence were found upon the pair; who they were remained a mystery, and neither could the sender of the box be traced. Of course, sensational crimes form the basis of many later 'ghost stories' in the county.

A word also ought to be said about the shifting borders and demographics of this county. An 1842 itinerary of Lancashire describes its boundaries thus,

> Lancashire, one of the most important territorial divisions of England, extending over large superficies, takes rank among the counties the first in population and the fifth in extent of surface. Cheshire and Derbyshire limit this county southward, Cumberland and Westmoreland northward, and Yorkshire upon the east. Upon the western side, bordering upon the Irish Channel, the boundary line is extremely irregular, from the indentations of the coast.

Lancashire is now much reduced in size. Although to some Merseyside and Greater Manchester – and indeed Furness, to the north – will always be part of the county, for the purposes of modern accuracy they are considered in light of their detached status as metropolitan counties, and not included in any great depth in this work. To some extent, this is a pity: for many traditional stories that have been told for generations in the region now belong to other works, the size and scope of Greater Manchester and Merseyside perhaps making them better candidates for books in their own right.

Hopefully, the reader will not be too disappointed by the exclusion of numerous well-known supernatural stories from these areas, such as the skull of Wardley Hall, the mummified corpse of Birchen Bower and the footstep of George Marsh being divinely pressed into the stone flooring at Smithills Hall. However, even taking into account this loss of large portions of the 'old' county, in many ways Lancashire's paranormal archives are bettered by nowhere else in Britain. This book is concerned not only with the many tales of 'ghosts' but also with UFOs, strange creatures and a plethora of general curiosities and weirdness. Some of the tales contained within are truly unique.

During the course of researching this book, I visited and contacted literally scores of commercial premises, public houses, tourist attractions and members of the public in a bid not only to obtain 'pointers' to sites historically associated with ghosts or other mysteries, but also to try and obtain as many contemporary first-hand accounts as was possible, in an effort to bring this subject matter up to date. Where archive material has been drawn upon, the source is referred to in the text and my own wording deviates as little as possible from the original source, so as to not generate falsities. It should also be observed that this is not a history book and largely concerns paranormal lore – a

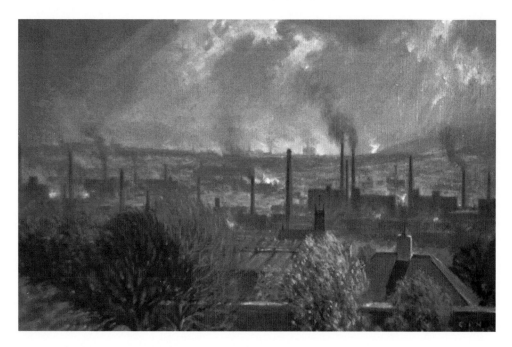

Darwen: Sir Charles Holmes' depiction of a landscape changed forever, *c.*1928.

subject that in itself is often repeated in all its sensationalism and historical inaccuracy – and although I have tried as best I can to ensure that this work is as historically accurate as possible, I apologise in advance for any unwitting errors that the sharp-eyed may pick out: I can only assure the reader that all sources utilised were considered reliable ones. *Paranormal Lancashire* has taken many years to fully compile, and I can but repeat what I was told by the owners of Thorneyholme Farm, Roughlee, that Lancashire is somewhere that is only 'driven through to Blackpool or Manchester' and thus is deserving of a closer look at its strange mysteries.

Over the years, the county of Lancashire has seen a scale and scope of change – historically, politically and technologically – that we can scarcely comprehend. Dynasties have fallen and society has changed; proud castles and stately abbeys are in ruins, industrialised towns and cities have risen where once thinly populated villages stood, and changing boundary lines have confused local identities. But despite this, the people of Lancashire do (and always will) love a good mystery. Come then, and enjoy a trip around paranormal Lancashire: from ancient Lancaster to modern Blackpool, from the barely inhabited Forest of Bowland to the urban population centres of Preston and Blackburn, and from the western Fylde to the witch country of Pendle. But most of all enjoy a journey into this part of Great Britain's hidden corners: its supernatural heritage, paranormal mysteries and unexplained phenomena of every shape and form.

PART I

THE WORLD OF BOGGARTS, GHOSTS & POLTERGEISTS

Introduction

Lancashire is, and always has been, a land of ghosts. Since the earliest days, ballads and tracts have played on our fear of the impossible, the supernatural and the phenomenal. Thus we learn, for example, of the pamphlet in 1615 declaring: *Newes Out of Lancashire, Or The Strange And Miraculous Revelacon of A Murther, by A Ghost, A Calfe, A Pigeon &c.*

But belief in ghosts, spirits and poltergeists has never really faded, although we can see that a genuine, daily fear of such paranormal entities appears to have died away in the 1800s; at least this is what the lion's share of material collected by folklorists suggests. We also learn from these archive sources of the distinct and peculiar northern terminology for these spirits: boggarts.

An introduction concerning Lancashire ghosts in C. J. S. Thompson's expansive *Mystery and Lore of Apparitions* (1930) explains that the word 'boggart' acted as an umbrella term for all kinds of ghosts and supernatural sprites: 'Although in some of the northern counties the word ghost is pronounced "gheist" or "guest", in Lancashire, the name boggart or bar-gaist is usually applied to a mischievous sprite that haunts houses and terrifies children and horses … should a horse take fright without apparent cause, it is said to have seen a boggart, and boggart holes, reputed to be the haunts of these terrible sprites, are still pointed out in some parts of Lancashire.' Many streets were thought haunted by 'gheists', which often took peculiar forms, such as a mastiff dog. In truth, the etymology of the word 'boggart' is uncertain, with bug and bogle being other derivations, these last being of Celtic origin and signifying 'to frighten.'

Edwin Waugh's *Lancashire Sketches* (1869) paints an atmospheric picture of out-of-the-way Lancashire in the 1800s, and the way stories of 'boggarts' endured:

When one gets a few miles off any of the populous towns in Lancashire, many an old wood, many a lonesome clough, many a quiet stream and ancient building, is the reputed haunt of some local sprite, or 'boggart', and is enveloped in an atmosphere of dread by the superstitions of the neighbourhood, as being the resort of fairies, or 'feeorin'. This is frequently the case in retired vales and nooks lying between the towns. But it is particularly so in the hilly parts, where the old manners of the people are little changed … there, still lingers the belief in witchcraft,

and in the power of certain persons to do ill, through peculiar connection with the evil one.

Particularly haunted was the region northwards of Heywood and Rochdale (now forming the southern Lancashire border). People would form small groups so they did not have to walk this way alone, because in the vicinity of Hooley Bridge the 'Yewood Ho' boggart comes a-suppin' i'th deeod time o'th neet.' There was much genuine terror hereabouts of 'those boggarts, and "fairees", and "feeorin", which, according to local tradition, roam the woods, and waters, and lonely places; sometimes with the malevolent intent of luring into their toil any careless intruder upon their secluded domain. Some lurking in the streams and pools, like "Green Teeth", and "Jenny Long Arms", [are] waiting, with skinny claws, for an opportunity to clutch the wanderer upon the bank into the water.'

I wonder how many watery fatalities or disappearances along this stretch of the River Roch were attributed to these phantasms. Then there was also the White Lady, the Skrikin' Woman, the Baum Rappit (rabbit), the Grizlehurst Boggart, the Clegg Hall Boggart, and Nu Nan, who could be glimpsed 'prowling about shady recesses of the woods, 'wi a poke-full of red-whot yetters, to brun nut-steylers their e'en eawt', (burn out the eyes of nut-stealers). There were also the 'lubber fiends', or house boggarts, of the type mentioned in Reverend William Thornber's *History of Blackpool* (1832): there was 'an ancient one of Rayscar and Inskip, which at times kindly housed the grain, collected the horses, and got them ready for the market; but at other times played the most mischievous pranks.' Here we have what might be recognised as a poltergeist, although of a type that could apparently be helpful as well as destructive.

An atmospheric place indeed then, was the Lancashire of the near past. Waugh also noted that a ritual to deal with ghosts was common knowledge among the peasantry,

> It is a common belief now, among the natives of the hills and solitary cloughs of Lancashire, that the best way of laying a ghost, or quieting any unearthly spirit whose restlessness troubles their lonely lives, is to sacrifice a cock to the goblin, and, with certain curious ceremonies, to bury the same deep in the earth at a 'four lone-eends' (i.e. where four roads met), firmly pinned to the ground by a hedge stake driven through its body.

It is interesting to note that 'ghost' and 'goblin' are used interchangeably to describe something supernatural, and definitions of such phantasms in this part of the world are a little blurred, as opposed to having a specific meaning.

James Bowker's *Goblin Tales of Lancashire* (1883) implies that the term 'Dobbie' was also used occasionally to mean 'ghost', despite this word being more often ascribed to a kind of helpful elfish creature that took up residence in a human dwelling. (This terminology appears to have been more evident in northern Lancashire.) But although 'boggart' appears to have been a coverall definition, numerous stories that depict boggarts as 'imps' or 'elves' also include many aspects of what we would now recognise as poltergeist activity.

Written Stone, Longridge.

Despite a certain confusion when it came to definitions, it is clear that tales of ghosts, dobbies, boggarts, bar-gaists (or gate-ghosts), barguests, sprites and 'goblins' were a collective part of local storytelling, and a permanent fixture in the popular imagination, featuring as they did in any number of Victorian ballads concerning real-life crimes and dramas. However ghosts – by whatever name they went under – were also posited to be 'real', and places abounded that the people of Lancashire swore to be haunted by a 'real' ghost. Reminders of these superstitions can be found in many places, such as at Longridge, where the inscribed 'Written Stone' on Written Stone Lane has imprisoned the restless boggart, or ghost, of a slain man since 1655. At some time the stone is said to have been moved, with great difficulty, to the dairy at adjacent Written Stone Farm, at which place the released spirit caused the pots, pans and crockery to dance and make an unholy din. When the Written Stone was taken back to its position in the lane, there were whispers that this had been accomplished with great ease, as though it weighed no more than a feather. Many stories like this were faithfully put to paper by such eminent collectors as Harland and Wilkinson in *Lancashire Folklore*, and also in a later collaboration, *Lancashire Legends, Traditions, Pageants, Sports Etc* (1873).

However, by then there were also a growing number of instances where a 'ghost's' appearance was recorded as being a contemporary event, as opposed to folklore, and the immediacy with which these superstitious and eerie tales were being related to the public in Harland and Wilkinson's era was greatly assisted by such periodicals as *Notes and Queries* and *The Gentleman's Magazine*, as well as an increasingly sophisticated media. Even gazetteers such as *An Illustrated Itinerary of the County of Lancaster* (1842), an otherwise sober introduction to the county for the benefit of the traveller, could not resist digressing into the fascinating lore of the peasantry, seeing it as part of the psychological make-up of Lancashire folk and necessary to understanding them as a people. *The Illustrated Itinerary*'s author, Cyrus Redding, had recently stopped to talk to a group of labourers at Holme Chapel, on the road to Burnley, and with no sense

of ridicule asked them what they knew of ghosts. One man replied, 'Noa, the country is too full of folk', which Redding interpreted as the man's own desire not to appear foolish to a stranger. A young lad, however, spoke for all of them when he blurted out, 'The boggart has driven William Clarke out of his house; he flitted last Friday!' Redding enquired as to why, and was told, 'O, he wouldn't let 'em sleep; he stript off the clothes … they are gone and the house is empty. You can go and see for yoursell if you loike. Will is a plasterer, and the house is in Burnley Wood, on Brown Hill.'

Lancashire's ghosts took – and still do take – almost every form imaginable. This we glean from a contributor, P. P., to *Choice Notes From: Folklore* (1859), who posited this all encompassing statement about ghosts here; 'I have heard of a calf with eyes like a saucer, a woman without a head, a white greyhound, a group of little cats as the shape of the bogard, and sometimes a lady who jumped behind hapless passengers on horseback. It is supposed that a Romish priest can lay them, and that it is best to cheat them to consent to being laid while hollies are green. Hollies being evergreens, the ghosts can reappear no more.'

Clearly, then, it was thought that ghosts were almost able to interact with the living, a phenomenon that somehow characterises Lancashire ghosts as being a lot less shy than in some other counties. Traditionally, it was believed that people born during twilight, or, as some said, midnight, were able to see spirits. I happen to agree that the answer to the riddle of ghosts (excluding poltergeists) seems to lie with the person who actually saw it, by which I mean that ghost hunters could set up camp for 100 years at a place where a ghost had recently been seen and still not see anything for themselves. The answer lies exclusively with the person who says they saw it: either they imagined it, misinterpreted something else or they invented it; or they possess a special ability that the rest of us do not. Or else they do not possess any special ability but happened unwittingly to be in a specific place at a specific time during which an exact set of million to one circumstances – atmospheric, supernatural and cosmic – combined for the ghost to be seen or heard: conditions that, realistically, might be highly unlikely to repeat themselves for the benefit of researchers.

These personal observations aside, it is clear that death and the afterlife are such a fixture of the popular imagination that the fascination with ghosts is unlikely ever to leave us, the hereafter being the great unknown that it is. These days, many online websites for commercial premises and tourist attractions in Lancashire actively promote themselves as being haunted; this is in spite of contemporary ghost stories often being little more than anecdotes, with the ghost itself sometimes not having a 'back story', an identity or even a visible (i.e. phantom) presence.

Ghost hunting these days is big business in Lancashire. The region boasts any number of paranormal investigation concerns and ghost experts. There are regular ghostly 'sleepovers' for charity, town 'ghost walks' and visits by television crews representing paranormal shows (often international as well as national), evidencing just how many locations here are believed have an attendant ghost or poltergeist.

And so with this in mind, in Part I of this chapter there are laid out some of Lancashire's most famous – and not so well known – supernatural stories for the reader to ponder. We also see in Part II how the miscellaneous boggarts of old have morphed into the ghosts and poltergeist mysteries of today.

'The Shapes that Walk at Dead of Night, and Clank their Chains'

'And Here Thou Shalt Stand …'

The oldest ghostly stories often concerned churches, although many church stories from Lancashire are familiar ones that can be found repeated in other parts of the country. A number of Victorian periodicals in the early 1880s record the legend that off the coast near Blackpool there once stood the church and cemetery of a place called Kilgrimal, long since submerged. Wanderers traversing these sands were, at the time, still said to occasionally be terrified by the dismal pealing of bells chiming over 'the murmuring sea'. It was believed that an earthquake had swallowed up the church of this place, but even then its bells could be heard ringing if one put their ear to the ground. (*Kilgrimhow* is believed to have been a village established by Viking settlers near Lytham St Anne's, sometime in the ninth or tenth century, before it was swallowed up by the encroaching sea.)

Even more common was the legend of the 'moving church'. At Newchurch, near Rawtenstall, the modern church (1825) superseded an old chapel that dated to Henry VIII's time. There is a story, that its founders attempted to situate the chapel in another location three times, but each time the materials were moved by supernatural agency to the present site during the course of the night. While the phantom builders were themselves invisible, the human watchers posted overnight to catch the culprits observed that they were at all times watched by a strange old woman holding a bottle. They even accepted her offer of drinking some of the liquid within; a circumstance that I suppose is held to have rendered them unconscious.

The church of St Leonard the Less, Samlesbury, possesses a similar tradition, as did St Peter's Church, at the end of Ormerod Road, Burnley. Here, they tried to build on the site of the old Saxon Cross on (what was then) Godly Lane, but the stones and scaffolding were moved in the night to where the church now stands. The goblins took the forms of pigs, and this is the explanation for the rough carving of such an animal that exists on the south side of the steeple. A similar story exists yet again at Goosnargh: here, St Mary's church was originally meant to be sited where now stands Beeseley Farm, to the north-west, but for some sprite moving all the materials during the night. This was all except a boulder, about a ton in weight: presumably an explanation for

a glacial relic that could be found there. Then again, they originally tried to build twelfth-century St Bartholomew's, Colne, at Church Clough, but the stones were whisked away during the night to their present location. *Notes And Queries* noted in 1852 that in one Lancashire case (where is not said) the supernatural agent responsible for changing the site of the church was, of all things, a fish. I cannot help but wonder how many of these stories originated with drunken watchmen inventing the tale to account for their own negligence or complicity in the disappearance of building materials.

Perhaps the most famous church story with the 'goblin builder' theme concerns Leyland's church. Here, at this sizeable town some 6 miles south of Preston, there can be found the famous Leyland Cross, and the parish church of St Andrew on Church Road. In 1849 J. O. Halliwell-Phillips' *Popular Rhymes And Nursery Tales* noted of this church that it 'stands on an eminence at the east side of the village'. There was a reason for this situation, and an old story explained that the church had originally been built elsewhere – but, on the first night it had stood fully completed, some supernatural agency had moved the entire structure some distance to its current position on Church Road. When the apprehensive villagers timidly entered their church they found an inscription had appeared on a marble tablet on the wall,

Here thou shalt be; And here thou shalt stand;
And thou shalt be called; the church of Ley-land.

Halliwell Phillips observed, 'The ancient tower is still standing, but the body of the church is modern.' Thirty-four years later, this legend had developed somewhat when the folklorist Bowker retold it. In this version, the original site of St Andrews had been to the east, at Whittle-le-Woods, but Bowker's tale includes odd details not usually associated with other well known legends of fairies, devils and what have you, moving churches during the night. At Whittle-le-Woods, one Father Ambrose was awoken and brought to the site of the church, where the suspicious and angry villagers pointed to an open meadow, where formerly the foundations of their church had stood. The priest was next alerted to another gathering crowd who had come to observe those very stones, timber and blocks, only in an entirely different location ... for the building materials had, somehow, been supernaturally transported from Whittle-le-Woods during the night and now stood on a miller's land at Leyland.

The crowd was highly agitated, but Father Ambrose took command and ordered the masonry to be carted back to Whittle-le-Woods, next picking two men to watch the fledgling church during the night, lest someone – or something – should again come and spirit off the materials. Unfortunately, the two fellows got hopelessly drunk in the night and awoke to find that, once again, the building materials had all been whisked away and deposited at Leyland.

The building blocks were again carted back, and the watchers were again ordered to spend the night protecting the partially built church; Father Ambrose even stayed with them to ensure they kept their vigil responsibly ... but he left at Midnight, and after he had gone the two watchers observed something very curious.

In the moonlight they saw 'a huge cat, with unearthly-looking eyes, and a tail with a barbed end'. This terrible monstrosity was whisking the stones away one by one, and

almost immediately returning for another. The younger of the two watchers, braver than his companion, stole up behind this feline creature and dealt it a heavy blow with his cudgel; it had no effect, and the cat merely turned on the petrified guard, springing on him with a horrific shriek. The second man present ran off in utter fright, while behind him the animal sank its teeth into its comatose victim's throat.

When the second man cautiously made his way back, he found his companion cold and dead, and after this it was considered wise to let the spectre – whatever it had been – have its own way, and St Andrews was built at Leyland instead.

Bowker noted as a postscript to this, 'A correct likeness of the cat has been preserved, and may be seen by the sceptical.' However, the Cat Stone no longer resided in the church by Bowker's time, having been removed in 1816. In 1855 a Miss Ffarington wrote of this curiosity, and other gargoyles, 'my father bought them. The first is the "cat stone", to which appends the usual story of the stones being moved by night (in this case from Whittle to Leyland), and the Devil, in the form of a cat, "throttling" a person who was bold enough to watch.'

An Abbot's Forewarning

One of the earliest recorded instances of a 'real' ghost is noted in Whitaker's *History Of Whalley*, reproducing a short note in Latin found in the *Cottonian MSS*. The note concerns the appearance of the ghost of a deceased monk called Edward Howard before Abbot John Paslew of Whalley Abbey. Howard had filled the office of Sub-Cellarer to the fraternity, and Whitaker's translation reads thus, 'A.D. 1520, May 9th, died Edmund Howard, monk of Whalley; the same after his death appeared a certain night to Master John Paslew, Abbot of the Monastery, and foretold to him that he had 16 years and not more to live.'

The supernatural warning presumably occurred within the abbey itself, now little more than a picturesque ruin; Paslew proved to be the last abbot, being hanged at Whalley for high treason on 20 March 1537 by the direction of King Henry VIII. Paslew's death has another strange rumour attached to it post-mortem, as we shall see.

Spirit-Watching at Walton-le-Dale

Bowker's *Goblin Tales of Lancashire* (1883) has a tale of spirit-watching at St Leonard's church on Church Brow, Walton-le-Dale. The story concerns a studious and secretive parish vicar, who, due to his habit of spending all his time poring over ancient texts and experimenting with chemistry, earned himself a reputation as a wizard, or necromancer, who dabbled in the black arts. Village gossip even had it that he had raised the Evil One, who had filled the house with brimstone and then vanished in a flash of fire – although not before he had laid his claws upon a sturdy table and left his imprints there.

However, many respected the vicar, as despite his strange habits he was always available to parishioners, and of late they had noted that he had sprung up a friendship

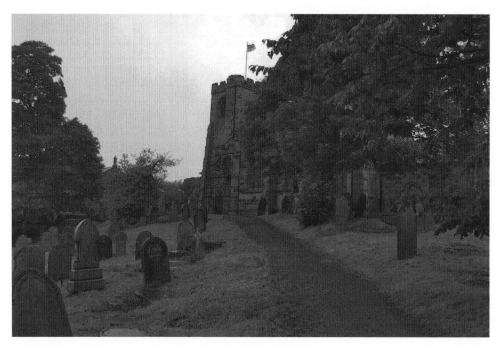

Walton-le-Dale, where these ghoulish experiments occurred.

with an equally eccentric character known in Walton as Old Abraham, a herb doctor who lived by himself in a cottage. This unlikely friendship was based on the pair's similar interests concerning antiquity, natural history and astrology, even despite Abraham claiming he was adept at 'finding things aat abaat fowk'.

However, the clergyman could go one better. He had read in an old volume that if one dared to wait in the church porch on Christmas Eve then the ghostly spirits of those destined to die in the next twelve months could be seen drifting into the church. When Christmas Eve came, the pair – armed with protective herbs and graveyard plants believed to be possessed of mysterious qualities – walked through a snowfall to the church and hid in the porch to see what would happen.

The clergyman performed an ancient and mystical rite involving Latin prayers, and almost immediately their ears caught the sound of sad, sweet music. They both stood, terror-struck, as a group of noiseless, glowing figures wrapped in grave clothes slowly drifted towards the church porch. As they silently passed into the church, the clergyman swooned with fear and Old Abraham saw why: his younger companion's own ghost was among those drifting past them!

The story of the night watch spread through the village like wildfire, mainly because Abraham had to requisition the help of the local bell-ringers to move his young comrade's prone form. The fallout from the episode forced the vicar to leave the parish, and within a year he was indeed dead – breathing his last in a wretched hovel in the fishing village where he had chosen to exile himself.

The story is a familiar one across Britain generally, but Bowker's tale may in part be based on the deeds of Edward Kelley, alias Talbot, a distinguished alchemist and

necromancer in the sixteenth century who had had his ears cut off at Lancaster for his Godless ways. Baines and Whatton's *History of The County Palatine … Of Lancaster* (1836) notes that the most famous story concerning this fellow told how he and a companion, Paul Waring, went to the churchyard at Walton-le-Dale *c.* 1560 and dug up a recently interred corpse. Through a series of mystical and secret incantations the pair brought the body of the old man partially to life, and zombie-like it delivered strange predictions for the benefit of a noble young gentleman who wished to know his future. The book notes that this trick was 'no doubt performed by a kind of ventriloquism', and that not long after, Kelley fled England with the celebrated astrologer and magician Dr Dee.

The Gabriel Ratchets

According to legend, a ghostly huntsman and a pack of baying, spectral hounds are said to charge after a milk-white doe round the Eagle's Crag in the Vale of Todmorden. The story behind this is that, during the time of the infamous Pendle witches, Lord William Towneley, of Hapton Tower, fell in love with Lady Sybil, of the long defunct Bernshaw Tower that stood in the Gorge of Cliviger, near Burnley. Lady Sybil dabbled in the Black Arts, such were the times, and often made her way about in the form of a white doe or a cat. She rejected Lord William's advances, and so he was forced to resort to equally nefarious measures to win her heart.

Eagle's Crag, Cliviger Gorge.

He employed the services of another witch, Mother Helston, who told him to hunt the doe on the crag on All Hallows (1 November), assisted by a magical hound that was, in fact, one of the witch's familiars. Lord William managed to snare the doe using an enchanted silken rope, upon which it changed back into the pleasing shape of Lady Sybil; she agreed to forego sorcery and marry her captor.

However, Sybil could not change her ways, and met her end when in the form of a cat, when her paw (or hand) was lopped off while causing mischief at Cliviger mill. Following this she wasted away, and Lord William had her buried near the Eagle's Crag. Since then a supernatural re-enactment of the chase is played out in the gorge on Halloween. The lord's hounds are said to fly yelping through the air by themselves on other occasions, earning the name 'Gabriel Ratchets' and being a precursor of death and misfortune to all that see or hear them.

The Curse of Barcroft Hall

Could it be that a curse ensured the demise of the resident Barcroft family at Barcroft Hall, on the Burnley Way and southeast of the town itself?

Here at this 'E-shaped' seventeenth-century stately home, with its stonework walls and arched gatepost, legend has it that one of the early Barcrofts met an untimely end in the ample cellarage beneath the property.

Upon the death in 1620 of William Barcroft, the founder of the hall in its present state, the building became the subject of some dispute among his sons. The younger son, Thomas, put it about that his elder brother and legitimate heir, another William, was insane, and contrived to have him chained to the wall in the cellar. The ruse worked, and the unhappy brother is said to have cursed the Barcroft line from his secret confinement as he wasted away to death; others swore that the demented William managed to escape from his imprisonment and interrupt a party being held by Thomas, dramatically declaring before all present that he had cursed the family line and the estate because of his brother's treatment of him. Some versions of the story have it that Thomas circulated that his elder brother had died, long before the captive had actually passed on.

This dire prophecy was borne out; an older brother, Robert, had died shortly after his father, and the captive William allegedly starved to death in 1641. When the treacherous Thomas died in 1688, the hall was left to his several daughters – his own son having died in childhood. After passing through the hands of the Bradshaws, the Pimlots and the Isherwoods, the property was finally sold to Charles Towneley, the celebrated antiquarian, in 1795.

The story is told in *Memories of Hurstwood, Burnley, Lancashire* (1889) by Tattersall Wilkinson and J. F. Tattersall. Confusing, disjointed and meaningless scribbles that adorned the cellar walls – such as 'The Lady Redman supp'd here a night with a leg of mutton', or 'Thou hast nothing to doe with Ann Coollars' – are alleged to have been written by William himself as he slowly lost his mind.

Of course, Barcroft Hall had its own boggart – although it does not appear to have been associated with the seventeenth-century Barcrofts and their misdeeds. 'He' was a

wood goblin or friendly elf, given to kindly assistance in household matters as well as outside affairs, who went by the name 'Hob o' th'hurst', or 'Goblin of the Wood'. The Barcroft boggart took the form of a wizened little elfish man, who worked barefoot; when some wooden clogs were left out for him he at once became incensed by this act of kindness, and all sorts of poltergeist activity followed. At length the farmer loaded up a wagon, preparing to leave the premises in exasperation. As he did so he heard a little voice emanate from atop the heap of furniture and tools; 'Stop, hold on while I've tied my clogs, and I'll come with you!'

It seems the Barcroft boggart intended to plague the man, wherever he went.

The Ghost of Tailor's Cross

During the English Civil War, it is said Cromwell's army marched on Colne. Being short of clothiers, they rounded up all the tailors they could find and forced them to make their clothes. However, one who was a staunch Royalist flatly refused, and so was taken to a spot about 200 yards from Kirk Bridge, just south of Foulridge between the two reservoirs, and summarily shot. The soldiers then dragged a heavy stone over the tailor's remains and carved a pair of scissors into it as a warning to all others who likewise refused to help them.

Colne historian J. Carr, writing in 1878, noted that the stone still existed at the spot now designated Tailor's Cross, and that locally it had been said for years that the tailor's ghost appeared at midnight. It signalled its presence by 'woeful groans.' However, he was unsure of the story's authenticity, as recent excavations beneath the stone had revealed no skeleton, and Tailor's Cross was perhaps a corruption of Templar's Cross – the carved 'scissors' perhaps representing a Greek cross.

There is another story of a like nature from these times of conflict. Today, the tiny portion of Greenhalgh Castle, off Castle Lane east of Garstang, tells its own story: of how it was one of the last two Royalist strongholds to submit to Cromwell's forces during a bitter siege. It was during the conflict that a besieging soldier named Broughton one evening encountered a woman dressed in white on Gubberford Bridge, further up the River Wyre at Cabus. Broughton, a local man, was astonished to find that it was his estranged wife, who some years earlier had deserted him for a Royalist rival named Rowton. Rowton himself then suddenly appeared on the bridge, and in a violent confrontation drew a dagger and stabbed the woman to death; for she was at the time embarking on another clandestine affair with a Royalist captain, and the suspicious Rowton had trailed her from Woodacre Hall. Bizarrely, the two men – Rowton and Broughton – had both been betrayed by the same woman, and despite their political differences they secretly buried the slain woman by the Wyre; the pact perhaps the result of mutual fear they would both be hanged. Following the castle's surrender in May 1645 the victorious Roundheads largely demolished it. But according to George Mould's *Lancashire's Unknown River: The Story Of The River Wyre* (1970), 'In August each year it is said that Peter Broughton's errant bride comes to the neighbourhood of Gubberford Bridge and to the riverbank to look for him.'

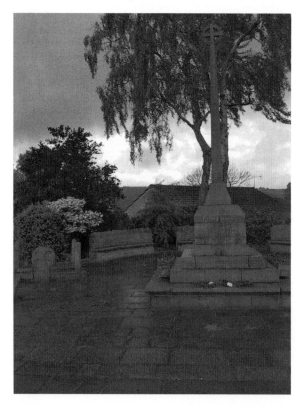

Tailor's Cross, Foulridge.

'The Surey Demoniack'

In 1688 a strange episode was played out in the parish of Whalley. A twenty-eight-year-old named Richard Dugdale, by profession a gardener, offered himself to the Devil during a pageant called the rush-burying, or rush-bearing, 'on the James-tide', on condition that he become an expert dancer. From then on he was troubled by strange fits, given to dancing better than professional dancers, but often succumbing to performing (seemingly unable to stop himself) a ridiculous and painful dance on his knees. Sometimes it was observed that his bodily mass was so light that he could be lifted by the buttons on his clothes; conversely, sometimes he was so heavy that seven men could not lift him up. But the young man also allegedly suffered many other demonic torments, such as falling into trances and displaying clairvoyant powers; he vomited stones an inch and a half wide, could not be restrained by twelve men when his struggles were at their worst, and was heard to have several different voices issue from his person. His house in Surey was also subjected to poltergeist activity.

In the end, the afflicted man obtained relief through the united efforts of a Puritan clergyman called Mr Jollie and five others of the faith, who apparently managed to expel the demon from Dugdale's person. The story was put together in 1697 in a pamphlet called *The Surey Demoniack, or the wonderful dealings of Satan, about the person of Richard Dugdale*, complete with the affidavits of many witnesses. However, the whole story was effectively demolished by a sceptic called Zachary Taylor, who (in

his response tract *The Surey Impostor*) declared the whole thing a nonsense designed to raise the reputation of the Puritans.

Nonetheless, there are intriguing question marks over the affair. There were clear religious dimensions, such were the times, to Dugdale's affliction, it being noted that although born of Catholic stock he himself was a Protestant. At the time of his illness, he seems to have been approached by 'popelings (Catholics) from Stoneyhurst' and, next, dissenting ministers, but all failed to cure his condition.

When Dugdale was exorcised, it was not, it seems, by Puritan ministers at all but by a physician called Edward Chew on 25 March 1690, with the nature of Dugdale's condition not being made public. Dugdale's old schoolfellows differed in their opinions of him, with one declaring that he had possessed a talent in his youth for agility and walking on his hands etc, while another declared with equal conviction that nothing of the sort had been observed in Dugdale's childhood behaviour. The case caused great controversy, first at the time and then among Victorian demonologists who were studying the phenomenon, and even today none of it seems to make much sense.

The Hag of the Fylde

As we shall see, the county's associations with witchcraft in the seventeenth century have made it in part infamous, and there are evidences that the superstition that bred the famous case of the Pendle Witches continued to exist in Lancashire for many decades afterwards.

There is physical evidence of that belief at St Anne's Church, Woodplumpton. The church itself is modern looking, although it has foundations that go back to at least *c.* 1630: on the grass by the path can be seen a great boulder. This, they say, marks the burial place of a village woman called Margery Hilton, better known as Mag, or Meg, Shelton, a reputed witch who is supposed to have lived at Singleton near the church. On the other hand, she is also said to have lived in a cottage called Cuckoo Hall, in a solitary part of Wesham, near the footpath from Kirkham to Singleton. Mag is nowadays commonly remembered as the 'Hag of the Fylde', being blamed for much mischief in the area in the late seventeenth century: stealing milk, running afoul of the local squire, turning herself into animals, and even into a sack of wheat (this latter disguise being revealed when a farmer thrust a pitchfork into the 'sack', whereupon it bled and screamed). Farmers blamed Mag if their cattle became ill, and their wives thought it was her fault if the milk went sour. It is famously said that she would milk her neighbour's cattle dry and, when she walked off, the pitcher containing the stolen milk would walk before her in the shape a goose. This ruse was discovered when someone struck the 'goose' and it transformed into a broken pitcher, leaking milk onto the ground.

An 1888 work entitled *The Haydock Papers* notes that, according to popular supposition, Mag was found in her house crushed to death between a barrel and the wall. In the village it was believed that the Devil had come to claim his own. She was buried by torchlight at the western end of Woodplumpton churchyard in 1705, but her restless spirit was not to be pacified: her corpse was found on the sod the following

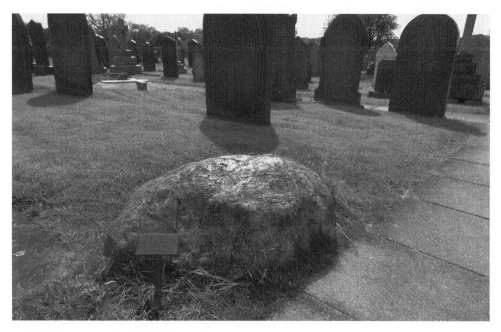

The Witch's Grave, Woodplumpton.

morning, and as often as it was interred it would reappear outside the grave laying in the wet grass. Eventually her spirit was exorcised by the priest at Cottam Hall, but just to be on the safe side, the glacial erratic boulder was hauled over her grave to make sure she stayed beneath the earth.

And there it still sits. It is often repeated that Mag was buried head downward during her final interment, so that if she tried to crawl her way out then she would only crawl deeper and deeper. Her story is a well-known one, and there are numerous legends pertaining to her grave. For instance, many people – particularly children – express that if you touch the stone then the hairs on the back of your neck will stand up, or you will experience an inexplicable sensation of unease or even terror. Some children say that you have to walk around the stone and then spit on it in order to ensure that Mag stays in her grave. Others say that if you walk round it forwards three times then her skinny, claw-like hand breaks the earth and grasps at your legs.

A sign by this weighty stone that imprisons Mag's spirit reads simply, 'The Witch's Grave. Beneath this stone lie the remains of Meg Shelton, alleged witch of Woodplumpton, buried in 1705.'

Terror at the Two Lads …

Legends of supernatural horsemen abound in Lancashire, but perhaps the most famous is the horseman of Rivington Pike. Roby places the story as happening around 1732, at the time of the building of the square, squat Pike Tower that crowns the summit of this irregular conical hill, south-east of Chorley.

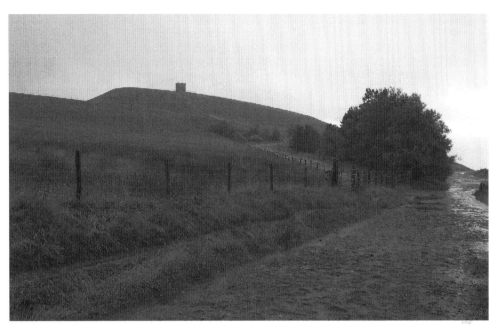

Rivington Pike, on a foggy day.

As evening fell, and the weather took a turn for the worse, a party of sportsmen opted to take shelter in this beacon. However, as their hounds howled dismally, and the weather outside got worse, one of their number – a young man named Norton – thought he could detect the thunder of horse's hooves on the heath outside, and so decided to go out and see who their new companion might be. To his amazement, he saw framed against the moonlight his own uncle, a man who had disappeared under mysterious circumstances some years earlier on the West Pennine Moors. Norton's uncle declared that he wished his nephew to follow him to the pile of stones on Wilder's Moor known locally as the Two Lads, on account of the traditional belief that they commemorated the deaths of two shepherd boys in the snow. ('Wilder's' was held to be a corruption of 'bewildered', the two boys having supposedly lost their way in a blizzard long before. To this end the landmark was also known as 'The Wilder Lads.') As his uncle spurred on his horse and thundered off into the darkness, Norton leapt onto his own steed and hotly pursued him – against the advice of his friends, who shouted after him to come back.

Norton never returned, and he was found in a state of stupor and abject terror the following morning at the foot of the pile known as Big Cairn. He was taken to an inn in nearby Horwich, and when he recovered his senses some weeks later he was able to tell an astonishing tale. On that strange night, his uncle, upon reaching the Two Lads, had dismounted and ordered young Norton – who was now beginning to realise with dawning terror what this might all be about – to wait by the biggest of the cairns. He promised to reveal the purpose of his visitation at midnight, and Norton opted to stay, in the main part because he was curious about his uncle's sudden reappearance. Midnight came and the boy awoke to the sound of his uncle's horse reining in next to him. As he looked up at his relative, Norton observed that his uncle's face was

now a ghastly, twisted demonic visage; and his uncle now made it clear that his own disappearance all those years ago was linked to Satan claiming his soul … and in order to free himself from the torments of Hell he himself needed to claim another soul as a substitute: young Norton's, in fact.

Norton put up such a spirited battle against the older man, however, that the plan failed, and the sinister, long-dead revenant of his uncle was forced to climb atop his horse and charge off, his plan thwarted by the strength and desperation of his younger nephew. Norton, in telling this story to his awestricken friends, also intimated that his salvation might have been due to a cry to Heaven he had yelled before he passed out during the battle.

The spectral horseman was never seen again on Rivington Pike – perhaps his one chance to swap his own soul for another being thwarted, he was led by his charging steed into the bowels of Hell, this time for good. Roby wrote, 'To his dying day Norton believed that his uncle's body was the abode of some foul spirit', and that 'the foul fiend was obliged to renew his habitation (i.e. claim a new soul) upon every twelfth return of the festival of St Bartholomew.' Roby's story may have been a drawn-out retelling of an actual ghostly legend, and not a complete fabrication, however. *Blackwood's Magazine* of June 1837 records that there was a strong tradition in southern Lancashire 'previous to the invention of the steam engine' that spoke of a dark, gigantic warrior who rode a giant steed upon Horwich Moor and who disappeared by the ancient relics that were the Two Lads.

The story was a long time in dying out: as late as 1877 it was written in a county handbook that, 'There is a popular tradition that Rivington Moor is the nightly resort of a spectre horseman' … and perhaps this sinister entity that we assume must be folklore is still there, even in this day and age.

'Some of Them Looked Very Sad …'

The entry for 29 July 1766 in the journals of the Methodist crusader John Wesley explains that he preached in Colne that day, where he met a twenty-six-year-old girl called Ann, who lived 2 miles from the town. She told him an extraordinary story.

As a little girl of about four, Ann had often seen 'several persons' walking up and down the bedroom during the night. These strange figures would glow with an ethereal light in the gloom of the bedroom, and although they would walk to the side of the bed and look down at her they would mostly not say anything. Ann explained, 'Some of them looked very sad, and some looked very cheerful: some seemed pleased and others very angry.'

The ones that looked angry had frightened the little girl, but worse was the fact that some of the ghosts she recognised. Two of the wraiths were a man and a woman from the parish who appeared to be arguing; these two were yet alive, but both died soon after.

Only one of these ghosts ever actually spoke, and this was a little boy, who appeared angry and did not seem to understand what had happened to him. Ann knew the boy, and knew he had died a week earlier from smallpox. She had stammered at him, 'You are dead! How did you get out of the other place?' He had replied, 'Easily enough', and

to this Ann said, 'Nay, I think if I were there I should not get out so easily.' At this the boy looked furious, and the terrified little girl began to pray, whereupon he vanished.

Ann suffered these visitations until the age of sixteen or seventeen, at which time she began to become not only frightened but also worried, as people were beginning to say she was a witch. She found herself crying earnestly to God to take the ghosts away from her, and within a week or two so fervent had been her prayers that these spectres gradually ceased to materialise.

Since then Ann had been untroubled, and the whole affair remains a strange paranormal mystery. However, Wesley found no reason to doubt her story and considered her 'of an unblameable behaviour'.

Supernatural Justice

In the late eighteenth century Clitheroe was scandalised by a shocking murder, which for decades afterwards prompted much speculation and comment. On the night of 25 March 1773 one George Battersby, of Slaidburn, was last seen alive at a cattle market in Clitheroe, and vanished off the face of the earth afterwards. Horrific screaming was remembered later on as being heard coming from a particular lane, but for three years the disappearance remained a mystery. Then, in 1776 a considerably decomposed body was found in the bone house of the church, having been apparently taken there recently and bearing the appearance of having been burned in a lime kiln.

Suspicion being directed at four men (including Nicholas Wilkinson, Dr Herd and Henry Worswick), a trial was forced in April 1778 but all were acquitted: it was simply not possible to prove that the remains belonged to the missing cattle dealer.

In Clitheroe, the memory of this unsolved crime was a long time dying out, in part due to the prominence of the accused. One was a butcher, one a barber, and one a publican, and the mystery surrounding the incident ensured it entered local lore. There was speculation as to where the body, if it was Battersby's, had been hidden for three years, and furthermore, what could the motive have been? Local gossip suggested that the butcher might have resented Battersby's interference in his trade, but that was the best anyone could come up with. There were also rumours that political allegiances led to the freeing of the accused men.

William Dobson's nineteenth-century serial-work *Rambles by the Ribble* remarks that, decades afterwards, old-timers were still alive 'who knew the men charged with the offence, and could tell of remorseful sufferings they were believed to have undergone'. These included the belief that, shortly after the crime, all four accused had suffered nightmarish visions of Battersby's ghost – and this was the circumstance that, after three years of torment, had led them to take up the corpse and try to bury it in consecrated ground. It was also said that a wound incurred upon one of the murderer's person during the killing reopened on the anniversary of the crime, and bled as though fresh. At the spot where the murder had occurred, they said, fresh bloodstains would appear every year on the anniversary of Battersby's mysterious disappearance.

The crime also gave rise to the proverb 'He's knocked about as ill as owd Battersby's bones.'

The Exorcising of Hannah Corbridge's Ghost

Another crime shocked Lancashire in 1789. The victim was Hannah Corbridge, a beautiful teenage girl from Colne who was pregnant, and when she disappeared on 19 January her family resorted to consulting a Todmorden 'wise man' in an attempt to locate her. After her body was found in a shallow grave in a newly-drained field near Barnside Hall, it was established she had been poisoned and hacked so violently that she had almost been decapitated.

At Barnside Farm lived a nineteen-year-old man called Christopher Hartley. Hartley lived with his mother, and was rumoured to be the dead woman's sweetheart and father of her unborn child. He was quickly arrested at Flookburgh, tried at Lancaster and hanged at York on 28 August 1789. Poor Hannah had been interred at Newchurch in Pendle on 29 January.

However, this was not the end of the sad, brutal affair. According to James Carr's *Annals and Stories of Colne and Neighbourhood* (1878), Hannah's ghost wandered the site of her death for years afterwards, appearing at various places in the neighbourhood but notably near Earl Hall, to the north. This was about halfway between her father's home, Knarrs, and Barnside Hall, where the crime occurred. Here, she appeared so regularly at midnight that the farmer and his family were forced to obtain the services of a Catholic priest to exorcise her. This he did by lighting the room in which she was wont to appear with candles, at which she almost immediately appeared in the form of a hay-cock that came down the chimney. The priest ordered her to appear in her 'proper' form, which she did, 'with a little babe in the palm of her hand'. He then proceeded to enter into a dialogue with her, upbraiding her for the terror she was causing at Earl Hall, although while he did this he simultaneously noticed that all the candles, bar one, were being extinguished. With this single, solitary candle still lit, he managed to get Hannah's ghost to agree to depart on the understanding that it was only for as long as this candle was useable; when it had burnt away, she would have the ability to reappear. The priest is said, upon her departure, to have blown out the flame and swallowed the candle, thus ensuring that, technically, it could never be burnt away.

When Barnside Hall was dismantled, some of the stonework was incorporated into Laneshaw Bridge, and it was believed that blood would seep from these stones. This was on account of the murderer having wiped his bloodied hands on these very stones on the night of the crime.

T' Park Mistress

According to a traditional verse, Margaret Brackin, who was born in 1745 and died in 1795, had an encounter with a ghostly woman at a place called Windy Bank, north of Hornby. Margaret had been up on Windy Bank collecting kindling when, as the sun

The lonely Trough of Bowland.

went down, she saw by the fringes of Hornby Park Wood a strange woman – 't' Park Mistress' – dressed in flowing white, who in the gathering dusk glided across the grass to Margaret's side and ignored her attempts to converse.

This strange ghostly woman merely grabbed Margaret's hand and proceeded to drag her into the woods and through the trees, and then in a completely aimless series of directions, and eventually into the River Wenning. Margaret's clothes were torn and tattered, but the phantom lady never once let up the pace and finally they disappeared into a wood near somewhere called Weaver's Ayr.

When Margaret was found the following morning, however, she was back on Windy Bank, terrified with fright and unable to say what had happened for certain or where she had ended up with t' Park Mistress. Apparently a 'stout and throddy' lass, Margaret had ever after been unable to quite explain her experience, and the shock of it caused her to lose weight and waste away.

This, at least, was how the verse, spun in the broad Lancashire dialect, interpreted (or invented) the incident. Harland and Wilkinson's *Lancashire Folk-lore* (1867) noted, 'The … story is told and believed by some persons in Hornby. The Park Mistress may be supposed to be the ghost of Lady Harrington, who committed murder three hundred years ago.'

Phantom ladies like this, their behaviour and motives as mysterious as their appearance, are very much a part of Lancashire's paranormal heritage. Bowker's *Goblin Tales of Lancashire* (1883) tells the story of a young lad called Giles Roper who encountered a mysterious woman on Fair Snape Fell, a large hill in the Forest of Bowland, while making his way home over the peat moorland and through the deep valleys. As the sun dimmed, he chanced upon a golden-haired young woman, who neither spoke nor looked of this

earth, and yet so enchanted him that he succumbed to a kind of mania. His obsession to see this strange and eerie phantom lady once more took him out onto the fell again and again, until one night Giles never came back; he was found by a search party, headed by his father, on the edge of a frozen stream. Two men out on the moors who had been poaching had apparently seen the delirious young man, on a previous occasion, imploring someone invisible to appear to him, and from this the story was put together.

'Murder' on the Wind …

During the reign of King George III, a solitary young man atop his steed was traversing the bare sands skirting the Lancashire coast. Night was coming, and as he looked over the low sand hills and across the Banks Sands out to sea, he observed that tempestuous weather was rolling in on the darkening horizon, and quickened his mount.

As darkness fell, the traveller felt that he was losing his way, and worse, his horse was become uncontrollable, halting every few steps and clearly frightened. The sea boomed and crashed away to the right, and at length he thought he could discern a voice – a fisherman's perhaps, although clearly the voice of someone in distress.

Out of nowhere, the voice became defined and articulate, and a horrific shrieking blasted in from the sea accompanied by the howling wind, screaming 'Murder! Murder!' The voice continued to scream its dire message, almost in his ear, and the traveller, looking wildly about him, yelled back, 'Where, in the name of God?' At this, a loud whistling noise and a tremendous thump was to be heard, as though something very heavy had landed at the horse's hooves in the gloom, and at this the spooked animal threw its rider and thundered off in fright.

The young man groped about him and to his utter terror felt his hands touch something – the moon, appearing from behind the clouds, partly illuminated a corpse before him, blooded and battered, and in torn clothes, its putty-coloured face contorted in a final deathly scream. At this the man fled in terror, away from the ghostly, shrieking cry of 'Murder!' that had filled the air before his grisly discovery.

Presently our hero reached an inn called the Sandy Holm in Southport, and a party of hardy souls made their way back to the banks where they threw a cloak over the body and conveyed it back inland to the tavern. Old Bridget Rimmer and her daughter ran the tavern, and they saw to it that the corpse was laid out on a straw pallet in the hayloft. However, midnight brought no respite for the traveller, who pondered his gruesome and mysterious discovery into the small hours as he lay abed.

Before long the small coastal community was whipped and thrashed by the tempest that had been rolling in off the sea, and like scavengers the locals appeared in the darkness, in their waterproofs and bearing lanterns, heading *en masse* in the direction of the sands. The rumour was abroad: a vessel was in distress, and there might be spoils if it sank.

There were spoils, and much looting that night, but among the flotsam and debris washed ashore was a man, a captain, who when conveyed gently to the Sandy Holm proved to be alive, and our hero, who had taken no part in the looting, explained that if the shipwrecked mariner wished a bed then he would have to share it with the corpse in the hayloft, as nowhere else was available.

It only remains to be said that the mariner, when presented with the battered face of the corpse, screamed in terror and recognition: for this very corpse that now stared glassily-eyed back at him was a former crewmate – a man that the shipwreck survivor had murdered the previous day. Trembling in wild-eyed fright, the man whom providence had rescued from death only to deliver him to the victim of his crime, explained that he had borne the dead man a grudge, and knocked him overboard when both stood alone at the helm and an opportunity presented itself. The man, however, had not sunk in the waters of the Irish Sea; his body had floated on the waves, and a dismal voice groaned 'Murder!' before it was lost to sight by the captain in the fog. The vessel had subsequently been wrecked off the Lancashire coast, all on board drowning in the storm except the one survivor – the guilty captain.

It is implied in the narrative of this tale that the guilty man was subsequently hanged, but the story's origins in truth, if any, are unclear. Roby, in his *Traditions of Lancashire* (1829), wrote,

> Southport, a bathing place of great resort on the Lancashire coast, has been pointed out as the scene of the following tragedy … Nearly one hundred vessels have been wrecked on this coast within the last 30 years, and more than half of them totally lost. Of these calamities the particulars are upon record. Which of them may have given rise to the events here detailed we have no means of ascertaining.

Longridge's Headless Woman

It was from the White Bull at Longridge, some 200 years ago, that a young man named Gabriel Fisher, accompanied by his dog Trotty, set out for home at midnight, in the direction of Thornley Hall. At the highest point of the road, which displayed before him the vista of Chipping Valley, he observed in the lane ahead a woman wearing a long, light cloak and hood, and a large coal-scuttle bonnet. She also carried a large market basket.

Gabriel's dog at this point went berserk, and, howling dismally, shot away from his master down the hillside and into the darkness. Undaunted, Gabriel attempted to strike up a conversation with the woman, despite wondering why she was out at such an hour. However, he received only muted responses and so said to her in frustration, 'Yo' met a left yir tung at whoam, Missis. Sin' yo' connot answer a civil mon!' Nonetheless, he offered to take her basket from her, to which she consented, and as Gabriel walked and wondered about this mysterious woman, a voice came from the basket, 'You're very kind, I'm sure!' followed by a peal of silvery laughter.

Gabriel dropped the basket in fright, and from under a white cloth a woman's head rolled out into the road. At this he saw the woman stoop to pick it up – and observed that there was nothing in her bonnet … for she had no head! Shrieking 'Th' yedless boggart' Gabriel fled down the hill!

As he charged along the old Chaigley Road, he heard footsteps clatter in the lane behind him, and a frightened glimpse over his shoulder told him that the headless woman was hot on his heels. Worse, she had thrown her detached head after him, and it landed in the road, forcing him to leap over it even while it snapped its teeth at his

feet. Gabriel arrived at his home in a state of abject fear, where he found his trembling dog. Upon narrating the story to his wife, she stated matter-of-factly that she always knew sooner or later he'd encounter a feeorin, but if it stopped him from having late nights in the White Bull then something good would have come of it!

The alleged encounter is mentioned in Bowker's *Goblin Tales of Lancashire*. There is another mention of a ghostly woman that haunted Longridge, although this one appears to be distinct. *A History of Longridge* (1888) notes that a spectral woman in white haunted 'Daniel Plot' – presumably Daniel's Farm, between Longridge and Grimsargh. She was supposed to have been a murder victim.

Family Death Omens

Within Whalley parish church of St Mary's and All Saints, there is a curious legend attached to a gravestone that, traditionally, represents the final resting place of John Paslew. He was the last Abbot of Whalley, who was hanged for his part in the Pilgrimage of Grace, a revolutionary movement against King Henry VIII that had as its principal objective the restoration of the Roman Catholic faith. The grave bears the weathered inscription *Jhs fili dei misereri mei*, and there was for centuries a tradition that if an Assheton or a Braddyll stood on the grave they were fated to die within a year; for Richard Assheton and John Braddyll had been the purchasers of the land following

Abbot Paslew's 'cursed' grave.

Henry VIII's notorious subjugation of the monasteries, known as the Dissolution. Abbot Paslew met his end on 20 March 1537 at Whalley, on a gallows erected on the gentle elevation of a field called Holehouses, immediately facing the place of his birth. Two of his monks, as well as William Trafford, the abbot of Sawley, shared his grim fate after their conviction for high treason at Lancaster.

There are other instances of supernatural family banshees. Thornber's *History of Blackpool* notes that the Walmsley family, historic residents of Poulton-le-Fylde, east of Blackpool, were terrorised by a boggart whose appearances were always marked by alarming noises that foretold a fatality among the family. At Lytham Hall, deep within Hall Wood, Lytham, near the banks of the mouth of the Ribble, there was another; it was at one time believed that the appearance of a white owl foretold a fatality among the Clifton family, who held the property from 1606 till 1960. Interestingly, a correspondent to *Notes And Queries* in 1854 remarks on other, similar phenomena: 'To two families of venerable antiquity, and both, if I remember right, in the county of Lancashire, the approaching death of a relative is made known in one case by loud and continued knockings at the hall door at the solemn hour of midnight; and in the other by strains of wild, unearthly music floating in the air.'

The Peril of Imitating a Ghost

Sometime around 1830 a bizarre occurrence took place in a little village near Garstang. There lived at the time an idiot called Gregory, the butt of village mockery and bullying, who wiled away his days wandering about the woods and thickets collecting flowers and singing to himself.

The village wags decided to play a trick on Gregory and to this end one of them donned a white sheet, intending to frighten him to death by pretending to be a ghost. Presently, the group of conspirators hid in a ditch by the lane, and that night as Gregory wandered home, the lad, dressed as a 'ghost', leapt out while his friends made suitably ghostly noises in the background.

However, the idiot merely looked with interest and curiosity at the 'spectre', laughing at the spectacle. Then suddenly, his expression changed: for in the gloom of the lane, he had observed a dark and terrible figure – a real ghost, none the less, looming up on the group of pranksters. The whole group, including the boy dressed in the sheet, fled yelling in terror in the direction of the village; all, that was, except Gregory, who merely watched this dark, shapeless form pass him and give chase to the fleeing group. As folklorist James Bowker told it, the real phantom simply vanished on the outskirts of the village, and presently Gregory caught up with the fleeing boy (still dressed in his white sheet) and watched him lose his way and crash into a ditch, where he knocked himself out.

After this, the prankster was ill for some time, his terror at being chased by a *real* ghost having unhinged his mind. However, Gregory's mother took him in and looked after him, and – strange to relate – in time the lad who had played the nasty trick, and Gregory, the village idiot, became the best of friends.

The Boggart of the Brook

Reader's Digest's *Folklore, Myths and Legends of Britain* (1973) retells the old story of a horrifying boggart that at one time patrolled Garstang Bridge over the River Wyre, between the town and Bonds. This malevolent entity was called the Boggart of the Brook, and took the form of a woman wrapped in a cloak and hood. She would entice horsemen into giving her a lift on their steed, but once they were moving she would begin cackling and produce a whip, striking the horse's flank and sending it bolting. Looking over his shoulder, the horseman would see the woman's hood concealed the ghoulish skeletal features of the long dead, but by now it was too late: the boggart had gripped him with her bony claws and the insane ride continued until the rider was either thrown off the horse or fainted from fright, only to end up fatally injured by the roadside.

I wonder if in such a superstition riddled era the story arose to account for the discovery of corpses by the wayside, or in the river, following accidents; at any rate the boggart was believed to be the vengeful spirit incarnate of a murdered woman.

Wycoller Hall's Spectre Horseman

There can be few more atmospheric and hauntingly evocative places in the county than the ruins of Wycoller Hall, situated on the southern extremity of the village of Wycoller along the Brontë Way. Wycoller was formerly the seat of the Hartleys and afterwards the Cunliffes, and was a very characteristic mansion seated at the foot of the wild landscape that forms the Forest of Trawden. Long a ruin, it still contains its noble fireplace detached from the wall and surrounded by stone benches. *Murray's Handbook For ... Lancashire* (1870) notes that the Cunliffe legislators still retained a very interesting MS that outlined the traditional Christmas 'open house' that the hall offered for twelve days throughout the festive period.

Wycoller Hall is believed to have been haunted for centuries, as an entry in one Elizabeth Shackleton's diary in 1779 implies when she refers to place simply as the 'haunted house'. Stories of the Cunliffes recklessly riding their horses up and down the hall's stairs, or down the breast of Pendle Hill, are legendary, as was their obsession with cock-fighting. Local tradition holds that a seventeenth-century Cunliffe murdered his wife, either because she was having an affair, or because she made a prediction during a heated row that the family line would die out; a dire prediction that actually came true, with the last Cunliffe dying in 1819. The hall was thus abandoned to its present state.

A fuller version of the legend claims that Cunliffe had his bride crowned Queen of May in Wycoller Dene, but that evening watched her embracing a young man whom he believed to be her secret lover: in fact, this was her brother. Blinded by rage, he killed her with the butt of his dog whip. When the enormity of what he had done gripped him, he mounted his steed and thundered off into the night, never to be seen again.

Either way, the last moments of the crime are said to have been re-enacted in spectral form, with the ghostly figure of Cunliffe being seen descending Wycoller's stairs to the accompaniment of a woman screaming hideously. These screams gradually subsided

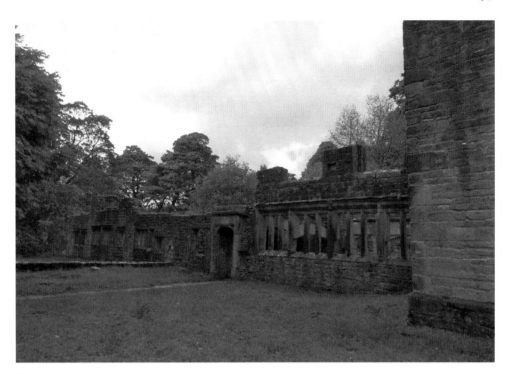

Wycoller ruins, 2011.

into muted groans. The ghostly Cunliffe would then, it was repeated in hushed tones, mount his steed and gallop furiously off through the village and away from the scene of his wicked deed. Both horse and rider were semi-translucent. According to *Lancashire Legends* (1873), the horseman was destined to re-enact his crime annually, and whenever he appeared, charging through Wycoller on his horse, the wind howled dismally and there was no moon. He was attired in the costume of the early Stuart period, and fire streamed from the horse's nostrils. F. Bannister's *The Annals of Trawden* (1922) notes how Bannister's own grandfather, John Bannister, a corn miller, bought and removed the 'haunted chamber', the front doorway and the entrance hall. These he established behind his own house, and Bannister Jnr wrote, 'This haunted chamber used to be the playroom and workshop for my brothers and myself, and from personal experiences extending over many dark nights I can swear that the ghost did not migrate with the building.'

Wycoller is hidden away, and takes some finding, but is worth seeking out. Like many landmark buildings in Lancashire, it has more than one ghost. Also said to haunt this place is the ghost of a woman wearing a full black silk dress, known as Old Bess or Black Bess: she apparently last materialised before a courting couple outside the ruins *c.* 1808, silently withdrawing as her gaze fell on the young lovers. Bess is believed by some to be the slain wife, returning to the ruins to seek out her murderous husband. I have also heard it said that Bess haunts the village's famous packhorse bridge, one unlikely story being that she is in fact a Jamaican lady who was married to one of the Cunliffe line during some misadventure in the West Indies. However, the poor lady was thrown overboard into the Atlantic during the return journey back the Britain, and lost beneath

the waves: it is her spirit that seeks vengeance upon her ruthless husband. Bannister, in drawing a line under both these ghosts, wrote, 'It is many long years since these spirits were last reported to appear, nor is there anyone living who has seen or heard these restless ghosts.'

The 'Old Madam' of Egerton

Ghostly ladies are a familiar theme in Lancashire folklore, one being recorded as early as 1842 in a county itinerary and concerning a farmhouse that stood on the site of Egerton Hall, now on the boundary between the boroughs of Blackburn with Darwen and Greater Manchester. This place stood not a million miles from a stone circle – the remains of a Bardic temple – on Cheetham Close, and although the hall had ceased to exist, in Egerton they claimed that the farm was haunted by an unearthly woman dressed in silk who went by the appellation of 'Old Madam.' Perhaps there was a suggestion in the common mind that she appeared to look for the two gold bracelets that were discovered on the site in 1831 when the foundations of the farmhouse were being dug.

Weeton Cairn's Hairy Boggart

John Porter's *History of The Fylde of Lancashire* (1876) remarks upon the antiquities that had lately been found in the vicinity of Weeton, including pieces of rudely-fashioned pottery and half-baked urns decorated with dots. These had been accidentally discovered at an extensive barrow, or 'cairn', near Weeton Lane Heads. Porter stated this place was 'now pointed out as the abode of the local hairy ghost, or boggart'.

The Historic Society of Lancashire and Cheshire explain how the cairn came by this rumour, in their *Transactions: Vol 3* (1851). To the northeast of Weeton was a field called Moor Hey, by Fleetwood Road, where at one time the farmer was ploughing the field when his horses took fright and bolted – 'would the fatty ground smell?' – swiftly followed by the farmer himself. For there had appeared on Moor Hey the 'demon of the Fylde', a paranormal *something*, in the shape of a calf.

For years the cairn remained untouched and avoided, until modern necessity meant that it was raided for paving stones, and the urns discovered. An 1880 handbook for Lancashire states that the strange phantasm was the 'oldest ghost of the Fylde country – the hairy ghost, the Celtic equivalent of the ancient Satyr'.

Something similar haunted the Gorge of Cliviger, on the other side of the county, with folklorist Harrison Ainsworth making reference to a 'frightful hirsute demon' that materialised along this glacial valley that extends into West Yorkshire.

'Gross Superstition'

A strange example, barely believable in the context it was reported, serves to illustrate that either the rustics of bygone Lancashire saw ghosts in their own shadows, or else

'Ghost lamp' of Carry Bridge, Colne, *c.* 1900. Some saw a man's face in the lamp. (Picture courtesy of the Lancashire Record Office.)

the press found it amusing to imply that country-dwellers were backward; it is more likely that the folk of Melling, east of Carnforth, were merely curious, but at any rate *The Tablet* of 26 July 1856 reported what, at the very least, appears to have been an interesting example of a simulacrum.

A sycamore tree on a village road had burst its bark, and the protruding glob of sap resembled the detailed head of a man, 'Rumour spread abroad that it was the appearance of Palmer, who "had come again because he was buried without a coffin!"'

The 'Palmer' concerned was the notorious William Palmer, who had been executed earlier that year for poisoning his friend Cook in a crime that shocked Shrewsbury betting circles. Palmer was also blamed for fourteen other killings by poison, including those of his own wife and brother, but why (in a county where there was a 'real' boggart on every corner) he should appear as sap is unclear. Still, 'Some inns in the neighbourhood of this singular tree reaped a rich harvest': some were clearly very canny, despite the *National Magazine* declaring the episode 'the worst kind of heathenish superstition'.

The Phantom Diggers

The discovery in 1840 of the famous 'Cuerdale hoard' – silver coins, marks, bracelets and other ornaments from the days of King Athelstan – naturally fed the old traditions

that spoke of an even mightier hoard of golden riches buried in the vicinity of the Ribble Way near Preston. The antiquarian Charles Hardwick was later struck by some of the strange rumours that circulated in this part of Lancashire, which he heard when he conducted his own excavations at an ancient Roman encampment at the junction of the Ribble and Darwen near Walton-le-Dale, on the south eastern edge of urban Preston. His workers had lately discovered a few brass coins, exciting the locals into thinking that the discovery of the fabled 'buried goud' could not be long in coming.

Some stated that the location of the 'buried treasure' could be observed from 'the promontory overlooking the valley on which Walton, or "Law", church is situated'. Some recalled divining rods being utilised in earlier hunts, it being expected that this forked twig would become highly agitated upon its carrier standing over subterranean metallic or golden substances. One farmer went so far at to deeply plough an entire field in an unsuccessful hunt for any treasure.

Perhaps the oddest story was told to Hardwick by a Mr Markland, and concerned the discovery of a gigantic hole 10 feet long and very deep that appeared overnight near Walton-le-Dale, that was assumed to be an excavation of some sort. This was around 1841, and when workers were employed to fill the hole back in, they discovered a single, solitary silver coin among the earth piles. Bizarrely, around 1800 another giant mysterious excavation had appeared in the same spot, and although a group of watchers camped out every night for two weeks, the mysterious person, or persons, who dug the pit never returned, nor was it ever explained what their mission had been. Hardwick wrote, 'The general impression, however, was that they were treasure hunters, and that they had acted under some magical or supernatural direction.'

Perhaps the rumour at the time was that the ghosts of Anglo-Saxon warriors had, in fact, returned to the scene to recover their treasure, perhaps dropping the single coin during the incident of 1841 as evidence of their presence. For there were most definitely believed to be ghosts in this area: during more excavations at an ancient British tumulus at Over Darwen in 1864 Hardwick learned that the mound was known by all to be haunted by a boggart. The children, he found, would even take their clogs or shoes off when walking past it at night-time – lest their noisy footsteps brought the thing out of hiding.

The Headless Ghost of Penny Street, Lancaster

It seems that at one time ghosts really could be headless. Cross Fleury's *Time Honoured Lancaster* (1891) tells how he received a letter from a lady who, in childhood, had lived in a haunted house on Penny Street, Lancaster.

During her residence there as a little girl, this lady and her siblings had on repeated occasions seen a headless figure materialise in their bedroom, which was at the top of the house. In fact, it showed itself so frequently that the initial terror experienced by its presence gave way to curiosity, more so for the fact that this strange phantasm never tried to interact with the occupants, or even appeared aware of their presence. Fleury wrote, 'All it seemed to have deemed it necessary to do for its own satisfaction was to show itself.'

Fleury noted that the house in question had been pulled down a few years ago, and that, 'Another haunted house is said to have stood in Church Street.'

'With Me, He Often Converses'

Notes And Queries (1873) carries a curious story from a well-informed young lady who a short time earlier had paid a visit with a friend to 'Bair Hall' (Bare Hall at Bare, near Morecambe). Their hostess received them very civilly and assigned them a spacious bedroom full of old-fashioned furniture that included an old press wardrobe.

In the very early hours of the morning, at about 5.00 a.m. – it being quite light and a mid-summer's dawn – the visitor awoke in the old four-poster bed and saw quite clearly 'an old gentleman seated in an arm chair, earnestly gazing at me with a pleasant expression of countenance'. The lady was not immediately alarmed, despite the fact that she knew she had locked the door; she squeezed her eyes shut thinking the man's appearance the extension of a dream. However, when she reopened her eyes, she found him still there, although the chair had changed position and now stood with its back to the chamber door. The old man still sat on it though, looking at her, with an 'amused expression', and now – panic rising – the lady turned to roughly awake her sleeping friend, who lay next to her. This second lady immediately awoke, although during this disturbance the old man had vanished entirely and so had the chair.

In the gloom of early dawn the pair fled the bedroom for that of their hostess. Their hostess was not unduly concerned, however, and asked them if they had expressed a curiosity in the old press wardrobe; it appeared they had. 'Oh!' said she, 'It is only James Bair, my uncle (or great-uncle); he does not like anyone but myself to examine his ancient clothes, or interfere with his press. He frequently joins me in the house, and some of the other members of the family also, but they don't like him. With me, he often converses.'

Rooms locked at night were also unaccountably found open the following morning, and it appeared the hostess was so used to this it had ceased to frighten her. A 1914 history of this part of Lancashire confirms, 'Bare Hall is said to be haunted'.

'A Most Singular Phenomenon'

The *Spiritual Magazine* (1873) remarks upon 'a most singular phenomenon' that year at Eccleston, which with hindsight may have been the first evidences of a poltergeist trying to manifest. It drew on a report in the *Chorley Standard* of 15 February that reported the strange events at Bank House, a place occupied by two elderly ladies and their niece.

Water had started falling like rain within the house, around the beginning of the month. Furniture and floors were soaked, worrying the occupants; but, weirdest of all, the water appeared to have no source, and although it seemed to be coming from the ceiling 'probably the most singular feature of the affair is that the ceilings were quite dry'.

This phenomenon occurred two or three times a day, the *Spiritual Magazine* remarking that it was being whispered the occupants had 'been subjected to some occult influence, which is at once unaccountable and annoying'.

There is no suggestion that the mystery was ever solved.

A 'Violent and Offensive' Ghost in Chorley

As if to evidence that the paranormal could disregard the trappings of a modernizing Chorley, and did not restrict itself to lonely out-of-the-way lanes in the countryside, the *Pall Mall Gazette* reported in 1877 on Chorley's haunted railway station.

A large railway shed, a short distance from Chorley's passenger station in the town, had earned the rumour that it was haunted on account of 'strange phenomena that have been manifested about this structure'. Considerable alarm was being created among the workers of the Lancashire and Yorkshire Railway Company, with the engineers reporting strange sounds – an unearthly moaning and groaning – that came from no known source and were therefore considered supernatural. However, the haunting had 'of late shown symptoms of becoming extremely violent and offensive', with large stones being hurled at some of the workmen over a period of several nights. Worryingly, these emanated from 'some unknown agency', and in consequence a number of employees had resigned.

This had led to an investigation by the railway company's detectives, but without any apparent explanation to the mystery. An American railway periodical of the time found it all rather amusing, writing that if the ghost were caught it should be dragged before the magistrate: 'A small ghost will, no doubt, be leniently dealt with, on account of its "extreme youth", but an old ghost who throws stones ought to be severely dealt with.' Perhaps this was not so amusing for the staff plagued by the entity, nor the authorities who couldn't understand it: the only explanation forthcoming was that some months earlier there had been a 'shocking suicide' close to the haunted shed.

Railway goods yard, Chorley. Picture courtesy of the Lancashire Record Office.

'Old Sykes's Wife'

North of Samlesbury Hall, in a secluded dell on the banks of the Mellor Brook, stood a lonely farmhouse called Sykes Lumb Farm, on land that was once occupied by generations of the Sykes family and whose earliest parts dated to *c.* 1600. Tradition holds that during the Wars of the Roses a childless couple buried their wealth in earthenware jars under a nearby apple tree in Mammon Wood, with fear of robbers preventing them from telling anyone exactly where they had buried it.

When the couple died, their relatives attempted to locate the treasure, but were unable to do so. As Sykes Lumb passed hands years later, the story gradually grew that the road to Lumb Brook, after which the house was named, was haunted by the ghost of a wizened old woman dressed in old-fashioned clothes, who walked with her head down and by the aide of a crooked walking stick. Sometimes she appeared in the barn, always at midnight, but mainly she was glimpsed near an apple tree; at length one of the tenants of Sykes Lumb Farm found the bravery to ask her what she wanted, in answer to which she merely pointed, sadly and silently, to a specific tree in the orchard. Spades were fetched, and the tenant and a number of helpers dug feverishly into the small hours until gold was unearthed. The ghostly old woman had stood and watched this all the while, and at the discovery she smiled and gradually dematerialised, never to reappear again. Dobson's *Rambles By The Ribble* (1883) wrote that the ghost, however, was still feared: 'Old Sykes's wife is believed to have found eternal rest; but there are many, both old and young, who walk with quickened pace past the Lumb whenever they are belated, fearful lest they should once more be confronted with the dreaded form of its unearthly visitor!'

The Victorian Lancashire folklorist T. T. Wilkinson observed a strange postscript to this curious episode, seemingly unrelated. The farm, in his time, was notorious as the home of one of the aforementioned 'boggarts', or domestic familiars. He wrote,

> When in good humour, this noted goblin will milk the cows, pull the hay, fodder the cattle, harness the horses, load the carts and stack the crops. When irritated by the utterance of some unguarded expression or marked disrespect, either from the farmer or one of his servants, the cream-mugs are smashed to atoms, no butter can be obtained by churning, the horses and other cattle are turned loose, or driven into the woods, two cows will sometimes be found fastened in the same stall, no hay can be pulled from the mow.

The two hauntings seem unrelated, the later one being ascribed to the elemental, otherworldly, fairy-like boggarts, while displaying the typical behavioural patterns of what we might now consider poltergeist activity. The blurred definitions of these types of entities are clear when we learn on the one hand that 'the wicked imp sits grinning with delight upon one of the cross-beams in the barn', while elsewhere it is stated that, 'invisible hands drag these individuals down the stone stairs by the legs, one step at a time'. Whatever was happening, by 1941 the remains of the farm were being used as a cottage in the grounds of a modern house of the same name, and memories of this boggart were but foggy by this time. (I have heard speculation stating that the place is the building now designated Sykes Holt that can be seen from Myerscough Smithy Road/A59. Since 1986 it has been a Grade II listed building.)

Old Scrat

If anything makes it clear that in days gone by the bogles that terrorised Lancashire could not be easily categorised, it is the sprite known as Old Scrat.

Although his name was often used as a synonym for the Devil, Old Scrat was primarily a mischief-causing boggart that upset farmer's horses with poltergeist-like behaviour. His favourite trick was to sit in an empty cart, making it so heavy that the horses could not pull it, and in *Lancashire Folk-lore* (1867), one of the authors had heard from a farmer how his own horses had experienced this; 'His horses reared, and then became almost frantic; their manes stood erect; and he himself could see the wicked imp actually dancing with delight between their ears.' Again, there is a kind of blurring of the lines here between poltergeist, demon and perhaps bewitchment, but another story firmly links Old Scrat to the Devil. For a similar phenomenon afflicted a coffin being carried into a Lancashire church 'not many years ago', when it suddenly became so heavy that it could not be carried. A clergyman was brought in, and he performed a short prayer, commanding that Old Scrat desist and take his own to Hell: whereupon the coffin was felt to lighten and the funeral proceeded.

There was once a place called Boggart Plat, along Mill Lane, Goosnargh, where one of these types of stories was generated in the nineteenth century following the discovery of the sexton, William Cowell, asleep by the roadside. He had been conveying a funeral bier to a place of overnight sanctuary, when all of a sudden it had become so immensely heavy he could not bear its burden, and had lain it down at Boggart Plat and fallen asleep. Although there was a sneaking suspicion he had been forced to do this because he had drunk too much ale in the village, the name of the place stuck – the event having been (perhaps half-seriously) ascribed to Old Scrat.

Peg o' Nell, the Spirit of the Ribble

In the grounds of Waddow Hall, on the north side of the Ribble near Brungerley Bridge, Clitheroe, is a spring called Peg o' Nell's Well. Next to this is a headless statue of what appears to be a woman wearing a cape; although she is likely a depiction of St Margaret, folklorist William Dobson was assured that this was a depiction of Peg herself, and his *Rambles by the Ribble* (1883) explained her story.

Peg o' Nell was in former times a young woman who worked at the hall, and used to collect water from the spring in a pail. Following an argument with her mistress, it was wished upon her by her irate employer that Peg might slip and break her neck – an oath uttered in a moment of rage which subsequently came to pass when Peg did indeed slip on the ice and lose her life. In the aftermath of her death her ghost would invade the hall, tormenting her former employers by 'making night hideous'. Every unexplained noise or accident at the hall was blamed on Peg's ghost – as was any loss of life in the Ribble, or drunkard sliding from his horse and breaking a bone. It was soon put about that the ghost required a sacrifice to take place every seven years, in order to appease her, at the same river where Peg had lost her life, on a specific night called 'Peg's Night', and in the event of a dog, cat, bird or livestock animal not being

Peg o' Nell: This depiction is reproduced in Clitheroe Castle Museum.

ritualistically slaughtered on this night, Peg (or the Ribble) would inevitably claim a human victim in compensation.

This spot at Brungerley, before there was a bridge, was navigable by 'hipping' (stepping) stones, and was already notorious for an incident when King Henry VI, in his last struggle for liberty, had slipped as he made his way to 'Clitherwood'. Following an incident on 'Peg's Night' when a young man and his horse were lost in the swollen river, it was decided to build a bridge at this sinister spot, and by Dobson's time the ritualistic killing of animals here was no longer practised: 'Peg has not been so exacting of lives, and people cross the bridge in times of flood with greater safety'. Dobson also heard a rumour that Peg's evil influence had been lessened when her likeness's head was cleft from its stone shoulders by a man with a hatchet. Cyrus Redding's 1842 *Itinerary* elaborated on this, telling us that it was in fact a woman of the house, Mistress Starkie, who decapitated Peg, when a Puritan preacher on his way to exorcise her demon-possessed son slipped into the river. Mistress Starkie firmly believed that the spirit of Peg possessed her son, and that the boggart was trying to stop the preacher in his rescue mission. When Redding visited, he was shown Peggy's head in the pantry cupboard, her stone neck bearing marks of violence.

Peg's story is probably a variant on the legend of the frightful Jenny Greenteeth, whom children were warned against if they went too near the water's edge; she would reach out of the rushing water and pull them in. The green plants growing in the shallows made it easy for them to believe that she lurked just beneath the surface, and as such acted as a natural caution to stay away from riverbanks. Although people

traversing the bridge might consider themselves safer nowadays, there are persistent stories that the woodland which envelopes Waddow Hall – and indeed the interior of the hall itself – are haunted by a larger than average dark, gliding figure who seems to be wearing some sort of cowl. It can be no surprise that most think this is Peg; after all, if the defaced statue did represent her, then she would appear to have been sculpted wearing some kind of shawl and hood. Whatever the truth behind the legend of Peg, it is interesting to note that some considered the local word 'boggart' a corruption of the Celtic *Boagh*, meaning a female Devil who dwelt in rivers; this would appear to be the category of the supernatural that Peg falls into, at any rate. What is clear is that the story still captures the public imagination: one Clitheroe resident, Mick Pye, who runs a website devoted to the old town, told me, 'I grew up around there. I've never known if it's all myth and story telling or whether there is something in it.'

The Ghostly Ladies Who Wander the Landscape

Ghostly ladies who wander the landscape are a remarkably common phenomenon in Lancashire. At the grand and prestigious Rossall School, on the Lancashire Coastal Way, north of Cleveleys, there is a long tradition of a White Lady haunting the place. Pupils know her as Lady Fleetwood, and she apparently at one time woke half the school with her night-time screaming; J. F. Rowbotham's *The History of Rossall School* (1894) recounts, 'The boys in their beds half-awake and dreaming, shuddered with terror and ensconced their heads under the bedclothes until the gruesome sounds had passed out of hearing.' Some claimed that a ghostly white lady had simultaneously passed through a dormitory, and one master, who had been out at supper and was coming belatedly through the square, confessed that he had heard Lady Fleetwood's chilling howl as he passed the old chapel. Although the suggestion is that the original episode may have been a scholarly joke, the ghost of Lady Fleetwood entered Rossall lore, and by 1894 it was said that she appeared yearly on a certain day (Halloween was usually specified); there was certainly no shortage of boys who claimed to have seen the notorious phantom, at any rate.

It is unclear who many ghostly ladies were in their lifetime, merely earning themselves a colour scheme based on their appearance. Ashton Hall, south of Lancaster, had a White Lady (supposedly a wraith who wandered the foot of the tower, having been locked in there by her husband), while Mossock Hall was graced by the presence of a Green Lady. According to Newstead's *Annals of Aughton* (1893), the hall (now a farmstead south of Ormskirk) earned the name Boggart Hall on account of a phantom lady dressed in green that would follow any departing visitor 'in the night season' and bang the door shut after them. There were other ghosts here at Mossock: one that walked down a lane from the old barn, clanking chains behind it as it went, and some kind of poltergeist that moved a huge stone trough near the stables back into a nearby field during the night on frequent occasions. This is said to have occurred *c.* 1850, when the hall was in a very neglected state. Apparently, these entities were exorcised upon the discovery of a stash of valuables hidden on the staircase in the hollow balustrades, and in a coffin-shaped receptacle on the landing. One has to wonder if these entities

Saturday 'ghost hunts' take place at Clitheroe Castle Museum.

were in fact inventions designed to ward away the superstitious locals, given that the Mossock family were Catholics. This would seem to be the case at Borwick Hall, by the Lancaster Canal north of Carnforth, where a White Lady haunted the attic in the vicinity of a priest's hiding place! Nowadays they say she was the errant daughter of one of the Whittington line who died of starvation while locked in an upper room of the tower in the early Tudor era.

Of course, no castle would be complete without its ghosts. Clitheroe Castle was built as early as the reign of William Rufus: it was never very large, and has suffered considerably from the ravages of time; all that remains now is a square keep and part of the court wall. Local tradition has it that the castle is haunted by the ghosts of an entire family – a man, woman and child – but the most famous ghost is the mysterious White Lady who drifts about the ancient landmark. Today, in the twenty-first century, the castle is a natural and atmospheric focus for ghost hunts, with one making headlines recently when it was forced to be abandoned and relocated at the Rose and Crown Hotel, on Castle Street, Clitheroe, as reported in the *Lancashire Telegraph*.

It is a Grey Lady that haunts the Old Cobblers Inn on New Hall Hey Road, Rawtenstall. A female ghost was also associated with Cross House, on White House Lane, Great Eccleston. Here, at the historic seat of the White family, they say that a strange, pale lady in white could be glimpsed at a small upper window overlooking the garden.

On occasion, these spectral white ladies did earn themselves an identity, however; the folklorist Kathleen Eyre heard tell that a strange, bespectacled white lady who

appeared and disappeared on a number of occasions in the vicinity of Hey Houses, Lytham St Anne's, may have been a Mrs Eastham who had lately passed away. She apparently favoured appearing before labouring men shortly after her death 'in the pre-motor era' near a thatched cottage called Fancy Lodge, which is now gone.

Ms Eyre also noted that another ghost accounted for the smell of thyme that pervaded the air between Kirkham and Freckleton. This was on account of a woman, who on the point of being slain in the vicinity screamed, 'Give me *time*!' She now haunted the lanes hereabout *sans* head. One ghostly woman who has earned an identity, true or false, is 'Lucette', a French governess at Dunkenhalgh Hall near Rishton, who (according to folklorist Jessica Lofthouse in 1976) was seduced and then betrayed by an officer guest or a son of the Walmesley family. Poor Lucette threw herself into the raging Hyndburn, where she drowned; but every year on 24 December a strange woman wrapped in a winding-sheet could be observed walking the banks of the river. The tragedy continued to play itself out when the offending cad was slain during a duel with Lucette's brother, who had come from France to avenge her honour. To this day, many staff at 'the Dunk', now the Dunkenhalgh Hotel, are convinced they have seen a white figure moving among the trees of Mill Wood, by Hyndburn Brook in the park grounds of the hotel.

The 8 December 2005 edition of the *Accrington Observer* reported on a series of overnight séances here, conducted by twenty participants and backed up by infrared cameras and recording equipment. One of those present was quoted by the newspaper as saying, 'Some strange things did happen. During the seances we got quite a few orbs of light appearing, which are supposed to be the first signs of a ghost showing itself … Also, while we were in the portrait room one girl suddenly said she felt like crying, but when she went outside she was fine. During another seance we think we made contact with *Lysette*. She said she wasn't happy and then we got a signal from her soldier lover who said he had never meant to hurt her. Then the glass flew off the table and we didn't ask any more questions.' Today, in the twenty-first century, investigations like this are phenomenally popular across Lancashire in general.

A Blood-Soaked Spectre

Picturesquely situated by the Ribble, south of Ribchester, can be found Osbaldeston Hall, the ancient seat of a great family of the same name. A 1911 survey of Lancashire notes that the west front of the house bears a carving dated 1593 depicting the arms of Osbaldeston impaling that of the Bradleys of Bradley Hall, although the hall is certainly older than even this date.

Osbaldeston itself is famously associated with Edward Osbaldeston, an English martyr executed at York in 1594, although the hall's resident ghost is not linked to this. According to T. F. Thiselton-Dyer's *Strange Pages from Family Papers* (1900), one of the early owners of the hall, Thomas Osbaldeston, fell into an argument with a relative during a banquet and the two came to such high words that they challenged each other to a duel. However, friends interceded and managed to calm the situation down.

However, soon afterwards the two rivals met in a particular room, and Thomas, without a moment's thought, drew his sword and killed his opponent in cold blood, a

crime for which he was declared a felon and his lands forfeited. According to tradition the ghost of the slain man haunted the room where the deed was done, in 'the silent hours of the night', passing from the room with his hands uplifted (presumably in surrender) and blood gushing from a wound to his chest. This ghostly figure 'made night hideous' with its unearthly moaning. Worse, it was even said that the blood from the crime had splashed all over the walls, and stubbornly refused any attempt to clean it away. To this day there are believed to be red stains on the wall within the hall.

Thomas may not have been the owner as such; Dobson's *Rambles By The Ribble* (1883) describes the dynastic family tree at the time thus: 'During the reign of Queen Elizabeth, the eldest son and heir of the then squire of Osbaldeston married a daughter and co-heir of John Bradley, of Bradley Hall, near Chipping, and the husband of one of the daughters of the marriage, was killed by one of the lady's brothers, Thomas Osbaldeston, in a family quarrel.' Although the 1593 carving bears the initial T. O. and might be thought a representation of the violent animosity between the two clans, and of T. O. slaying a Bradley, it would appear not to be: the crime occurred later, with Thomas Osbaldeston being convicted of murder at Lancaster in 1606. He reportedly managed to escape into exile.

Although privately owned, this stately pile can be viewed from the opposite side of the Ribble, where I once met with a dog-walker who readily agreed that the place had been haunted, although by a poltergeist. Apparently, 'Everyone knows it was haunted.'

Boggart House: the name of this private dwelling near Wrightington, lately for sale, is suggestive.

'All Houses Wherein Men have Died are Haunted Houses'

'Clankin' Round th' Field in Chains ...'

It really does seem that in days gone by ghosts actually did carry their own heads, or rattle chains to announce their presence. The nineteenth-century folklorist Charles Hardwick heard tell in his youth of a headless ghost that wandered the streets of Preston, and outlying lanes, 'Its presence was often accompanied by the rattling of chains.' Although none could profess to know its mission, it was said that it sometimes appeared as a great black dog or a strange woman – but in whatever form it materialised, it was always headless. Apparently it was 'laid' by a religious ceremony in the grounds of St Leonard's church, Walton-le-Dale, and perhaps there is a connection with the other stories of a ghoulish nature that are thought to have occurred there. However, even by the advent of the twentieth century the 'shapes that walk at dead of night, and clank their chains', as Bowker put it, had not entirely disappeared from an increasingly modernising Lancashire.

The area around Dangerous Corner, Appley Bridge, contains a number of curiosities. The grassed over hump known as the Boar's Den tumulus is believed to be a Bronze Age round barrow, and according to the Lancashire and Cheshire Antiquarian Society's *Transactions: Volume 19* (1902) it was believed that 'the neighbourhood is infested with spirits, boggarts and fairies'. There is a copse actually designated Fairy Glen that enshrouds Sprodley Brook. The worst of these entities haunted Robin Hood Lane, where there is a farmstead still designated Boggart House. *Transactions* recorded the belief that between a certain gate and Dangerous Corner there was a ghastly spectre that had been seen many times 'clankin' round th' field in chains'. When a representative of the Society visited the farm, they found it deserted – on account, it was believed, of an incident two years earlier (*c.* 1900) when one of the occupants fell sick and the 'house ghost' took to visiting the premises more frequently. Ultimately, the inhabitants fled in terror.

An old labourer at Boars Den Farm explained that 'sperrits' were also frequently seen at Hill House Fold, an adjacent farm on the hill nearby.

Preston, *c.* 1844, the stalking ground of a chained ghost. (Picture courtesy of the Lancashire Record Office.)

Boar's Den Tumulus, Appley Bridge.

Frightened to Death

There are numerous stories of people being frightened into insanity by an encounter with a ghost; Kathleen Eyre's *Lancashire Ghosts* (1974) remarks that one such person who scornfully traversed a reputedly haunted field linking Cherry Tree Gardens with Little Marton was found petrified and incomprehensible the morning after his act of bravado.

A strange story of this type is noted in Terence Whitaker's *Lancashire's Ghosts and Legends* (1980), concerning Lancaster Priory. More properly the Priory Church of St Mary, this church dates to Saxon times, although all that remains of the Saxon church is a doorway at the western end. Most of the present Perpendicular church was built in the late fifteenth century, and if anywhere should have a ghost then it is here. However, the story told to Terence Whitaker *c.* 1950 by the then-verger concerned no actual sight of a ghost; nonetheless, it is singularly suggestive. The incident appears to have occurred sometime in the early twentieth century, when two tramps sought shelter in the unlocked church, and as they bedded down near the altar both began to harbour thoughts of stealing the candlesticks. One waited for his companion to doze off and then stealthily approached the altar ... at which point his terrified screaming awoke his fellow vagrant, who found the miscreant had stopped yelling and lay stone dead. One of the brass candlesticks was gripped tightly in his hand, and his face bore an expression of abject fear.

This story appears to have been largely forgotten, however; no one knew of it when I made enquiries in May 2011, upon seeking shelter in St Mary's during possibly the worst thunderstorm seen in Lancaster that year. But images of the Virgin are within and without, both modern, and ancient; perhaps she keeps an eye on desecrators of this holy place, even now.

The Up Holland Highwayman

Lancaster Records, an 1869 compendium of the first fifty years' worth of reporting in the *Lancaster Gazette* since 1801, has the following entry for 25 March 1815;

> Lancaster Assize Commission opened before Baron Thompson and Justice Le Blanc. Their lordships attended Divine service at the Parish Church on the following day, when the assize sermon was preached by the Rev. Mr. Moss ... the business terminated on the afternoon of Saturday, the 8th of April, soon after which their lordships left the town for the metropolis. Six prisoners were left for execution, (among them) George Lyon, David Bennett and William Houghton, (for) burglary.

This brief entry implies that at the time the trio were thought no more notorious than the scores of other forgers, arsonists, rioters, murderers and footpads that the *Records* tell us ended their days on the gallows 'behind our Castle'. Lyon was executed along with his two compatriots and two other felons in a mass hanging that no doubt brought out the usual community spirit and carnival atmosphere in people who attended such occasions.

Folklore has remembered George Lyon in particular quite popularly. Even before his death, his reputation was notorious in Up Holland for more than one reason. A local governess, Ellen Weeton, recorded in her *Journal* in May 1809 how in two village houses, a mother and daughter were birthing simultaneously, and Lyon was gossiped to be the father of all three generations! Despite his being past the first flush of youth when he was executed (he was fifty-four), and his being more of a habitual thief than a romantic highwayman, there were a number of elements about his case that marked it out of the ordinary. The crime for which Lyon and his two companions were principally found guilty was the holding up and robbery of a stagecoach in the Tawd Valley, Skelmersdale. Firing their pistols to force the stagecoach over to the side of the road, the gang systematically robbed the occupants and fled to Up Holland, where they ensconced themselves in the Bull's Head tavern. Presently, the robbed stagecoach pulled up outside the inn, asking for assistance, and Lyon and his fellows had the audacity to sit there and look as concerned as everyone else. They had made sure that they had been seen at the inn earlier that day, so as to provide themselves with an alibi – who could prove for sure that they had not spent the entire day at the Bull's Head?

Following a moderately successful career in crime, Lyon's downfall came when he entered into an arrangement with a receiver of stolen goods named MacDonald, who turned out to be a thief-taker in the employ of the Wigan authorities. Lyon had made the mistake of taking MacDonald to his home and showing him property stolen during a burglary, and once his betrayer reported back to his superiors, Lyon's days were numbered. A contemporary account of his arrest in the *New Monthly Magazine* explains that Lyon had carried out his profession as a housebreaker for thirty years, and that he had already suffered seven years transportation in punishment for this, and upon his being taken by Nadin, the chief constable of Manchester, 100 guineas in gold and a quantity of bank notes in two large rolls were found at his address in Up Holland.

Following his execution, and in accordance with a personal wish expressed to his wife, Lyon's body was handed over to Simon Washington, the landlord of the Old Dog Inn in Up Holland, who, with a companion, loaded the corpse on the back of a wagon for the long journey to the village from Lancaster. The journey was abysmal: a violent thunderstorm broke, rain poured and lightning seemed to flash about the cart as it trundled along the muddy roads. At one point they were forced to take shelter for fear of being struck by lightning; Washington was of the firm opinion that Satan himself had actually accompanied them back to Up Holland, and he vowed never to undertake such a dismal, melancholy journey ever again.

George Lyon's burial was quite an event: hundreds rushed through fields to meet Washington and the bier at Dangerous Corner, Appley Bridge, and accompany it on its final journey to the tavern. There were chaotic scenes the following day when Up Holland was literally deluged with thousands of curious spectators, who swarmed the village and clambered across rooftops to see the coffin leave the pub for its interment in the church grounds.

Some ninety years later, towards the end of August 1904, sensational reports appeared in several of the daily papers concerning a 'haunted house' at Up Holland, next door to the White Lion, where poltergeist phenomena was said to be occurring

Up Holland's 'ghost house', *c.* 1930. (Picture courtesy of the Lancashire Record Office.)

in abundance in a 'haunted bedroom'. A widow named Mrs Winstanley and her seven children tenanted the three-storied house. Among the more excitable rumours that swept the village, one was that between 10.00 p.m. and 12.30 in the morning the sound of trickling water could be heard; books and stones were thrown across the room by unseen hands, and it was whispered locally that tormented screams could be heard emanating from the premises, from as far away as 60 yards outside. Pieces of mortar had also been thrown about, and the property echoed to a strange persistent knocking sound that ultimately (after two weeks of disturbances) led Mrs Winstanley to contact the police. Stones and other debris were striking members of the household, and a number of local dignitaries who took up residence in the bedroom saw this phenomenon for themselves. Before long, rumours that a poltergeist was gradually destroying the house from within were bringing people out into the streets, despite the poor autumn weather. On one occasion, police struggled to control the crowd, from which bottles and other missiles were hurled towards the sinister property.

According to the *Journal of the Society for Psychical Research: Vol 12* (1906), who investigated the claims, 'Popular superstition attributes the disturbance to the spirit of a highwayman who was buried in the churchyard near the house about a hundred years ago.' Strange and pointless phenomena continued to plague the property, the last manifestation being two days before an investigator from the SPR arrived – he observed that lately a hole about the size of an orange had been punched in the wall and the wallpaper about the hole appeared much ripped and torn. This was near a window on the property designated the 'haunted window'. The SPR representative observed that 'Frequent attempts have been made to detect intelligence, with no result',

although he did hear for himself the wallpaper being torn and was privy to another mysterious incident of mortar throwing.

The haunted house was demolished in 1934 to form a car parking bay for the White Lion. The pub, incidentally, is also supposed to have its own ghost, that of a phantom nun. But to return to George Lyon, there is an interesting suggestion that part of his criminal proceeds were discovered there as late as August 1921, when the old fireplace was being removed. The horde consisted of sovereigns, half-sovereigns and copper coins. According to village legend, George Lyon had resided at the 'haunted house' next door during his lifetime: could his ghost have returned to the premises to seek out his hidden proceeds? Or was the entire thing a hoax? There is a question mark over the entire affair to this day, although much, much earlier – even before George Lyon's execution – the governess Ellen Weeton implied the village had a reputation for unpleasant phenomena. She observed in her journal that, 'at least a tenth of the houses in the neighbourhood' were haunted. The worst, in her day, was the 'Mill House', where mysterious knocking plagued the property and among the unholy din tongs and pokers danced by themselves before the hearth.

George Lyon himself lies interred some 80 feet away from the site of the demolished house, in the grounds of St Thomas the Martyr's church, although his tombstone will be looked for in vain: for he lies beneath the slab inscribed 'Nanny Lyon: Died April 17th 1801'. Some say locally that this is the grave of his mother, although others believe it to be his grandmother's grave. Most likely, in fact, it is that of his daughter who predeceased him. Interestingly, as late as 2010, fresh flowers were still being laid on the tombstone.

In a write-up about the highwayman in 1965, the Historic Society of Cheshire and Lancashire observed in *Transactions (Volume 116)* that Lyon's ghost was still reckoned to haunt the village: 'This writer knows two people from Up Holland who claim that, one Saturday afternoon, they not only saw George Lyon in the churchyard but actually spoke to him!' There are also modern stories that speak of the ghostly highwayman being seen to hold up an equally spectral victim at the crossroads near Billinge, Merseyside. It is also often said that Lyon was the last highwayman executed at Lancaster, although this is not true: Thomas Price paid the ultimate price for highway robbery on 25 September 1819, and in the years afterwards a number of others similarly went to the gallows for the same crime.

The Skulls of Timberbottom

Lancashire is a county particularly associated with stories of 'screaming skulls.' For instance, tucked away in the wilds of Bowland is the early Tudor-era Browsholme Hall. The hall retains a skull from the days of the Pilgrimage of Grace, which was described in 1815 as being a polished and well cared for 'monitor of death'. Local historian Ann Thomas wrote in 1976 that 'A cupboard in Browsholme's Tudor Hall contains a skull of great age. The household treated it with respect until one of the boys buried it in the garden as a practical joke. Immediately disaster struck the family.' The stonework appeared to decay, becoming in perilous danger of collapse, fires broke out

inexplicably, and several members of the household died. Only when the boy confessed his jape and the skull was recovered did the trouble end, although the family had to reside elsewhere for two years while the damage was repaired. (I have been told by a representative of the hall that the skull is never put on public display, and 'that only the male heir can look at it.') Browsholme now functions as one of the county's most elegant wedding venues.

At the other extremity of the county can be found Skull House Cottage, on Skull House Lane, Appley Bridge, which retains another varnished relic of this nature. The skull here is believed to have belonged to a resident priest who was murdered by Cromwellian soldiers. The ghost hunter Harry Ludlam was told that on certain summer nights the footfalls of the priest were heard on the flagstones outside the cottage, followed by footsteps that clattered up the spiral staircase within. Then, the door to the single bedroom upstairs would crash open, and suddenly all would be quiet again. These were supposed to be the last frantic attempts by the priest to escape before he was caught attempting to clamber through a skylight, and two young girls apparently experienced the reality of this legend themselves when staying overnight in the cottage in the 1940s.

But one of the county's most famous ghostly legends concerns the two human skulls – one of them a mere fragment on a silver stand – which are at the time of writing displayed in Turton Tower, a twelfth-century house with sixteenth-century alterations at Turton Bottoms near Edgworth. Both relics have been reverently placed on the huge Bradshaw Hall Bible, a ritualistic perch for the skulls and, in many ways appropriate – given their history.

The skulls, one of which appears very much decayed and the other cut through on the left side by a blow from some sharp instrument, were supposedly discovered in Bradshaw Brook *c.* 1750 and conveyed to the mantelpiece of Timberbottom, a farm at Bradshaw – the place subsequently earning the moniker of 'the Skull House', or merely 'Scull House'. *Country Life* (10 January 1963) tells the story of Timberbottom's early owners experiencing 'footsteps (that were) heard ascending the stairs. They were followed as far as the upstairs room, where in a ghostly light two men seemed to be engaged in battle, while the ghostly form of a girl was watching them till she eventually left the scene.' Quite apart from this, strange noises were heard overhead, crockery rattled like there was an earth tremor, and domestic animals appeared cowed, agitated and sensitive to some presence. According to the legend, whenever an attempt was made to bury these remains in the graveyard at Bradshaw Chapel, bangs, crashes, poltergeist activity, plates rattling and – most unnervingly – horrific screaming would force the owners to exhume the skulls and return them to Timberbottom. On one occasion they were thrown into the adjacent river, only to be fished out once more upon the racket plaguing the farmstead yet again.

The story was current in 1842, when the compilers of *An Illustrated Itinerary of the County of Lancaster* visited the farm and were told by the wife there that 'they are obliged to keep these skulls in the house in order to have peace ... whenever they were sent away there was no rest in the house on account of frightful noises; as soon, however, as the skulls return, quiet is restored. The owner of the skull that is cut doubtless met with an untimely end; but whether in battle or by wilful murder no one now

The Timberbottom skulls.

can pretend to say.' However, modern folklore ascribes these skulls numerous origins, including their being the decapitated heads of two robbers who were apprehended by the servants at Timberbottom farmstead in the seventeenth century.

Further poltergeist activity was reported by Colonel Hardcastle, the owner of the property at the turn of the century, prompting the American Society for Psychic Research to note, in 1929, that 'a stumbling ghost has just paid its annual visit to Timberbottom Farm, Bradshaw, near Bolton. It walks up and down the stairs … and we read that it often stumbles and knocks things over.' It was noted that the occupants of the time believed that a man had once murdered a woman there, and the crime was being re-enacted: would this account for the two skulls, if the man threw the woman's body into Bradshaw Brook, and then committed suicide by throwing himself into the water after her?

Unfortunately the origins of the skulls are conjecture, but they are themselves very famous in this part of Lancashire to this day. Timberbottom was demolished in 1939 and the skulls subsequently conveyed to Bradshaw Hall. Bradshaw Hall was itself pulled down in 1949, and the skulls were next conveyed to Turton Tower, where they were kept for a long time locked away in a storeroom. However, they are (currently) back on display, perched on top of the Bible, and available for visitors to observe and wonder at. In fact, during a visit to Turton in May 2011, I was told by one of the workers there – in genuine seriousness – that the skulls will never be moved off the Bible, for when they are 'very bad things happen'. During this visit, a fellow enthusiast

of Lancashire's mysteries also expressed the belief to me that the skulls were the remains of two religious martyrs, dumped following their execution and quartering, which accounted for the lack of other body parts.

Of Turton Tower itself, the *Itinerary* of 1842 noted, 'There is a tradition of its being haunted', but there is no further information provided. However, Henry Fishwicks' 1894 *A History of Lancashire* tells us the ghost was 'a lady in white, who passed from room to room in rustling silken dress'. Later works on folklore in the 1970s have turned her into a Black Lady who appears on the top storey of the tower and throws herself down a shaft – thought to be an escape shaft for Catholic clergy and engineered by removing the floorboards of the privies on three floors. Of privies, Turton had two or three – unusual for being indoors, considering that in the Elizabethan era waste was simply tipped out of windows. At Turton I was told that this shaft was blocked up when some of the resident children here winched one child down for a dare in the hope of discovering treasure. However, all they found was broken glass: the remains of liquor bottles lobbed down there that had been stolen by one of his lordship's servants!

There are two more recent stories here: the guide told me that a former employee had seen a gentleman dressed in Tudor clothes merely standing at a window near the kitchen, arms behind his back, as though waiting for someone to arrive. This witness had fled in panic, searching for someone else, but when she returned the strange person had simply vanished.

My informant himself had experienced the bizarre sensation in an unused bedroom of being 'watched' by someone. He found this presence so overwhelming that he turned to ask the person something – only to find in bewilderment that he was, as expected, alone. Yet as he closed the curtains that Sunday at closing time, the bedroom was suddenly and inexplicably lit up by a strange illumination beside him that spooked him so badly that he literally fled the room, slamming the door behind him in an attempt to get out of there as quickly as possible.

The ancient four-poster bed in this room displays a number of strange faces carved into its frame that were 'designed to ward off evil spirits'; evidently they don't work, to a certain extent!

A Visit Every Lent

A. R. Wright's *English Folklore* (1930) observes a now almost forgotten ghost – a phantom woman or girl named Lizzie, who visited the little village of Withnell, between Leyland and Darwen. This ghost appeared in the village every Lent, coming from 'the Bolton Moors'; why she came such a long distance, and what her spectral mission was is unknown, nonetheless, she had been seen in 1923 and 1926.

A Christmas Ghost Story

While looking into the background of a reported ghost seen at the gates of Carleton Crematorium and Cemetery on Stocks Lane, Carleton, Poulton-le-Fylde (this concerned

a spectral greenish-tinged old man with long hair and a Punch-like countenance who glared into a taxi cab one night in December 1936, terrifying both the driver and his female passenger), I was intrigued to find another Christmas ghost story from the area.

In the days approaching Christmas 1936, Fred, a boatman and night watchman, had been on duty at some road works in Freckleton, and was seated comfortably in his cabin, having made up his brazier fire at midnight.

Looking up, out of nowhere there had appeared in the cabin a strange figure by the light of the fire, 'It was an old man, with a long white beard, gazing steadily into the glowing brazier. There was a nip in the air, and the frost on the old man's beard glistened and sparkled in the light of the dancing flames.'

Fred was momentarily distracted by the sound of the church bell tolling midnight and when he looked back his eerie visitor had utterly vanished in the blink of an eye – leaving Fred a trifle worried that he had just briefly encountered a ghost from the nearby graveyard! The story was reported in the *West Lancashire Evening Gazette* (24 December 1936), the columnist observing, 'If you want to hear creepy experiences you should spend a half-hour in some of the inns of the Fylde on these dark evenings, as I did recently.' Fred had told the columnist of his bizarre experience during a chat at the Ship Inn, Freckleton.

The Lady with the Lamp

Recently I was told a fascinating piece of family lore by an old Euxtonian, Al Heffron, who grew up at Armetriding Farm, a modest, isolated little place off Mill Lane, Euxton, that was formerly known as Armetriding Hall and which dates to 1570.

Al recalls that one night, *c.* 1948, the mood in the house was somewhat gloomy; his father was very sick with pneumonia at the time, with his mother taking care of the five children. After she had got them all to bed, she was making her own way up the staircase when a female figure holding what looked to be a lamp brushed past her, sweeping clean through the front door and continuing down the long flight of stone steps that led to Mill Lane.

The family named this entity 'the Lady with the Lamp', and although when I asked Al for more details he was unclear what the strange lady had looked like (he had been very young), 'the issue was widely acknowledged at the time throughout the family'.

The story is interesting, though, from the point of view that Al's mother – Mrs Emma Heffron – was a very spiritual lady, with the gift of clairvoyance, who had experienced a number of 'spiritual visits.' I cannot help but wonder if the ghost were seen because of this ability – and whether a second party present who possessed no such ability would have shared the vision?

The Thing of Old Hive

Reminiscent of the old spectres from days gone by, that clanked their chains and moaned, is the rumour of a strange phantasm that plagued Chipping in the 1950s.

This 'thing' lurked in the Old Hive area, in the vicinity of Malt Kiln Brow, where the north-west road out of Chipping divides; however, witness descriptions painted a confusing picture of this 'ghost', ascribing it blazing eyes and large hands. Rumours of it spooked the children in a playing field off the lane, as did the stories of its padding footsteps following people along the Longridge Road. Disturbing screams were caught on the wind, and frightened residents bolted and shuttered their doors and windows, even going so far as to alert the local constabulary. The story was reported in the *Lancashire Evening Post* (4 September 1958). The paper observed that just over a year before villagers had been terrified by another wandering spook: that of a ghost let loose from the lately demolished Leagram Hall. However, the story's main interest lies in the fact that such random fear, as reported, seems to belong to another age: an age of superstition and bogles, where a boggart lurked on every corner.

The 'Gory Head' of Mowbreck Hall

The Haydock Papers (1888) recall a very famous story associated with Mowbreck Hall, which stood on the eastern edge of Wesham in the Fylde District. The legend dates to the time of the Catholic Haydock family, and tells how on Halloween 1583 Vivian Haydock was standing, robed in his vestments, at the foot of the altar in Mowbreck's domestic chapel. The old man had lately taken the Jesuit faith, and he often made his way clandestinely to the hall – at the time the property of the Westby family – to perform illegal Masses.

As the clock announced the hour of midnight, Haydock suddenly beheld the apparition of a disembodied head float slowly above the altar; the ghoulish visage clearly displayed signs of decapitation, and its blood smeared lips appeared to be repeating in Latin, 'Your sadness is turning to joy.' Most alarming, the head that spoke to Haydock bore the features of his favourite son, George! Vivian Haydock passed out in front of this spectacle, and was carried to his secret bedchamber; afterwards the children of Mowbreck took to adding 'God be merciful to the soul of Vivian Haydock' as part of their prayers. The old man died shortly afterwards and his body was sombrely interred beneath the chapel at Cottam Hall by his other son, Dr Richard Haydock.

At the time, the old man's son, George Haydock, had recently been ordained a Catholic priest in France, but upon his return to London he had been almost immediately betrayed and arrested in St Paul's churchyard on 6 February 1582. Attempts to get him to renounce his faith failed, and during one interrogation by the Recorder of London, Sir William Fleetwood, George was punched in the face, his only reaction being to say, 'Use your might, for in behalf of the Catholic faith I will cheerfully suffer anything.' George Haydock in fact suffered death by hanging, drawing and quartering at Tyburn on 12 February 1584.

Throughout its life Mowbreck Hall was bedevilled by rumours that it was badly haunted. Kathleen Eyre's *Lancashire Ghosts* (1974) states that in the late 1800s a woman delivering a hat to the Earl of Derby's wife was found in a catatonic state, stupefied with terror at something she had seen while approaching the hall. Whatever it was, it had chased her to the hall's main door where she had managed to give the

doorbell a frantic yank, summoning a butler, before fainting. An interesting interview in the *Blackpool Evening Gazette* on 2 April 2008, with a former resident who had spent his teenage years at the hall in the 1960s, evidences that there was more than one ghost. Proprietors in the fifties and sixties had been plagued by the sound of mysterious footsteps walking about the hall – supposedly the unhappy march of a suicidal butler who later hanged himself. And as a boy, this witness recalled how a friend had seen a strange figure walk across the lawn one night, accompanied by some dogs. This had been during a campout and it may be that what was spotted was the ghost of 'Lord Derby', the former owner, who apparently still walked the grounds in the vicinity of an oak tree that had been put aside in his lifetime as a graveyard for his beloved hounds. But the enduring legend was that of George Haydock's head: the article in the *Gazette* noted how, even in the 1960s, 'The housekeeper ... wouldn't go anywhere near the chapel because she said she'd seen the head of a priest who'd been beheaded.' (Some believe that it is George Haydock's own head that resides at Lane End's House, Mawdesley, although most believe the relic here to be that of a relative, William Haydock, executed in 1537 for taking part in the Pilgrimage of Grace. The house is known as 'Skull House' on account of its acquisition of this relic.)

Old photographs show that in its later incarnation the hall was quite something to behold: a fine edifice of red brick, castellated with stone, its trimmed lawns and driveway bordered by immense trees. However, by the end of the twentieth century it was falling into disrepair, and in 2000 it was finished off by fire.

The Malevolent Form

No. 38 Pendle Street, Accrington, is (at the time of writing) a nondescript no-garden terraced house, ugly, bland and with nothing to distinguish it from the others that line this street in the Scaitcliffe area of the town. However, in the 1960s this place was the haunt of a fittingly psychedelic – yet terrifying – apparition.

A couple and their three young children lived here at the time, the thirteen-year-old daughter being prone to minor bouts of sleepwalking. It was in April 1965 that she awoke from one of these bouts of mobile slumber near the foot of the stairs; it was the small hours of the morning, and the girl awoke with the terrifying certainty that something evil was near at hand. This was an unheard-of panicked reaction that she had never experienced upon waking before: her sleepwalking was usually so minor that it did not even concern her parents too much.

Fully awake, her ears caught a sound from the gloom of the lobby, following which she was hit by a wall of intense heat. Before her then materialised a glowing formless shape of human height and appearance, whose contorted face waxed and waned in constant flux. Although she could discern no features in this flowing, formless entity's face, she felt instinctively that it was male; however, as it stood but a yard in front of her she was struck more by the pure malevolence that the thing exuded. Its 'body', such as it was, changed and morphed like the swirling head and face, but was even less distinguishable. What was overwhelming, though, was the sensation of male violence directed straight at the teenage girl.

By chance her nocturnal sojourn had ended beside the light switch, and at her push the light bulb pinged on and the form vanished. In the weeks that followed, members of the family were subjected to strange and unnerving night-time noises from a downstairs room while they lay awake upstairs in bed: the sound of something being dragged and a peculiar scratching noise were heard over and over again. The girl's brother witnessed an indistinct ball of light – shifting and changing with movement – floating in the darkness of the living room one night; that is, until he switched on the light, whereupon it vanished.

The story is first noted in Peter Moss's *Ghosts over Britain* (1977), a valuable attempt to collate recent first-hand accounts of latter-day ghosts. It observes a number of other cases from 1960s Lancashire: among them the phantom footsteps at Chorley Hospital that alerted the sisters to a choking infant in 1968, and the spectral figures that glided through cars upon the removal of coffins from Leagram Hall, near Chipping, in 1963.

But what of Pendle Street in Accrington? It is the mundane setting that somehow makes the events there more alarming, with Peter Moss affirming it was a 'well-authenticated haunting lasting several years'. Could the strange phantom that manifested in the house have been trying to lure the sleepwalking girl; or did the phenomenon exist because of the children, and not in spite of them? Whatever was happening, No. 38 was among the properties in the street that were lately listed to be demolished, being considered as unsafe, and at the time of writing (2009) this house – with its forgotten ghost – looks doomed.

Memories of Old Croston

Croston is a beautiful village west of Chorley, built around its church and bordered on the north by the River Lostock and on the south by the Yarrow, the railway line to the west reminding the inhabitants that no way of life stays the same forever. Recently, Elizabeth G. N. Sleaford, whose lineage hails from Croston, was good enough to tell me of two village ghosts that have been seen in living memory.

The first ghost, as told to Elizabeth by her father, concerns the Sarscow Lady (also spelt 'Sarascoe' or 'Sayscah'), a white or grey female apparition that wanders the grounds near Sarscow Farm and the lanes to the east of the village. According to legend, the Sarscow Lady was in life a young girl who fell in love with a Catholic priest who resided with the Gradwell family nearby at the end of the sixteenth century. According to some, the girl was a servant employed by the Gradwells, and some repeat that she was carrying the priest's child; however, he fell sick and died, and in despair the young girl threw herself down a well near the Gradwell residence. According to Elizabeth,

> My father told me that one night a bus driver was convinced he had run a young lady down, although there was no sign of anyone on the road. The bus driver refused to carry on. This was said to have happened only a few hours after an old stone cross was removed from the grounds where the Gradwells lived. There are tales of her walking down Southport Road ... My father used to cycle home from Whittle-le-Woods to Drinkhouse Lane, when he was courting my mother, (although) he has never seen the Sarscow Lady.

Another story that Elizabeth was told by her father concerned a ghostly little girl. In the village churchyard of St Michael's and All Angels can be found the grave of Mary Elizabeth Hudson, the stone cross there telling us that she died aged thirteen at Croston Industrial Home on 30 May 1890. The girl had died of a fever and been buried in a far corner plot, for fear the fever might spread. According to the story, as told by Elizabeth,

> In 1976 a schoolteacher came to Croston and lived opposite the cemetery, and said that a little girl in a red shawl was a regular visitor to her garden: the red shawl she was wearing was the uniform of the little girl who died in 1890. Another lady said that she was in the kitchen and felt a tug on her skirt; she thought it was her child, but when she looked it was the little girl in the red shawl.

As a strange and poignant postscript to this, Elizabeth adds, 'It is said that there are always wild flowers on her grave.'

The Hob of Hobstones

J. Carr's *Annals of Colne and Neighbourhood* (1878) explains that Hobstones, a genteel residence and later a farm, about one mile north-north-west of Colne, obtained its name from 'Hob', a Saxon word for a dancing elf, or fairy. The place dates to about 1700 (although it has earlier foundations) and its curious gateway was erected four years later; in Carr's time the neighbourhood of 'Hob Stones', and especially the adjoining rocks, were said to be a haunt of fairies. He wrote, 'Such was the common belief among the Colne children of a past generation. Doubtless (the) story originated in some now lost tradition respecting the place.'

It was not fairies, but ghosts that plagued this property in the twentieth century. The place, although now converted into three cottages and said to be quiet, has in the past boasted numerous well known ghosts. Some of these were covered in the Halloween 2008 edition of the *Lancashire Telegraph*, which notes a story that I have also been told is 'true': that ghostly soldiers from the Civil War, armed with pikes, muskets and swords, are supposed to have been seen marching across the grassy slopes near Foulridge Lower Reservoir, known as Back o' th' Edge. The newspaper also mentioned that a tenant farmer in 1959 was confronted while sat in a lavatory outhouse by the singular sight of a furious-looking dwarfish friar cradling an amputated arm severed at the elbow. Local lore has it that this entity began to bedevil Hobstones, appearing more frequently, and ultimately leading the farmer and his family to vacate the property.

However, the most famous paranormal event at Hobstones concerns the nightmarish entity that renovation work in 1974 apparently disturbed. As was well reported at the time, the Berry family who resided here were terrorised by the sturdy walls shaking, furniture moving, apports of stones and rocks on the stairs and diamond-shaped sections of the mullioned windows being blasted to atoms out into the yard. Much of the phenomena centred on the kitchen, where milk bottles were dashed to pieces and packets of lard and margarine flew across the room; here also, eggs were smashed, in

one notoriously memorable instance a box of eggs being upset with all the white ones smashed – yet all the brown-shelled eggs staying intact and forming the shape of a cross on the floor. The *Telegraph* reminisced, 'One day there was a terrific pounding on the front door and all the couple could see was a giant fist.'

The unnerving events might have had something to do with a spectral Cavalier soldier seen three times in the youngest daughter's bedroom. According to the story, the noise and destruction reached such a crescendo one night late in September that an exorcist had to be called out. However, Hobstones seems to have been at peace for some time now, the events of 1974 a vague, disturbing memory only.

The Woman and Baby of Bradford Bridge

Some years ago, M—, a local historian, was researching the history of the Clitheroe area at Clitheroe Reference Library when his eye was drawn to a remarkable archive article referring to an event in the early nineteenth century, prior to the construction *c.* 1822 of the first wooden bridge over the Ribble between West Bradford and Horrocksford. Before this, people had had to cross the river at a ford, via the 'rapids', and the article made reference to a recent tragedy at this ford: the deaths of a mother and the infant she was carrying when both were lost in the swollen Ribble while trying to escape the woman's abusive and drunken husband.

The cutting sent a shiver down M—'s spine, stirring almost-forgotten memories

West Bradford Bridge.

of a curious story he recalled doing the rounds when he was a boy on the point of leaving school in 1982. M— has told me, 'Around that time of 1982–1983 people quite frequently would see a ghost of a woman carrying a baby over some "rapids" near the bridge. A very close friend saw it one night … I wasn't there … but I really scrutinized him the next day in a quiet moment and he swore he had seen what he had seen … It was at the time a well-known thing.' Apparently this strange and tragic wraith was never seen when looked for, only glimpsed most unexpectedly when looking out over Bradford Bridge.

M— thinks that the first wooden bridge might have been built here around 1822 by Gyles Hoyle of Horrocksford Hall in response to the accident. The scare at the time certainly caught the imagination of the people, for M— tells me;

Cycling home from Clitheroe used to be hard work! I had a choice of three ways home and all were haunted! You had Peg o'Nell at Waddington Bridge to interact with … this ghost of a woman on the river at West Bradford and a ghost in a now-demolished red barn on the road from Chatburn … The Chatburn one I know nothing about … never saw anything … though I guess I didn't try … but local people used to say it was haunted.

The Hitcher

There are said to be many ghosts that appear by the side of the road to shock Lancashire's fatigued motorists back to their senses: murder victims, so they say in many cases, who are looking for revenge, sometimes displaying the skeletal features of the long-dead from beneath cowls or hoods. In other instances they appear at crossroads, or near water, and in some cases are bolder; I understand that a woman in a long, dark cloak supposedly glides in front of cars near the Horns Reservoir on the lonely road to the B5269, before one reaches the relative reassurance of the little population centre that is Goosnargh. Black tyre marks on this winding back road supposedly denote evidence of cars slewing to a skidded halt to avoid slamming into this strange lady – who naturally has disappeared entirely when an attempt is made to look for her.

But what if one of these ghosts, far from materialising by the road, actually appeared in the very car you were driving? These were the terrifying circumstances under which a contributor to an online forum for the *Liverpool Daily Post* encountered a ghost. The eerie incident happened on the back road known as Carr Moss Lane, between Halsall and Ainsdale, Southport, at nearly midnight in November 1994. The interior of the car became very cold, and the blogger posted, 'When I looked in my rear view mirror I saw an old man sat in the back seat, he looked about 75–80 years old wearing a flat cap and black jacket and had a walking stick and looked very pale, when I looked back he was gone. I was terrified. I never drove down that road again.'

Although generally speaking the Internet is not an ideal place to start looking for information, it does well to illustrate the wealth of information, true or false, that is accessible to the public at any time. From a research point of view though, the anecdote stirred memories: some years ago (*c.* 2004) I recall being told during a work-related

conference in Blackpool of a 'man who suddenly appears in cars between Ormskirk and Southport'.

The Great Lancashire Pub Crawl

Many of Lancashire's most famously haunted places are public houses, it perhaps being no surprise that often the combination of an isolated location and the consumption of vast quantities of ale bred so many stories. These days many pubs actively promote themselves as having a resident ghost however, and 'pub ghosts' are more likely nowadays to crop up in the local media than, say, resident spooks at churches or stately homes. However, the phenomenon is not a new one. Cross Fleury's *Time Honoured Lancaster* (1891) notes of the seventeenth-century Cross Keys Inn in the town, 'I may remark that one of the old bedrooms is stated to have been haunted by the ghost of a woman who many years ago hanged herself therein.' Elsewhere on Market Street, the old Kings Arms (pulled down and rebuilt in 1880) had a tradition that the Bride's Bedroom was haunted by the ghost of a young bride poisoned to death in that room, and whose lover swung for the crime at Lancaster. It was the practice to offer guests in the room a piece of bride-cake; apparently, many preferred not to sleep in the old four-poster bed there because of the ghost, although Charles Dickens took up the challenge and survived unscathed.

At Mawdesley, south-west of Eccleston, the landlord of the Black Bull Inn caused a sensation when he claimed to have a bottled ghost in his possession. According to writer Anthony Hewitson in 1872, nearby Mawdesley Hall was whispered locally to have at one time been haunted by a ghostly old lady, who 'played such serious pranks' that she was exorcised not far from the hall (the ceremony involving some kind of mysterious 'reading out'). The spirit was trapped in a bottle and lobbed into a local pit of water. Fuelled by rumours that this ghostly old lady had in her time wandered up to the Black Bull, the then- landlord, Mr Rogerson, coated an ordinary bottle with mud and claimed it to be the one containing the ghost's essence. For a while the landlord made a trade on curious visitors coming to see the 'bottled ghost', but after a while it seems the nervous villagers forced him to throw his money-earner back into the pit out of fear that the ghost might, in fact, begin to reappear.

In 1954 Samuel Arrowsmith and his wife Margaret took over the Duckworth Hall Inn on Duckworth Hall Brow, Oswaldtwistle, only to be tormented by strange noises in the night: clumping footfalls accompanied by the clanking of chains, and doors suddenly bursting open when no one was on the threshold. It is believed that the responsible party was, in life, one of those executed at Whalley following the Pilgrimage of Grace, and a mysterious dark, cloaked figure is spoken of as having been seen drifting away from the pub's entrance and along the brow. (By Halloween 2003, when the *Accrington Observer* reminded its readership of the stir here forty-nine years earlier, minor poltergeist activity still bedevilled the inn.)

Twenty years later, folklorist Kathleen Eyre observed in 1974 that her local, the grand four-storied, timber and brick Ship and Royal at Lytham-St-Anne's, was haunted by a ghost that had earned the nickname 'Charlie' by successive landlords. Even as she wrote,

the place was still haunted; a waitress had observed 'the tall dark eerie figure of a man staring at her from the far end of the Mariners' Grill on the second floor'. One theory was that this mysterious vanishing customer was the colourful Squire J. T. Clifton, who had died in 1928 and had been a frequent patron. However, in the twenty-first century the haunting here manifests in a different guise, with the *Blackpool Gazette* (26 March 2008) noting that the mysterious sound of running water emanating from a derelict corner of the building – where there is no plumbing – might be linked to the story that a mother and son who were resident in the early twentieth century both drowned themselves.

Nowadays, one of Lancashire's most famous ghosts is the spirit that haunts the Sun Inn, Chipping, a grand old mid-Georgian pub entered at an elevated door level on either side via a triangle of weathered stone steps that front onto Talbot Street. Many people – former staff, landlords and customers – all attest that this pub is undoubtedly haunted, suffering arbitrary poltergeist activity such as objects being misplaced when backs are turned. These minor phenomena seem to be linked to the appearance in the snug room of a rather less frequently seen spectral woman. She looks to be dressed colourfully (one person that hadn't seen her themselves nonetheless told me that she appears to be semi-transparent and dressed in greenish-burgundy); but she has her head bowed, and slowly disappears or is simply gone when next looked for. I was also told by this same person that sometimes people do not actually realise that she is a ghost, merely that when seen she is noticeably out of place. The pub itself bears a certificate from the National Ghost Federation, confirming its status as a haunted pub, and a hoarding outside announces the a la carte menu on offer in 'Lizzie's Lounge – Lancashire's most haunted dining room.'

The reason for this can be found across the road – where in the grounds of the thirteenth-century church of St Bartholomew lie the remains of a parlourmaid called Elizabeth 'Lizzie' Dean, her simple tombstone by the entrance path declaring that she died on 5 November 1835. The story broadly follows these lines. Lizzie was jilted at the altar on her wedding day, and forced to witness, from the upper window of the Sun Inn, her betrothed lead her best friend up the aisle instead. She silently took herself to the attic and roped a cord around her neck, and when she was later found dangling from a beam, there was a scrawled note upon her person declaring that she wished only to be buried as near the church path as possible – so that her treacherous husband-to-be and false friend might have to walk past her remains every Sunday, and so forever be reminded of their betrayal. She was aged about nineteen at the time of her death, and her grave is beneath the elm on the corner of the church.

At Padiham, it is a ghost nicknamed 'Mary' that haunts the Red Rock Inn on Sabden Road. The pub made local headlines in 2003 when the *Lancashire Telegraph* reported how the landlady was appealing for help to identify who 'Mary' might have been; her presence was linked to a paranormal force that threw glasses across the room and smashed them to pieces, but also to a nun seen a few years earlier by a passing motorist. This figure had drifted across the road and disappeared into the wall of the Red Rock.

Another famous ghost is the disembodied, incessant talking ascribed to 'Bleeding Ears Murph' at The Eagle and Child, Weeton, north-west of Kirkham in the Fylde.

Lizzie's grave, Chipping.

Here at the Three Mariners, Lancaster's oldest pub, a ghost is said to have been spotted upstairs in the unique gravity-fed cellar: a strange misty figure seen by the little algae-stream that flows through here.

However, no one can claim to have seen this spectre at the historic Tudor inn, and he appears to be voice only. Not to be outdone, another Eagle and Child, this time on Church Road, Leyland, has experienced poltergeist activity in the past. Back on 15 March 2002 the *Lancashire Telegraph* quoted the owner as saying, 'The pub is a former courthouse and is thought to date back to at least 1610, so who knows what could be hidden here. I have been present when glasses have moved – with real vengeance – off the shelves or from one side of the room to another.'

The Four Alls Inn at Higham is one of many pubs that boasts 'phantom customers', in the shape of a strange male glimpsed at the end of the bar and an even stranger woman who walks through the bar and dematerialises near the toilets. In the case of some pub ghosts, there is, however, no sight of an actual spectre – just odd and unnerving incidents that cannot be put down to anything rational. Such a circumstance was reported in the *Lancashire Telegraph* (18 August 2006), when the new owners of the Hand and Dagger on Treales Road, west of Preston, found that tables and chairs were rearranged during the night and male voices could be heard upstairs. The ghost was nicknamed 'Fred', but it was unclear who he might have been in life.

At the ancient Black Horse Hotel on Long Lane, Limbrick – which celebrated 1,000 years as a tavern of some description in 1997 – it is said that an icy cold hand sometimes touches customers and staff on the shoulders; when they whisk round, of course, no one is anywhere near them. Although the current owners (2011) had not heard this story, they nonetheless thought there might be ghosts here, telling me, 'The pub is steeped in history … my wife is very interested in the spirit world and has been told many times that there are spirits in the pub. She has also been told that a spirit has followed us from our previous pub – her name is Elizabeth Parsons.' The previous pub had been the New Hall Tavern, Cuerdale Lane, Samlesbury. Here, 'Elizabeth's' name had first been mentioned at a séance; 'Apparently she used to wander about the pub looking for her husband, who had died and passed over to the spirit world. For whatever reason "Elizabeth" did not know this; every reading (i.e. spiritualist) my wife has had, "Elizabeth" is always mentioned. There is no possible connection with any of the readings.'

At the Ley Inn, Back Lane, Clayton-le-Woods, the owners told the *Chorley Guardian* (7 November 2007) of more bizarre phenomena of this miscellaneous type,

> Once we were organising a function in the room … All the tables were laid out but 10 minutes later the member of staff came back and found the tablecloths and cutlery on the floor … Next to the pub is a converted barn that is used as a function room – it's claimed that in the late 18th century a landowner killed the father of a young girl he was having an affair with.

Similar poltergeist-like mischief is held to have plagued the Boars Head on Preston Old Road, Great Marton, Blackpool, with stories that a former owner was, among other things, plagued by an invisible entity that hid – or stole – ladies jewellery. Apparently, some kind of séance was conducted not so long ago, with the culprit being identified as a little boy who passed away in the 1800s. In 2011, the new manager here told me, 'Personally I am very sceptical about ghosts and ghouls etc but my partner is very keen

The Punch Bowl Inn, Hurst Green, has long been said to be badly haunted by poltergeist activity linked to a highwayman, Ned King, who was apprehended here. His ghost also thunders through the village on a spectral horse.

and interested, she believes that the CCTV monitor in the office shows orbs on the screen at night after we have locked up and turned off the lights downstairs.'

Elsewhere, the *Burnley Citizen* (5 September 2007) reported on the efforts of the new owner of the Cross Gaits Inn, Beverley Road, Blacko, to discover if the place was haunted. Locals had told him that there was some kind of holding cell for witches, fitted with shackles and chains, in the pub cellar, although – to his disappointment – he had had found it filled in with concrete. There was also a tale of a woman who materialised by the fire, sat accompanied by a dog. The new landlord told the paper, 'I haven't seen her yet, but during winter time when the fire is on, it is said to be cold where she sits.' In Burnley itself, historic Coal Clough House, off Coal Clough Lane, has recently made local headlines when it was reported that this former pub would be renovated and turned into houses. The upstairs room over the entrance porch is traditionally haunted every 27 November by the ghost of a murdered pedlar, who hides in spectral form from his erstwhile murderer by positioning himself in a corner of the room, where he remains until dawn, whereupon he disappears. More intriguingly, the *Lancashire Telegraph* also observed on 19 August 2010 that an animal like a bull haunted the same room, with two bright cherubs upon each of its horns. This, the paper supposed, was the shadow-like 'guardian of Coal Clough House'. I wonder if it is this phantasm's protection of the seventeenth-century former manor house that saw it survive a devastating £500,000 blaze in 2004, and may yet potentially ensure its (at the time of writing) survival via a future transformation into a private nursery.

As is clear, both the media and the public are greatly fascinated by stories of pub ghosts. As the *Lancashire Evening Post* commented on 3 December 2009, 'There's

rumours of a grey lady at Euxton Mills on Wigan Road. And there are reports of flying CDs at The Wellington Inn, Glovers Court, Preston – to name but a few.' Barely a week later, the *Blackpool Gazette* was reporting that the Saddle Inn on Whitegate Drive, Blackpool, was plagued by glasses smashing mysteriously, objects moving and a strange misty-white figure who appeared to be wearing a cloth cap and a long coat who had materialised in the cellar.

Why should it be that 'pub ghosts' so frequently take the persona of a mildly destructive poltergeist, and quite often desire to make their presence known upon the acquisition of the premises by a new landlord? After all this, a pint or two might be required, either to steady one's nerves, drown one's exasperated disbelief or else ponder the perplexing riddle of the 'truth' of it all! So why not sit down at the New Inn, Foulridge, with an ice-cold beer – where I have been told that part of the place was built using materials pinched from the nearby Quaker Meeting House, a building dating to 1666 and later a textile manufacturer called the Foulridge Dandy Shop. Human bones and burial registers have led to the supposition that there was once a Quaker burial ground opposite the old Dandy Shop, and tombstones were allegedly taken from here during the building of the New Inn. As you cradle your pint in nervous reflection you might well see one of those folk from long ago; for, so they say, the Inn was at one time recently troubled by a ghost, a Quaker they tell me, who wandered about the place at night knocking on the doors, perhaps in an indignant attempt to reclaim his tomb. Could this ghost have been anything to do with the man whose death was recorded in the parish registers? '1678. Sept. John Greenwood, of Ffouldridge, a Quaker, buried at Ffouldridge.'

The White Lady of Samlesbury Hall, and Other Ghosts

An 1859 gazetteer of English architecture describes Samlesbury Hall, between Preston and Blackburn, thus, 'This is a very fine timber house, built by John Southworth in 1545, as appears by inscriptions on the music-gallery in the hall, and over the fireplace in the kitchen ... the plan of the house forms the letter L, the shorter arm being the hall, which has a fine massive open timber roof.' The hall, however, actually has much earlier origins, dating back to the fourteenth century and the D'Ewyas family. This original was mostly destroyed when a Scottish force under Robert the Bruce pillaged their way along the River Ribble around 1314. It became the property of Gilbert de Southworth *c.* 1336, in time being inherited by the notorious Sir Thomas Southworth in 1517, 'probably the most turbulent member of a long race of self-willed men'. These days, the hall is a prestigious venue for weddings, and a popular tourist attraction, transformed into a museum and gallery.

Samlesbury is also home to what is perhaps Lancashire's most famous ghost – the White Lady of Samlesbury Hall. Her story is so well known it hardly needs repeating, but, briefly, the legend states that during the reign of Elizabeth I, one of Sir John Southworth's daughters, a lass named Dorothy, fell deeply in love with the heir to a neighbouring knightly house, and he in turn fell in love with her. However, the old knight was an ardent Roman Catholic, while Dorothy's lover was from Protestant

Samlesbury Hall, near Preston.

stock, and an attempt to reconcile this led Sir John to fly into a rage, banishing the young man from Samlesbury Hall and ordering him to desist with his romantic intentions towards Dorothy.

The smitten couple, however, took to arranging secret trysts among the wooded slopes by the Ribble, and at length made the decision to elope. On the agreed night, Dorothy's beau, accompanied by two friends, arrived at Samlesbury Hall to collect her. However, Dorothy's brother, having learned of the plot, leapt from a coppice where he had secreted himself and murdered the whole party, with the exception of Dorothy – who he carried, half-insensible, back into the hall. The three slain rescuers were secretly buried in the precincts of the domestic chapel of the hall, and Dorothy was sent out of the country to a convent. It is said that here she died, having become increasingly deranged, and with the name of her murdered lover ever on her lips.

In time, it was being whispered that, on certain clear and still evenings, the apparition of Dorothy Southworth could frequently be seen gliding along the gallery or through the corridors of the hall. She would descend the staircase and sweep silently through the grounds towards the wooded slopes near the river. Here an equally spectral knight would meet her, a handsome young man who would receive her on bended knee before standing and accompanying her along the glade. At a certain spot both would stop and utter soft wailings of despair before tenderly embracing each other. Afterwards, the two forms would rise from the ground and fade away into the sky.

Dobson's *Rambles by the Ribble* (1883) places this story as taking place 'at the end of the sixteenth century' (Sir John died in 1595), and sometime in the 1800s three

human skeletons were supposedly unearthed by workmen excavating near the outer walls of the hall. In truth, Sir John appears not to have had a daughter by the name of Dorothy, and it may be that the story was woven around possibly his sister, or one Dorothy Winkley, who had resided at nearby Pleasington Old Hall. Nonetheless, Robert Eaton's *Stories of Samlesbury* (1937) quotes numerous reports of encounters with the ghost here that had appeared in the regional and national press. Perhaps the most intriguing concerned the reminisces of an old colonel who had been garrisoned at the hall during the 1878 cotton riots; he was awoken in the middle of the night by the sound of tormented weeping, the plaintive sobbing so alarming him that he searched – fruitlessly – for the source. Eaton also observed the legend that *c.* 1870 two (not three) human bodies were discovered in a chamber outside the garden wall during the digging of a ditch, which when inspected began to crumble away to bone and dust. These two corpses were believed to be those of the murdered lover and Dorothy's brother, who had also perished in the bloody skirmish. In fact, there are general variations on this story. In 2010 I learned that at nearby Hoghton Tower, they believe that Dorothy's ill-fated lover was Richard de Hoghton, son of Sir Richard. Here, they say that Dorothy's ghost, dressed in white, sweeps across the grass in a phantom replay of a secret rendezvous at Hoghton with Richard, her lover. At the tower, they told me of this;

> This lady courted Sir Richard's son (Richard) and according to tradition would ride across to Hoghton Tower from Samlesbury Hall in the evening to meet young Richard on 'The Dorothy Steps' at the rear of the house. On our ghost tours we take our visitors to the rear of the house and show them the Dorothy Steps and the lawn which people claim to see Dorothy on moonlit nights crossing in search of young Richard.

Modern folklore has it that the White Lady also drifts outside the entrance to Samlesbury itself. According to the *Lancashire Evening Telegraph*, a girl waiting at the nearby bus stop one night in February 1960 glimpsed the White Lady through a sheet of rain, and collapsed in a dead faint. Other motorists have allegedly seen her stood by the roadside, caught in car headlights, although she frequently dematerialises when heads are turned or attention distracted. Reportedly, one motorist actually collided with 'her' on the A677 in 1987.

On the afternoon of 2 March 2011 I paid a visit to this wonderful old hall, and (the place being quiet), was able to discuss these stories at length with the knowledgeable lady on the desk who acted as a very helpful 'tour guide'. She claimed to know that the place was full of ghosts, although she hadn't had any experiences herself. However, she knew of visitors in the recent past, who had been on the grand staircase near the entrance hall, that had experienced the chilling sensation of automatically moving to one side and pressing their backs against the wall because they were convinced that some presence was rushing past them down the stairs! Some claimed that this motion was accompanied by the noise of a rustling crinoline dress, and to this I suggested that perhaps these people were sensing Dorothy herself as she rushed to the porch to meet her lover on that fateful night. I was also told a story of a 'very level headed' bus driver who actually stopped his bus at the bus stop on the A677 one night, as there appeared

to be a woman dressed in white waiting in the gloom. He actually pushed the button to open the doors for her to get on – yet found no one stood there, and the pavement empty.

However, although Dorothy is the hall's most famous spectre, there have been observed to be others. The hall's own website actively promotes itself as being extremely haunted, and visitors can learn about the little boy who peers into the hall from the old entrance (they say he was, in life, a servant's son, who was never allowed inside), as well as the tragic end of William Harrison, who fatally shot himself in 1879 and whose ghost now haunts the Minstrel Gallery. There is also a well known story of one guest seeing a cadaverous-looking coachman, missing many teeth and an eye, who led a funeral cortege along the driveway to the hall.

Perhaps the hall's most famous ghost other than Dorothy herself is the one that haunts the Priest Room, where legend has it an unnamed priest was barbarically beheaded during the days of King Henry VIII. The blood from this crime washed over the floorboards, and has been visible ever since, stubbornly resisting all attempts to clean it away. William Harrison (or his father Joseph, an ironworks magnate) is held to have had these floorboards ripped up and replaced, only for the same odd discolouration the begin appearing on the woodwork where the killing happened. This staining can still be observed to this day, and does indeed present the illusion of some liquid discolouration having washed over the floor and seeped down between the varnished wooden floorboards. I understand the crime occurred *c.* 1582; upon visiting the hall I was shown two supposed 'priest holes' where members of the Catholic clergy hid themselves when the situation forced it. One is beside the Priest Room, naturally, but the other is in a suffocating little cranny to the left of the huge fireplace in the entrance hall. I was also told that a tunnel had been found recently that led from the vicinity of this fireplace out into the grounds – although whether it was for drainage or escape purposes was not known. However, it is in this very fireplace that a visitor, so I understand, took a photograph that depicted the simulacrum of a coffin in its shadowy recesses.

In fact, there are so many ghosts at Samlesbury that these days their mythology has a tendency to overlap, for some say that Harrison's sad demise was brought about not by his own financial ruination but by his becoming obsessed with the 'cursed' Priest's Room, to such a degree that he took his own life. The hall is remarkable in that on more than one occasion strange shapes have been caught on camera, but perhaps the most compelling of these is a photograph taken in 2008 by a visitor which has since been flashed around the world via the Internet. The image was captured during the night using a mobile phone, and appears to depict a vaguely human looking form, which once spotted in the gloom, bears the outlines of eyes, nose, beard, possibly some kind of 'crown' and what appears to be a thick, light-coloured robe of some sort on the shoulders and joining at the neck. When the incident was reported in the *Daily Mail* of 7 February 2008 there was speculation that the strange figure might have been the ghost of King Henry VIII himself, the Tudor monarch whose soldiers were supposed to have slain the venerable priest all those years ago.

At the time of writing, the hall is preparing an upstairs Ghost Room, and further ghost tours are planned. One of the events co-ordinators at Samlesbury Old Hall

confirmed to me that there were many curious incidents of haunting here, in the present day, and all things considered Samlesbury would seem to be one of Lancashire's – if not Britain's – most haunted locations. It is a place where anyone with an interest in the phenomenal ought to visit, a place where, it would seem, the atmosphere is genuinely conducive to the appearance of ghosts, if even a fraction of the many tales told here are to be believed.

Lancashire's Halls and Their Ghosts

The haunting of stately homes is a British cultural phenomenon, and historically, many other halls in Lancashire had their resident supernatural entities.

At Hackensall Hall, by the Wyre at Knott End-on-Sea, which dates to *c.* 1656, the resident ghost was a huge horse. It was regarded as a friendly benefactor if treated well, and this indulgence involved lighting a fire for it (presumably in the grounds) before which it was frequently seen reclining. When this bizarre act was not performed, however, the hall and its grounds echoed to the 'fearful outcries' of this strange manifestation.

At St Michael's Hall, St Michael's on Wyre, it was a former owner who haunted the premises after his demise. This, they say, was around the time of the Pretender. The ghost of Major Longworth caused such consternation with his nightly visits over a number of years that it took the combined power of a priest and a parson to lay his restless spirit. This they did beneath St Michael's Bridge that crosses the River Wyre near the church. According to the rite, the spirit would lay trapped so long as the water flowed down the hills and the ivy remained green. The old major's ghost has not stirred since then, although these days the A586 is so busy that I doubt the spirit would want to appear, even if it could. Not to be outdone, another old house in the vicinity – White Hall – boasted a phantom of its own that made its appearance in the garden.

The ghost of a Scottish traveller who was murdered beneath a tree haunted Staining Hall, a mediaeval moated house at Staining, east of Blackpool. Where he fell, the ground was marked by the strange odour of thyme, and this phenomenon was being cited at least as late as Harland and Wilkinson's time; perhaps the victim had been a herb peddler or a gardener.

At Hothersall Hall by the Ribble there is another tradition of a boggart. The hall is the ancient seat of the Hothersall family, Lords of the Manor of Ribchester, and at some point in its history was troubled by a mischief-making sprite. William Dobson, writing in 1883, states that this was 'a generation or two ago'. The spirit of the goblin was 'laid' (i.e. exorcised) beneath the roots of a large laurel tree and will not be able to escape until the tree no longer exists. To this end, at least until the nineteenth century, it was the practice to moisten the roots of the tree with milk to prolong its existence.

Some go further and say that the boggart was in actual fact a demon, the hall being freed from its evil influence after it was tricked by a Catholic priest into the hopeless task of spinning a rope from the sands of the Ribble. *A History of Longridge* (1888) notes another such tale in the area that may or may not be the same one: 'At Walton Fold was a demon who committed many strange vagaries until "laid" by a priest, the

The petrified goblin: photograph taken
from Hothersall Lane.

Rev. Jas. Fisher.' At any rate, two versions of the paranormal trouble-causing here have
long circulated.

Hothersall Hall is at present private property, and inaccessible to the public.
But interestingly, wedged in the fork of a tree on Hothersall Lane can be found the
grotesque, weather-beaten stone head of a gargoyle that was dug up in the grounds and
is rumoured to be the petrified remains of the exorcised goblin. It has been stuck in its
present position for some time now, and has been described to me by a local resident as
a 'creepy, horrible little thing'. I was also told by this same person that she had known
her dog to become exceptionally agitated and excitable near this tree, growling and
whining before backing off from it, apparently cowed.

At Lytham Hall, Lytham, the bedrooms of the first and second floors are supposedly
haunted by the sound of clumping footsteps and the clanking of chains being dragged,
which many believe to be the spectre of one of the hall's owners, Sir Cuthbert Clifton,
who purchased the place in 1606 from Sir John Holcroft. Like many in these parts,
Sir Cuthbert was an ardent Catholic, who had taken a vow to join the crusaders in
their attempts to 'rescue' the Holy Land. He had symbolically 'crossed' himself – that
is, assumed the emblem of the cross – but he died in 1634 before he could set out. As
a result it became the custom of saying mass at stated times for the repose of the soul
of Sir Cuthbert, and this practice was recorded as still taking place at least as late as
1853. This ritual is probably the reason why they say Sir Cuthbert has haunted this old
place, even despite its modernisation around 1749 and its development into the fine
Georgian building we see now. Several other ghosts are believed to haunt this place as
well, Kathleen Eyre mentions 'the celebrated White Lady' as being one. This consisted

of a ghostly female form that wafted along the Long Gallery and dissolved at the far end of that apartment, who many claimed to have seen. These included nurses and servicemen convalescing there during the Second World War.

However, many stories of this type are rather more up to date. For instance, at Park Hall – now a hotel, conference and leisure centre, on the western edge of Charnock Richard, but with manorial origins dating back to 1284 – it is famously repeated that in 1967 a number of people saw a white shimmering female figure rise from the centre of the lake known as the Dam, by Swift's Wood, who evaporated into thin air even as they looked at her. Not surprisingly, she became known as the Lady of the Lake. North of Padiham can be found the palatial, historic seat of the Shuttleworth family, Gawthorpe Hall. The present house is of Stuart age, built c. 1605 by Laurence Shuttleworth, and the family were for a long time held in high importance – Captain William Shuttleworth died fighting for the parliamentary cause during the English Civil War. When the house was being restored in 1850 under the direction of master architect Sir Charles Barry, there is a story that a large number of gold coins were found under a panel in one of the rooms, which were believed to have been hidden there in 1745 when the Jacobite army marched on Lancashire. Gawthorpe's rooms are said to be haunted by 'Miss Rachel' – the ghost of Rachel Kay Shuttleworth (1888–1967). It is also believed the place is haunted by Colonel Richard Shuttleworth, a former inhabitant involved in the Pendle witch trials, and staff here – both past and present – are alleged to experience an uncanny sensation that they are being followed.

Rufford Old Hall stands to the north of Rufford, by the Liverpool Canal, surrounded by park-like grounds and built of wood, brick and plaster. The ancient seat of the Hesketh family, it dates to the fifteenth century and contains a secretive 'priest-hole' in the Great Hall where Catholic priests were hidden away. It boasts numerous ghosts, including that of a young fellow in Elizabethan-style doublet and hose, who many equate with the ghost of William Shakespeare. There is a persistent legend at the hall to the effect that, while a young man, Shakespeare lived at Rufford Old Hall when he entered the employment of Sir Thomas Hesketh around 1585 as part of a troupe of performers. There is also a story that a regal-looking woman dressed in Elizabethan clothes has been seen to dematerialise as she looks distractedly out of a window, and many believe this to be the ghost of Queen Elizabeth I herself.

However, Rufford's most famous ghost is the Grey Lady, whose appearances were described by the fondly remembered local historian and writer Jessica Lofthouse, who died in 1988. In her *North-Country Folklore in Lancashire …* (1976), she wrote, 'She has been seen in the gardens and in the withdrawing room at various times, and in living memory she lingered long in the room where Philip Ashcroft, the late curator, was playing on the piano, drawn, it seemed, by the power of music.' She has also been seen very clearly in the grounds and along the drive leading to the church, according to folklorist Kathleen Eyre in 1974. It is commonly said that this is the ghost of Elizabeth Hesketh, who was due to be married sometime in the 1580s. However, her husband-to-be was called away to fight in the Netherlands, and lost his life on the battlefield of Zutphen. Poor Elizabeth was left to mourn, and upon her own demise (some say that she pined away to death, waiting for news of her betrothed) the Grey Lady would be seen 'to wander disconsolately around the Hall sighing for her lost lover'.

Towneley Hall is surrounded by extensive woodland.

Towneley Hall

An 1830 gazetteer of Lancashire describes Towneley Hall, south-east of Burnley, as, 'a large and venerable pile, with two deep wings and as many towers, assuming a very formidable and castle-like air'. Interestingly, the bridge that crosses Copy Clough is called Boggart Bridge, and this is where a troublesome imp was 'laid' by a priest after its poltergeist mischief in the hall grounds began to get out of control. According to the *Spectator* (1892), this occurred 'some three centuries ago'. However, from Harland and Wilkinson we also learn that the resident boggart put in an appearance once every seven years, and this was likely to act as an omen portending a death in the house. Sir John Towneley is supposed to have set this in motion in the late 1400s by 'laying in' a great portion of common land within the boundaries of his park, and as punishment his ghost haunted the scenes of his greed. In 1867 *Lancashire Folk-lore* noted that the peasantry of the Burnley district firmly believed that the knight himself wandered the hall and the grounds, his ghost wailing piteously, 'Be warned! Lay out! Be warned! Lay out! Around Hore-law and Hollin-hey clough, to her children give back the widow's cot: for you and yours there is still enough!' It is unclear if both stories concern the same ghost.

The hall now functions as an art gallery and museum. I was kindly passed a number of anecdotes concerning a spectral White Lady' at Towneley by professional photographer Janet Wood, who has a great interest in the place. She had been contacted by a couple of people who claimed to have seen this ghost, a strange gliding white phantasm that appears to be a woman. I have heard rumours myself that the ground floor of the hall

is haunted by a White Lady, but Janet was told of one incident in 1988 when three young school friends saw what might have been the White Lady while larking about at around 9.30 p.m. The boys had been messing about near playing fields on Broad Ing, where the path leads up to the hall itself, when they had seen a strange white figure in amongst the tree line of Wet Marl Wood on the opposite side of River Calder. Suddenly this figure drifted out from the trees and across the water, towards them. It stopped about 10 feet from them, a hovering, human-shaped shimmering white mass that floated above the ground. This presence put the three boys to flight after several seconds of staring at it in utter disbelief. Janet's correspondent was sincerely convinced, as an adult in later years, that what they had seen that night was, without question, a ghost. Another person claimed that they and three others had observed the White Lady while undertaking a Youth and Community event involving night orienteering in the grounds to the rear of Towneley Hall in the late 1990s. All four had seen a lady dressed in white from head to toe, who seemed to be quite tall and moved in a gliding motion, and the phenomenon is likely to be the same one seen by the schoolboys. It is sometimes said that Lady Alice O'Hagan – the last private owner of the hall, who sold it in 1901 – revisits her old home via Manchester Road (A682). But she could be glimpsed in a spectral pony and trap, and so the identity of the strange White Lady seen more recently is presently unknown.

Bogles of the Beautiful Game

There are a number of urban legends attached to football in Lancashire – hardly a surprise in this part of the UK where the game is in some quarters almost a religion. According to folklorist Jessica Lofthouse, football on a Sunday brought the Devil to the Forest of Rossendale, where he joined in a kickabout with a bunch of local youths. He literally hoofed the football into the stratosphere, whereupon some perceived the new player to have a cloven hoof for a foot, and the horrendous smell of brimstone drifted through the air. I have no doubt that this story was first heard in church where the vicar would use it as a warning from the pulpit that playing sports on a Sunday would lead one into temptation. But it is interesting to note that football was used as the medium most likely to get through to those disrespecting the Lord's day.

A former work colleague of mine, an avid football follower, told me a number of anecdotes about county football grounds, including the story that a boggart killed an old woman and skinned her alive in Brunshaw, Burnley, vanishing into the night but leaving her bloodied skin scattered along a hedgerow, at the site of what went on to become the Bee Hole End terrace at Turf Moor, itself redeveloped in 1995.

This same person also told me that sometimes certain grounds were judged to be haunted, or cursed, the 'curse' being deemed responsible for the excessive number of losses suffered by the home team on certain occasions. One example in particular he found humorously ironic concerned a 1-0 defeat that Preston North End FC suffered at Deepdale in 1994; this was despite the club having the ground blessed by 'a psychic' (Blackpool clairvoyant Paula Paradema, as I later found out) to eradicate some kind of vague 'gypsy curse' placed on the team – an unusual explanation for a losing streak

if ever there was one. Rivals Blackpool FC are not immune from this either; the boardroom at Bloomfield Road is reportedly panelled with timber salvaged from Lord Nelson's old flagship the *Foudroyant*. This vessel was being brought to Blackpool for display, staffed by twenty-eight men and boys in 'Jack Tar' costumes, but on 16 June 1897 she was wrenched by gales from her moorings 2 miles out to sea and deposited on the beach near North Pier. Thousands poured onto the beach to see this, but eventually her timbers were dismantled and made into a variety of souvenirs.

In fact, according to the story my informant had heard, the boardroom was supposedly haunted – some said by Nelson himself – and suffered strange 'cold spots' and mysterious noises that emanated from nowhere. Nelson's unhappy influence following the demise of his old ship, which he had taken to the Mediterranean in its golden heyday, was even blamed for arguments among the board of directors – and Blackpool missing out on promotion several seasons back!

The Most Haunted House in Lancashire?

Chingle Hall, a whitewashed manor house in Goosnargh parish whose bland, Tudor façade belies its reputation, is another contender for the title of 'most haunted house' in Lancashire. It has gone by many names down the ages: Shynglehall, Shinglehall, Singleton hall and Gingle hall. This place is famous and notorious in equal measure on account of the paranormal activity experienced here down the years, and has attracted the attention of numerous ghost investigators – Kathleen Eyre, Terence Whitaker and Peter Underwood, among others – all of who have found the rumours of ghosts here very credible.

The hall has been around in some form since the medieval era, with its most famous resident said to have been the Catholic martyr Saint John Wall, who was born in a bedroom here in the year 1620. The holy man was ultimately arraigned before Justice Atkins after five months in gaol in an era when it was illegal to practise mass. He suffered execution at Worcester on 22 August 1679, and afterwards his head was privately conveyed to his friend F. Randolph, a missionary who took it as a holy relic on a grand tour of Europe. There is a persistent story that the head, after much travelling, was returned to Chingle Hall *c.* 1834, where it now resides in a secret location.

There is little need to go into too much detail concerning Chingle's reputation, suffice to say that it boasts some sixteen or seventeen different paranormal entities. Phantom footsteps have, in the past, been heard crunching on the ground as though someone invisible were walking across the moat bridge, a paranormal force has lifted the flowers out of a vase on occasion, mysterious disastrous-sounding crashes have woken the occupants in the early hours, water has pooled from no discernable source, objects are mysteriously moved, strange figures are seen staring out of upstairs windows … and in one show-stopping piece several people witnessed a heavy, hanging galleon sail itself through the air in the lounge. According to folklore, a wooden cross was found hidden in a wall here, its hiding place revealed by a fire that spontaneously ignited on one of the ancient, blackened beams in the 1970s. This flame also extinguished itself.

Perhaps the hall's most famous ghost is the spectral monk, whom ghost hunter Kathleen Eyre wrote in 1974 had been seen very clearly 'a few years ago' in the

bedroom where John Wall was supposed to have been born. Numerous times during the night, the latch on the bedroom door had lifted, allowing the door to swing open; on the last occasion, the then-owners, Mr and Mrs Howarth, had seen 'the form of a cloaked figure moving slowly along the wall'. The couple were able to observe this phantasm for some fifteen minutes before it faded from view. The Priest Room is said to be very haunted, with a strange long-haired figure having been glimpsed striding past outside the window – all the more remarkable for the window being some 13 feet from ground level. The room contains a secretive priest hole, designed to hide Catholic fathers in the event of the place being raided by Protestant soldiers, and from within this cubby hole worrying thumps and knocking have been heard. One ghost hunter in 1985 peered into the priest hole upon hearing strange sounds, and supposedly saw a disembodied hand in the gloom moving one of the bricks about. The hand simply froze and then vanished.

Eleanor's Room is said to be the room where Eleanor Singleton died in her teens in 1585, orphaned and apparently having degenerated into idiocy. There are some that say she was starved to death, or murdered, but this gloomy room is said to pervade an atmosphere of such sadness that the air is almost saturated with it, with the smell of lavender also being detected from no known source. Phantom hands are said to tug at the garments of little girls, Eleanor's ghost being believed to be particularly fond of blonde children.

There are several instances of what are alleged to be the ghosts of Chingle being captured on camera, or detected by microphone. Upon the opening of Chingle Hall for a ghostly sleepover, an article by Lyndsay Russal in the *Independent* of 19 March 1994 observed, 'the house is home to a Lady in Black, a Weeping Child and a Headless Man. During the night, "happenings", according to owner John Bruce, occur nine times out of ten (though a paranormal event could be something as minor as your camera jamming or the sensation of a sudden "cold spot").' For decades now, the hall has been the subject of such overnight ghost hunts, with one such participant, Andrew Usher, telling fellow enthusiast Peter Underwood, whose account of the place appears in *This Haunted Isle* (1984), 'I heard and saw things that I didn't believe were possible ... I have seen and felt some strange things in other places, but never as much as at Chingle Hall.'

Today, the house and gardens are private property, and ghost hunting is not encouraged. It is sufficient to say that locally Chingle's reputation is notorious, and some even profess to experiencing dread or panic attacks upon merely passing the place, despite the hall not even being visible from Whittingham Lane. With some sixteen ghosts, it is not for nothing that Chingle Hall is declared to be Britain's most haunted house, but it does have competition elsewhere in Lancashire ... lately in the shape of Mains Hall. For this Grade II listed building by the River Wyre at Little Singleton is reputed to have over ten different paranormal entities, according to its website.

Ghosts of Blackpool

Somehow it is difficult to associate Blackpool with ghosts. The town began to develop as a recreational resort in the mid-eighteenth century, and its population has grown

Early pleasure flight over Blackpool, *c.* 1930. (Picture courtesy of the Lancashire Record Office.)

with the years. It now has a resident population of some 152,000 and attracts around eight million summer visitors – as well as being a popular venue all year round for stag and hen nights. The famed 518-foot Blackpool Tower dominates the 6-mile Promenade, well known for its autumn illuminations. In many respects, the town seems too 'new' to have ever been haunted.

The truth is that there has been settlement in the region of the town since at least the ninth and tenth centuries, with some of the earliest villages on the Fylde Coast (that were later incorporated into the town) being named in the Domesday Book in 1086. Although mainly oak forests and bog land when the Romans landed, by mediaeval times 'Black Poole' was emerging as a few farmsteads on the coast.

These days, the annual ritual of a celebrity endorsing the town by switching on its illuminations, and the many fantastic attractions here, are well known and we need not be sidetracked by them too much; suffice to say that the lively, crowded, jostling resort that Blackpool presents to the world is, at least in part, not the whole picture: the town, of course, sleeps, like any other, and has its 'quiet' seasons. And, like anywhere else, Blackpool – the 'pleasure capital of Europe' – has its ghosts.

The phenomenon is an old one. The Revd William Thornber's *History of Blackpool* declared that there were several different ghosts that haunted that part of the Fylde near the steadily-growing town. Lubber fiends, house boggarts, horse boggarts and industrious – yet mischievous – imps haunted dwellings, while the roads were haunted by the ghosts of suicides, murder victims and the avaricious. Whitegate Lane (Whitegate

Drive) was notoriously haunted by the 'Headless Boggart' of a slain man, for instance, in Thornber's day.

To be more up to date, there is a reference to an exorcism having been carried out 'recently' at a house in Blackpool in Kathleen Eyre's *Lancashire Ghosts* (1974), indicating that the 'house boggarts' of remote Lancashire villages still yet may make their unwelcome presence known in busy Blackpool. The writer also alludes to a paranormal disturbance at a property in nearby Thornton 'about 12 months ago'. It is likely that she was referring to the so-called 'Thornton Thing', a strange entity that the *Gazette* reported as plaguing a residential property in Windsor Avenue, Thornton, in 1971. This nightmarish spectre would invade the bedroom at night, breathing into the ears of members of the Ross family, pervading the room with a vile odour and whipping bed covers off the sleeping occupants. In the end, they upped and left the house. (In fact, the *Sun* of 3 April 2008 reported a postscript to these events: in 1996 the owner had arranged for Fleetwood Spiritualist Church to perform an exorcism, following mysterious banging noises and an earthy smell pervading the place. Taps were turned on full force, and 'a mist' appeared to inhabit the bedroom. But in 2008 it was also widely reported that, after some years of peace, a new type of ghost seemed to have materialised at the property and that the then-owner's late wife appeared to be sending text messages from beyond the grave, having been buried with her mobile phone.)

Ms Eyre also mentioned a spectre associated with the spacious, elegant Georgian building on Liverpool Road known as Raikes Hall. The hall, prior to its present incarnation, has seen numerous owners and many guises: for some fifteen years until the mid-1870s it was the site of a Roman Catholic Convent School, and there is a legend that the 30 acres of estate that the hall once sat in was haunted by a phantom blue nun. Tradition says that in life she drowned herself in one of the expanses of water near (what is now) the Stanley Park Boating Lake. The 'blue nun' has been, in the past, blamed for any little annoyance or minor poltergeist behaviour at the hall, so I understand. The site is now given over to a housing estate, Raikes Hall being its only remnant of a forgotten era – except perhaps, for its ghost.

There are, in fact, haunted places all over the town. For instance, the former Royal Pavilion Cinema on Rigby Road (making recent headlines in its later incarnation as a smoking ban-defying bar, the Happy Scots) held a séance in February 1972 that saw off a troubled soul haunting the back of the Circle. Elsewhere, ghost hunter Terence Whitaker wrote in 1980 that the old Lobster Pot restaurant on Market Street (that later became Brannigans and the Super Bowl) was bedevilled by some kind of invisible entity that had a strange compulsion to 'grab' the waitresses there. This paranormal phenomenon only occurred on a Tuesday or Wednesday, but nonetheless must have been singularly unnerving for the women, who were left with red finger marks on their arms and legs thanks to this manifestation's unwanted attention.

Perhaps the most famous urban legend here concerns the phantom tram that they say glides silently along the Promenade in the small hours, after the regular tram service has ceased. Some even say this tram glows, or, if not actually seen, then the sound of an oncoming tram can be heard, with the overhead wires heard to make the peculiar electronic sound distinctive to the Balloon trams. This phenomenon is most closely

Tram on Squires Gate Lane, *c.* 1910. (Picture courtesy of the Lancashire Record Office.)

associated with Bispham tram stop. Everyone here knows this story, just as they know the one about the strange figure who wanders onto the tramline from the direction of the beach during appalling weather conditions, swinging a lantern as though in warning. Perhaps he is something to do with one of the early fatalities occasioned by the tramline's installation; for instance, an inquest in Blackpool in 1906 heard the strange circumstances of the death of a man named M'Keag, who simply walked out in front of one of the trams, ignoring the driver's shouts of alarm, and was hit squarely. He was so wedged that it took twenty minutes to release him by lifting the car. Some people in Blackpool think the mysterious 'lantern man' is trying to stop this type of thing happening.

Nearer our own time, there was an unusual case reported in some of the national newspapers in 1994 concerning a Blackpool woman who had resorted to calling in a priest, two psychics and a Mormon missionary in order to rid her house of a frightful entity that appeared to have taken a wholly unnatural interest in her. This 'ghost' had begun to manifest itself early in the year, and among its disturbing proclivities it had, invisibly, climbed into the bed next to her where it had whipped off a towel that she had been wearing wrapped round her head. The lady concerned had then heard something whisper near her ear that it was going to molest her and next felt a vile sensation as of 'tiny needles' touching her skin. Placing an ioniser in her room seemed to keep it from the threshold; whatever was behind this, her resort to faith rather than to the police is indicative that she felt it was a supernatural phenomenon; the strange nature of the incident ensured that there was much speculation at the time.

According to a feature in the *Blackpool Gazette* (31 March 2008), the Star pub at Pleasure Beach is haunted by a strange male figure sighted in the cellar and the old

living accommodation, who was seen by builders on one occasion. The pub has also experienced the 'phantom customer' phenomenon, with a figure seen walking through the bar at 3 a.m. only to dematerialise. The newspaper also observed the often repeated belief that the Ice Rink was haunted by 'several ghosts, with performers reporting seeing strange things backstage and in the dressing rooms'. Most recently, the *Gazette* (23 February 2009) carried an article concerning the television psychic, Ian Lawman, who had declared a house in central Blackpool to be one of England's most haunted houses. This followed an investigation over two nights by the team of paranormal investigators, after the family concerned reported a number of phenomena – including the apparition of at least two different wraiths. These were a 'child with brown ringletted hair sitting on the stairs' and a strict-looking, straight-laced governess type lady seen by the eighteen-year-old son. The results of the investigation were aired on Living TV's popular *Living with the Dead* on 31 March, allowing television viewers to make their own minds up. Back at Pleasure Beach, the famous psychic and spirit medium Derek Acorah dubbed *Ripley's Believe It Or Not!* Museum, one of the most haunted places in the seaside town. Living TV's *Most Haunted* (screened 12 December 2004) appeared to show Derek Acorah becoming possessed by an exotic, hirsute shrunken head from Ecuador that was on display in the 'Strange, Unusual and Bizarre' exhibition.

Blackpool is fast becoming the premier place in Lancashire for ghost hunters. It is a town peppered with well-known haunted locations, for all its bustling modernity, but perhaps a fuller study of the many contemporary ghosts here ought to be left to the local ghost hunting experts and paranormal concerns. But a good indication of just how big this industry is can be gleaned from the *Gazette's* list of venues for 'ghost tours' conducted by paranormal experts in its edition of 29 July 2008. The upper dress circle of the Grand Theatre, North Pier Theatre, Lytham Lowther Pavilion, Blackpool Opera House, Louis Tussaud's Waxworks, Winter Gardens, Blackpool Zoo … the list is endless. Of these, perhaps Blackpool Zoo is the most intriguing venue. Today home to hundreds of exotic animals from all around the world, the zoo is built on the edge of what was Blackpool Municipal Aerodrome, work on which commenced in 1927 at the behest of the aviation savvy Blackpool Corporation. The Prime Minister Ramsay MacDonald officiated at the opening ceremony in 1931. Blackpool International Airport developed at Squire's Gate, but at the site of the zoo at Stanley Park many of the original aerodrome buildings and hangers were left standing. According to the *Gazette* (31 March 2008), staff had reported weird noises, odd lights and a sensation that they were not alone. Lights would go on and off, particularly in the region of the keeper's flats (which are housed in the old air traffic control building), and the hangers, where the elephants were housed. The disturbances were ascribed to the spirits of former airmen. Either way, in the Blackpool of today it is strange to contemplate that one might not actually need to visit the Ghost Train at Pleasure Beach – for the real thing could be lurking anywhere in the 'pleasure capital of Europe'. However, to truly enter the world of the surreal, the Ghost Train itself (originally established here back in 1930) has an actual ghost – a well known spirit called 'Cloggy.' According to the *Gazette* (31 March 2008), the ghost is thought to be that of a former operator who worked the attraction decades ago, and who died about thirty years back. Apparently, this employee wore clogs, and it is thought that the mysterious 'clonking' sound that echoes round the place

after lights out is Cloggy returning to keep an eye on his former place of employment. His presence is also blamed for electrical glitches that cannot be explained.

Hoghton Tower's Green Lady

The ancient tower denominated Hoghton Tower stands on the summit of a hill, King's Hill, enshrouded by the trees of Hoghton Tower Wood. It was erected by Sir Thomas Hoghton in the beginning of Queen Elizabeth I's reign, when he rebuilt the original building dating back to *c.* 1109. It remained for several generations the principal seat of the Hoghton family; Sir Thomas was, evidently, highly regarded, his life – and death – sung in a ballad:

But now my life is at an end; and death is at the door;
That grisly ghost his bow doth bend; and through my body gore …

In mid-August 1617 the splendid banqueting hall played host to King James I of England (the Sixth of Scotland) and his noble retinue of courtiers, baronets, knights and notables. Much feasting and riotous drinking accompanied the stag-hunting – it is written that 'there was a man almost *slayne* with fighting' – and Lancashire tradition has it that the king bestowed many a chivalric order upon his companions, even jovially knighting a loin of beef at one banquet on 17 August – the part ever since called the sir-loin! In entertaining his sovereign, Sir Richard de Hoghton had presided over a roister that entered local folklore, with those present being 'as merrie as Robin Hood and all his fellows'. Sir Richard's descendents fared less well as part of the tower was blown up by accident while it was garrisoned for Charles I during the Civil War. The explosion, on 16 February 1642, happened upon Hoghton's surrender to Captain Starkie; the gunpowder and arms in the central tower caught fire (some say it was sabotaged), vaporising the tower and killing some sixty men (possibly over 200 died), including Starkie himself. At the time, Starkie had been congratulating himself on the ease of his victory, and his is just one of a number of wraiths believed to haunt this historic place.

In 1828 it was observed of Hoghton, 'The family have now removed to Walton Hall, and Hoghton Tower is left to decay, two poor families inhabiting the south wing only.' Hoghton nearly fell into complete ruination, with Dickens observing later that floors and ceilings were falling in, beams and rafters bowed dangerously, windows stood boarded up or smashed and oaken panelling had been stripped away. Happily the restoration work, begun in 1862 by Sir Henry Bold Hoghton, commenced the preservation of this landmark building, and it now presents one of the premier tourist attractions in the county, its commanding position 650 feet above sea level providing spectacular views for miles in each direction.

In fact, so many ghostly experiences have happened here that a special 'Ghost File' has been drawn up, and Hoghton now popularly goes by the moniker 'the third most haunted house in Britain'.

Hoghton is today the home of Sir Bernard and Lady Rosanna de Hoghton. There have been guided ghost tours here since 1995, when Sir Bernard finally gave permission

for the guides to tell some of the ghost stories. This permission coincided with Sir Bernard's own ghostly encounter when, one late autumnal eve following his return from London, he had a strange experience while making himself a late night snack. While preparing his meal, he distinctly heard footsteps clumping about an attic room directly above his head in the full knowledge that not only was there no ladder leaning against the loft access but the room was full of water tanks, with no room to walk about, even if someone were up there. Twice on the table did the plate of food Sir Bernard was preparing move 18 inches to the left; the table was level and dry, and its second displacement coincided with more thumping footsteps overhead, at which Sir Bernard retreated from the room, his hair on end.

Stories such as these were told by one of the guides to the audience during one of the Hoghton Tower Ghost Tours in 2008, events which have become extremely popular – so popular, in fact, that the Ghost File has been begun to bulge with the many strange incidents that guides, visitors, paranormal concerns and even the resident family have experienced. One of the most curious stories concerns an embalmed Egyptian mummy that some say resides – interred or entombed – somewhere in the foundations of Hoghton, having been collected in the late eighteenth century by Sir Henry Phillip Hoghton. I suppose that this is the same artefact vaguely referred to in an 1825 study entitled *An Essay on Egyptian Mummies*, in which it is observed that a mummy was 'bought at the same time (1821) by Sir Archibald Edmondstone's fellow traveller, Mr Hoghton, and (is) now lying *unopened* at his seat near Preston, in Lancashire'. Perhaps it was hidden away in one of the subterranean passages that at one time radiated into the fields about Hoghton, but are now sealed up. Another legend, more eerily supernatural, concerns a bizarre phenomenon experienced by an American visitor one night in 1976, while staying in the East Wing. In the middle of the night this guest made her way to the bathroom, and to her astonishment found that the door to the stairs obligingly opened itself for her. In the gloom, this lady shone a small torch and was perturbed to observe that the beam fell on nothing … literally nothing, no stairs, walls or landing floor, just a black void of nothingness. She spent the rest of the night sat on the edge of the bed, and in the morning requested that she be moved.

But the most intriguing ghost here is perhaps the Green Lady, or Lady Anne. One of the Hoghton Tower guides observes,

> The Green Lady is apparently referenced in history books as having lived in the sixteenth century and was unfortunate enough to have seen her father kill her mother. Vera Higginson, a medium who was on a normal Sunday tour with Jean Calvert (Hoghton Tower's Head Guide), was reported to have seen the Green Lady and upon talking to Jean afterwards, claimed to know how she had died – of consumption.

The experiences of 'Aunt Francis' (Francis, the younger sister of Sir Charles de Hoghton, who died in 1893) are also logged in the Ghost File, which reads in part,

> One evening Francis was alone. While crossing the Minstrel's Gallery with needlework in her hands, an imposing lady dressed in a green velvet costume materialised in front of her. Startled yet not afraid, Francis faced up to her while the lady in green showed

interest in the needlework. Within seconds the apparition had vanished. This episode repeated many times and according to Aunt Francis she not only became very familiar with the lady in green, but also learned from her old stitching techniques.

At the time of writing the next ghost tour is scheduled for November; I would advise anyone with an interest in such matters to attend, for if indeed there are such things as 'ghosts', then this is certainly the place where one would find them.

'Rambles by the Ribble', 2011

In March 2011 I was fortunate enough to speak with a local resident, Katie Duxbury, by the banks of the Ribble, who told me a few stories of Ribchester's ghosts.

Ribchester is an attractive and interesting village, with a history dating back to the first century AD, when it was the site of the Roman fort of *Bremetennacum*; this used to guard the crossing of the road from Ilkley to the Fylde with the main highway from Manchester to Carlisle. The fort was one of the largest in England, and part of the Roman bathhouse can still be seen, along with a number of Roman antiquities discovered during nineteenth-century excavations. These are housed in a small museum next to St Wilfrid's Church. Tradition records the curious discovery of the skull of an ox, covered with the remains of some leather and studded with gold. It is possible that this object was for sacrificial purposes. There is also a legend that the place was entirely ruined by an earthquake, and that it lay for centuries neglected. Ribchester was later a Royalist outpost during the Civil War and the scene of several skirmishes. However, perhaps the biggest threat today might come from a swollen River Ribble, as houses were observed to have collapsed into the river during flooding in the nineteenth century.

Quite a place then, is Ribchester, and it also has its ghosts. Not surprisingly, many are linked to the Roman ruins. I was told that a recent former rector of St Wilfrid's Church had encountered the ghosts of two Roman legionaries as clear as day within the church, and although he was fond of the occasional gin and tonic this reverend gentleman had, at the time, been stone-cold sober. I suggested that belief in ghosts was an unusual stance for a rector to take; many members of the cloth steer clear of superstitions, so to have one who freely admitted to actually having seen two ghosts is remarkable. I was also told by Katie that she knew of someone who had awoken in their house on Water Street to see a fully kitted out Roman centurion standing at the foot of their bed one night. Apparently, Water Street was the site of the Roman brothel, so goodness knows what this spectre's intentions were! I also understand that a solitary spectral Roman legionary has been seen far away from the ruined fort at Hothersall Hall, which he apparently visits in veneration of a long-deceased commander who is buried somewhere in the grounds.

The White Bull public house is haunted by the ghost of a long-dead drayman, with one of the upstairs rooms – currently used as an office – being described as uncomfortable, as though someone were stood in the room with you, looking at you. The pub's front is supported by four Romanesque columns. Out along the banks of the Ribble, the hilly land between the two bunches of woodland called Parsonage Wood

Roman-era ghosts were seen at Ribchester's church.

and Red Bank is haunted by the ghost of a man called Thomas Dewhurst. Apparently this person lost his life aged fifty-nine in the late eighteenth century when he drowned in marl pits, known as the Double Pits; his grave can be found at the church.

All in all, Ribchester is a fascinating and picturesque place; and as Katie told me, 'That's just the half of it! I could talk all day about the ghosts we have round here!'

Heskin Hall

Heskin Hall, a fine example of Tudor architecture south of Eccleston dating to *c.* 1548, was last occupied in the 1960s by Lord and Lady Lilford; although the hall serves multiple commercial functions these days (wedding venue, conference venue, Shakespeare on the lawn etc), it is still said that a phantom White Lady haunts the Scarlet Room, and has done for generations. I have been told that this lady's name was, in life, Matilda, and she was strung up and hanged from a beam at the hall upon the denouncement of a cowardly priest found hiding there by some of Cromwell's soldiers during the Civil War. The priest was made to participate in the hanging to prove that he had converted to Protestantism, and as such Catholics like Matilda were now his enemies. However, afterwards, the soldiers themselves executed the priest by lynching him from the same beam – and because of this both Matilda and the priest haunted the hall.

Intrigued, I contacted Heskin, and was informed by Lynn Harrison, of Heskin Hall Antiques, a solid oak furniture and soft furnishings retailer that operates from the hall, of the strange experiences that have recently been reported here. In Lynn's own words,

Heskin Hall.

There are numerous reports of sightings and events before we came here. When the Lilfords had it in the 1960s, guests left during the night saying they couldn't stand it, and we have spoken to Lady Lilford's daughters who assure us they would rather not sleep here ever again! Those who worked here when the place was a training establishment talk of pans flying round the kitchen and sightings of a female in the courtyard. For ourselves we seem to live relatively happy with whatever it is. Things get moved and disappear for months on end (even a chair on one occasion) but sightings are rare. We have nevertheless had a few reports from visitors claiming to have seen a 'woman in period clothing'. Some have been visibly shocked by the experience, others determinedly refuse to believe we do not have an 'actress' in our employ.

Echoes of the Past at Lancaster Castle

Lancaster, the county town, takes its name from the Roman *castrum*, or camp, built beside the River Lune on this site. As would benefit such an imposing place, the medieval castle, with its Norman keep on Castle Hill, dominates the old town and its impressive history is testament to the pivotal role it has played in the county's politics and drama. The castle itself stands on the site of a Roman military station. In 1102 the Normans replaced the Saxon wooden tower here, and this in turn was refortified by King John.

John of Gaunt, Duke of Lancaster and father of King Henry IV, enlarged the castle and Elizabeth I added fortifications against the Spanish Armada. In fact, the keep, 78 feet high with walls 10 feet thick, is surmounted by a beacon tower known as John of Gaunt's Chair, from which the Armada's approach was signalled. The castle was a parliamentary stronghold during the Civil War, and George Fox, founder of the Friends (Quakers) was imprisoned here in 1663–65. Catholic martyrs were also interred here (Francis Farrington was 'butchered alive' in 1646), and the witches of Pendle had been incarcerated here earlier that century. The town gave lodging to Bonnie Prince Charlie and his army on their ill-fated march south during the Jacobite rebellion of 1745, and there was intrigue here in 1746 following the death of a Franciscan, F. Germanus Helmes, who attained the status of martyr. Helmes, a lecturer in Catholic philosophy at Douay, was arrested amid a hostile public reaction to his visit to England and consigned to Lancaster Castle, loaded with chains, where after about four months he died – 'not without suspicion of poison administered to him by a wicked woman'. Besides being a prison, Crown Court opened there in 1796, with the fortress also boasting a nearby Judge's Lodgings to facilitate visiting Assize Court judges.

In the later Georgian era, the castle saw much death and despair. Prior to 1800, executions took place 'on the Moor, a little above the place where Christ Church now stands, and was well known as "Gallows Hill"'. In the seventeen years leading up to this, forty-eight persons were conveyed, seated in their own coffins, in carts from the gaol to the place of execution close to Williamson Park. According to *Lancaster Records*, a collection of snippets from the *Gazette*, between 1801 and 1835, when executions started taking place behind the castle, 127 persons were launched into oblivion for a variety of crimes. This place became known as 'Hanging Corner', in an angle between the Round Tower and the wall: sometimes a number of criminals were 'turned off' in a grim multiple hanging. Eleven were supposedly hanged in 1800, and nine in 1817, when 'so badly were the arrangements conducted that the suspended men struggled fearfully, and were almost on the top of each other'. The bodies of these nine are believed to be buried in the grounds beneath two canons taken at Sebastopol. The last public execution took place in 1865, and last execution here occurred in 1910.

In 1891, historian Cross Fleury noted that the castle had a strange atmosphere all of its own; 'In the "Drop-Room" some very harrowing stories are heard' and it was possible to conjure up the 'ghosts of the coffins of the condemned' that were laid out on a massive inside window sill. Fleury was talking metaphorically, but rumours abound here of actual ghosts – not surprisingly, given the castle's impressive history. It is said that a young girl, accompanied by a middle-aged woman on one occasion and by a haggard old crone on another, has been glimpsed by the cells. It might be speculated that this is something to do with the three generations of 'witches' incarcerated here in 1612, although perhaps they are the pathetic shades of a later generation. In the year 1818 the Dungeon Tower, that some supposed to be 1,500 years old, was taken down and that same year the foundation stone was laid for the Penitentiary for female prisoners. If anyone should haunt the castle it is one of these; the wretched Jane Scott, for instance, who was wheeled out to the scaffold on a converted office chair fitted with armrests and castors, she having become too emaciated to be capable of walking. Jane was only eighteen when she was hanged on 22 March 1828, for killing her

This framed aerial view of Lancaster can be found in the Shire Hall.

mother in Preston, and after death her body was taken back to the town. Until the late nineteenth century her skeleton could be viewed at a house in Walker Street, Preston. Tradition also says that the greyish shade of a monkish figure has been observed, perhaps having something to do with the hanging of one of John Paslew's followers at Lancaster, a number of whom were convicted of high treason in 1537. The other often repeated phenomenon here is the mysterious shoving, or pushing, of visitors by no discernible source.

The castle's haunted heritage is now very well known. Many of the stories about the place can be ascribed to folklore; legends of the stonework 'bleeding' can no doubt be put down to a natural phenomenon. But others here are strangely unnerving. The *Lancashire Evening Post* of 8 May 2007 reported on some of the well known tales, quoting the castle tour guide as saying, 'The ghost of a lady is said to haunt Hadrian's Tower, where the castle museum is now based. A woman's figure has been seen by members of staff floating high above the floor – at a level where the floor probably would have been centuries ago. The appearance has been likened to a bubble bursting, one minute she is there, the next she pops out of sight.' There has also been spotted by a security officer a 'young girl in a blue dress and with Victorian hair ringlets'.

The Shire Hall, a magnificent late eighteenth-century addition, contains over 600 heraldic shields. The Manager here neatly summed up the mysterious atmosphere for me,

There are some interesting stories from that side of the wall (i.e. the prison) – ghostly carriages complete with hoof beats for example, and a cell where the bad boys were put to frighten them into behaving better! I think you'd need to be a person with very little empathy or imagination not to feel the weight of history here, and I doubt that there is a single member of the guiding team who hasn't experienced something that they couldn't explain. I saw something myself here late one evening that still puzzles me, and people on tours have claimed to experience the odd occurrence as well.

Incidentally, in 1811 the Corporation of Lancaster gave to the county magistrates a piece of land on the outskirts of the town for the purposes of erecting an asylum – the Lancaster Moor County Asylum. Work began in 1813, and three years later 'nurses', or 'female keepers' were advertised to staff the asylum: some of its first inmates were transferred from Lancaster Castle. Although the move bore the façade of humanity, in truth it was a double-edged sword, for conditions at the new asylum were far from perfect. Suicide was not unknown, and a disturbed inmate murdered a keeper named Joseph Coates on 1 July 1835. In 1832, an outbreak of cholera killed 94\ of the 354 inmates. The asylum closed in 1999, its remaining portions (visible from Stone Row Head) now being said to echo to the sounds of disturbed, soulless wailing and manic laughter on gloomy winter nights.

(NB At the time of writing, HMP Lancaster has just been closed, with all the prisoners having left by the end of March 2011, bringing another era at Lancaster Castle to a close. There are high hopes that the relaxation of movement restrictions for tourists will increase visitors.)

The Theatrical World

No theatre in Britain is complete without its age-old rituals that superstition says must be performed to ensure a good show. Sometimes these superstitions extend to the appearance of ghosts, their observation either being seen as heralding a good performance, or a disastrous flop. Most recently, the *Burnley Express* on 2 July 2010 published a photograph taken of the partially demolished Palace Theatre in Nelson on a Sunday morning late in June. Despite there being no one around, the image taken later showed what appeared to be a hooded figure in the gods of the theatre, the puzzled photographer being reported as saying, 'I have no idea what it is and I could not see it when I took the photo. Many theatres have their ghosts and it makes you think whether the Palace has one.'

Many theatres do indeed have their ghosts. There is a famous haunting at the Grand Theatre, on St Leonards Gate, Lancaster. The theatre dates back to 1782, and reportedly abounds with paranormal activity. Overnight ghost hunts here are not unknown, and urban legend has it that the place is haunted by the ghost of the Georgian tragedienne Sarah Siddons (*d.* 1831), who played Lady Macbeth there in 1795. Terence W. Whitaker's *Lancashire's Ghosts and Legends* (1980) tells the story of one encounter: a nightwatchman claimed to have seen 'an elderly woman floating down the aisle towards him. She appeared to be cut off, just below the ankles, and she

had a smile on her face. Gliding past the row of seats where he sat, she disappeared through a door at the far end of the theatre, near the stage.' It is even said that, on one occasion, a visitor actually stood up and walked out of a performance because the lady sitting in the seat in front of her was semi-transparent! However, these ghosts are not conclusively linked to Sarah Siddons' alleged presence, and may be entirely different ghostly ladies. The place abounds with rumours of spring-loaded seats being seen in the 'down' position, as though someone invisible were sat in them, and Ellie Singleton, the Theatre Manager, told me, 'We have loads of paranormal nights held at the Grand and it is a hive of activity. Our Duty Manager goes on all of them and has had lots of experiences and he was a non-believer!' Most recently, the *Lancaster Guardian* (5 March 2009) carried an interview with an eighty-five-year-old lady who had fled her job as an usherette here just before the Second World War. This was on account of seeing a ghost. 'She was a bonny girl with a lovely figure wearing a purple veil over her head and down her back. She turned round, smiled at me and floated down the stairs', according to the newspaper report.

The Royal Court Theatre on Rochdale Road, Bacup, also has a resident spook, called 'Norah'. There are stories that performers, stage crew, staff and the visiting public have glimpsed this shadowy spectre on numerous occasions; on 3 June 2008 *The Sun* published a photograph taken by a member of a regional paranormal concern, the Paranormal Activity Research Team (PART) in March that appeared to show Norah taking a seat just before a performance by the Second Rossendale Scout Band. Surrounded by oblivious patrons, there is visible the blurred form of an elderly woman in black stood in the stalls, who seems to have bunched grey hair and a white collar. Something that looks like a handbag swings beneath her arm, and she is opaque, fading away at the waist. It is implied in the report that this person was not visible at the time, and was first seen when the image was downloaded onto a PC.

Maybe all of Lancashire's theatres have a ghost? I remember hearing some time ago that Preston's Charter Theatre on Lancaster Road was supposed to be haunted by an electrician or labourer who fell from a gantry that ran along the wall to the left of the stage. Apparently he had died in the accident, and I seem to recall that this was within recent living memory; at any rate the gantry, high up in the gods, echoed afterwards with a clanking as though someone in heavy boots was making their way along it in the gloom of the upper levels. I also remember hearing that a member of the theatre's staff had physically moved out of the way of this phenomenon, convinced a presence was making its way past.

At the Preston Playhouse theatre building on Market Street West in Preston – 'the home of amateur theatre since 1949' – there are (or were) modern ghosts. The building was turned into a theatre in the aftermath of the Second World War, thanks to the patronage of many supportive parties including the Preston Drama Club, and now prides itself as the showcase for local amateur talent displayed in productions by drama societies and dance groups. Its modern facilities are also available to any interested parties to hire these days; however, in a former life the building is believed to have been a meeting house for the Religious Society of Friends, with a burial ground on adjoining land. According to theatre lore, there were numerous ghosts in evidence even before the building was transformed in 1949, and for the cleaning lady here, Alison Brown,

it became a question of hearing strange sounds in the empty place so frequently that she even began to greet them upon her arrival at work. She found the presences (the suggestion is that there was more than one entity here) benign, and non-threatening; however, to her dismay the presences seem to have been effectively exorcised following an investigation by a regional paranormal concern in 2006. The group held a séance, which was apparently very eventful, experiencing a number of strange incidents and making contact with a ghost called 'Albert' who appeared to be hunting for his two lost children. But for Alison, the real mystery is where these spectres went following the séance, for she has not caught sight nor sound of anything strange since then and believes the investigation may have caused the ghosts to depart the building. I was also told that 'We have had no recent experiences reported': so perhaps on this occasion we have actually seen the 'death' of a ghost?

Who is the Lady of the Park Hill Barn?

It might be expected that the ghost that haunts the Pendle Heritage Centre at Barrowford might in some way be linked to the events of 1612 – a story of which we shall learn more later, if indeed there be anybody in this part of Lancashire who is not at least

Park Hill Barn, Barrowford.

partially familiar with those strange events. The Centre is set in a range of beautifully restored farm buildings dating to the 1660s, and its museum shows the visitor all kinds of memorabilia concerning the saga of the witches, as well as the development of the house and its owners.

However, the ghost concerns the art gallery housed in the sympathetically restored Park Hill Barn, which stands on the same site as the Heritage Centre. Frank Walsh, who is a Friend of Pendle Heritage Centre, kindly told me a story concerning a gentleman (a friend of his) who was fortunate enough to twice see the same spirit after arriving at Park Hill to pick up his wife, who had been working weekends.

Built in the late seventeenth century, the barn has a two-floor extension with a small window on the second floor. At the time, the building was locked and alarmed. Yet the man concerned glimpsed a face at this window: that of a woman wearing some kind of headgear, possibly a serving girl's mob cap. Hearing of this, the following week Frank Walsh investigated the barn himself but could find no explanation.

However, the second time the ghost was seen (by the same gentleman), it was more dramatic. Frank tells me that his friend saw a woman at ground level, who appeared out of nowhere 'wearing a black dress with white apron, again with a mob cap. She moved from left to right down the west facing wall of the barn before vanishing.'

Frank considers his friend a level-headed person who would not make up stories, and considers the matter unexplained, and probably supernatural.

'As if Someone had had a Fit …'

I was told this story in the aftermath of the severe winter of December 2010, and although it came to me second-hand I still find it exceptionally creepy. 'A friend' of the person who told me this resides just outside of Blackburn, and for some time had suffered an annoyance at around three in the morning, when three feeble knocks at his front door had awoken him. This was not a nightly occurrence, but once every two to three weeks; and although the sounds woke the man up, he never roused himself to find out who it was since the sounds never repeated themselves. This had happened some three times by late 2010, and happened again during the heavy snowfall of December.

However, on this occasion, the following morning the man concerned was shocked to find a line of footsteps leading up to his front door and away again through the snow: clearly, someone had walked up to his front door in the night and knocked three times. The imprints were clear, but the strangest thing was that outside his front door the footprints were a confusing mass, as though someone had walked to and fro outside the door, repeatedly over their own footprints, back and forth as though they had been in a state of high agitation. In the words of my informant, 'It looked as though someone had had a fit outside the front door' before calmly walking away again through the snow.

And the punchline to this? The owner of the house followed the line of footprints in the snow as they left his front door … they vanished into nothing on the threshold of his property.

Ghosts of Today

These days, very little has changed when it comes to ghosts: people still claim to see them, hear them and know of them. A last selection of well-attested ghostly stories that have featured heavily in the local media, and sometimes the national media, goes to show just how far-reaching the phenomenon of 'ghosts' still is in the modern era.

At the Queen's Lancashire Regiment Museum on the site of Fulwood Barracks, off Watling Street Road on the northern fringes of Preston, they tell me the Officer's Mess has been haunted by a nonedescript 'presence' for some fifty years now. This presence is believed to be the spirit of a Preston private of Irish descent, Patrick McCaffrey, who on 19 September 1861 assassinated two of his officers – his colonel, Colonel Crofton, and his adjutant, Captain Hanham. Both victims were men of distinguished service, and heirs to baronetcies. McCaffrey had earlier been sentenced to fourteen days confinement to barracks for not dealing with some young vagrants who were sneaking into the barrack yard: his response was to clean his rifle with an oily rag and then kneel down at the window of his room and, sniper-like, shoot at both officers in the barrack square. Private McCaffrey, who offered no further resistance, was convicted of murder at Liverpool Assizes and executed.

However, an article in the *Lancashire Telegraph* highlights the fact that anywhere can be haunted, even the relatively modern Blackburn Telephone Exchange building. The newspaper reported on 2 April 2002 that a cleaning lady had spotted a ghost by the lift on the fourth floor of this otherwise-nondescript building on Jubilee Street, describing her thus; 'She had blondish mousy hair, with sunken eyes and was grey-looking in the face. She turned to look at me with a frown, and then shot into the lift really fast.' The cleaning lady went over to the lift doors and found them closed however, and the lift not in use at that moment. Pushing the button to open the lift doors, she found the compartment totally empty; so it would seem the woman vanished through the closed lift doors! In cases like this, there really are no half-measures. Either the incident happened as claimed, and is, therefore, anecdotal evidence of the 'proof' of ghosts, or it did not. This event (which took place at lunchtime) reinforced the belief that the Exchange building had harboured one or more ghosts since the 1960s, when it was built upon the site of the demolished Grand Theatre.

In 2003 there was correspondence among the readers of *Fortean Times* magazine concerning a red telephone box in Burnley that apparently, gave out an eerie, sinister message. A contributor to *FT176* remembered the story doing the rounds in childhood from the 1980s, and that there were two 'haunted' red telephone boxes. One was on Dalton Street, the other at the end of Harold Street; if a coin was pushed into the slot and 20 20 20 20 dialled, a terrifying, crackly voice at the other end said 'Help me, Susie's dying …' This message of doom that sent children scattering in all directions appears to be an urban legend; I have heard virtually the same story told almost word-for-word as happening in Northampton, although it does make you wonder what it might have all been about.

The *Observer* reported on 30 October 2003 that the modern Hynd Brook House on Dale Street, Accrington, presently offering extra care housing for those requiring assisted living, had a ghost. The place dates to 1993; yet many residents claim to have

glimpsed a man in a brown suit so frequently that he has been given the nickname of 'Albert.' The manageress here explained at the time, 'He isn't malevolent, he seems friendly. It is quite spooky, but it sounds like you catch him in the corner of your eye and then he's gone.'

A most impressive modern account generated a lot of excited comment following its initial reporting in the *Craven Herald and Pioneer* on 23 January 2004. A retired policewoman and her partner told the newspaper that not long before they had been driving towards Barnoldswick at 11.20 a.m. when near Rolls Royce's Bankfield factory both saw a strange aeroplane sweeping silently out of the mist to their right. They described it as a 'huge, grey-coloured plane – possibly a Lancaster bomber-type with four propellers' – that flew so low they feared it would hit the roofs of nearby houses, or even their own car. However, as they drove past and looked back, they saw that the bomber had simply vanished back into the mist, without trace and without noise. The mystery of this sighting, which prompted other likewise correspondence in the *Herald*, has (at the time of writing) not been explained.

And if this seems strange, consider the story published in the *Ormskirk, Maghull & Skelmersdale Advertiser* (30 July 1998), reporting the search four days earlier for a one-man microlight aircraft that witnesses swore they saw nosedive into fields between Bickerstaffe and Rainford. Smoke and flames billowed from the stricken aircraft, but despite an intensive two-hour search by the emergency services, no wreckage was found, leaving the police, fire brigade and paramedics scratching their heads as to exactly what it was that was seen plummeting near the Rainford bypass.

In 2004 the publication of a book, *Wall of Silence: the Peculiar Murder of Jim Dawson* by J. L. Cobban, revived interest in the murder, on 18 March 1934, of Jim Dawson. Mr Dawson was fatally wounded in a shooting while walking to his farm from the Edisford Bridge public house in the tiny hamlet of Bashall Eaves, by the Hodder west of Clitheroe. Dawson had been slain by a huge bullet that had lodged near his liver, the bullet having apparently been specially fashioned and cut from a piece of steel on a lathe. Ms Cobban told the *Bolton News* that 'I do believe that some villagers knew who the murderer was and there are rumours of a deathbed confession', although in truth the police came up against a wall of silence so impenetrable that even at the time Bashall Eaves was coined 'the village that wouldn't talk' by officers. Jim's dog, Shep, was shot dead just days before his own murder, but the crime was never solved and the reason for his deadly persecution remained an intangible mystery.

Unfortunately, folklore has a tendency to link ghosts to such crimes; this is the case, for instance, with Kitty Breaks, who was fatally shot on the sand dunes near Blackpool in 1919 by a man named Holt who had been invalided out of the army. Her spirit allegedly still wanders the sands of St Anne's. According to *A Ghost Hunter's Road Book* (1968) by John Harries, a ghost seen at Bashall Eaves was supposedly that of Jim Dawson: 'There are … stories of a squat figure with a gaping wound showing through a tattered coat as it passes through the hedge near the farm, sometimes bending down, vainly seeking for the weapon or assailant who used it.'

Chorley Little Theatre

Like its old halls, there must be something conducive to Lancashire theatres that encourages collections of ghosts – for Chorley Little Theatre on Dole Lane, Chorley, boasts not one but five spectres!

Chorley Little Theatre began life in 1910, as one of this town's first electric cinemas, built upon the site of a row of houses in the days when this market town's skyline was still dominated by factory chimneys and the cotton industry. It has been owned and operated by volunteers from Chorley Amateur Dramatic and Operatic Society (CADOS) since 1960, and underwent refurbishment on its 100-year anniversary in 2010.

In May 2011 I was told of these numerous ghosts by theatre chairman Ian Robinson. The oldest ones are seemingly a 'Victorian Lady and her son' who haunt the auditorium, walking down the centre aisle and along the front of the stage. It is surmised that this pair date to pre-1910, given their appearance.

Some years ago a volunteer worker, building a set on the stage, suddenly observed a strange man walking down the Dole Lane side of the auditorium. When the volunteer attempted to find this man, he had vanished, but it appears that this ghost wears a 1950s style suit and a hat. This spirit is linked to events in 2009 during the refurbishment when builders would find their things moved overnight; one even filmed the auditorium door opening by itself: this would be the door that the man in the suit approaches in his wanderings!

A former actress is believed also to haunt the building, but the most well known ghost is 'Fred the Technician'. As Ian explained,

(Fred) is frequently spotted wandering the back corridor of the building, along from the Director's Box, to the sound desk, and the lighting/projection room. Our current, living, technicians have taken to leaving the doors open while up there or else Fred will open them as he wanders through (they also play loud music to hide the footsteps). His silhouette is often seen by people looking up from the audience or the stage, and the latest sighting was just three weeks ago during the pre-production of *An Inspector Calls*

All this is certainly food for thought for those who enjoy these plays, or watch the contemporary comedy of Jenny Éclair, Richard Herring, Russell Howard, etc., – for a ghost may even be among them, according to Ian 'There's also a presence in one of the seats, who generally seems to enjoy the shows!'

Photographing the Paranormal

New ghostly mysteries are being discovered, or rediscovered, all the time. At the time of writing, I have been kindly passed a photograph by the editor of a regional website, a singular image purporting to show a true ghost. The image is black and white, and shows a line-up of some ten men who are presumably workers at Fleetwood Fish

The Fleetwood 'ghost'.

Market. The photograph seems to date to the early Edwardian era (that is to say the early twentieth century), and boxes of produce stamped Pratt Ellis & C from Liverpool are piled before the men. However, to the right and slightly apart from the group stands a cadaverous-looking and opaque figure, in cloth cap and scarf, who fades away at the waste. His head is bent slightly, and he seems to be looking – like the rest – at the photographer, yet he is clearly transparent: shutters to the rear can be seen 'through' him. Apparently he bore a resemblance to a packer who had died about a year earlier. The photograph is the same one mentioned in the *Blackpool Gazette* (1 April 2008) as having been validated by Sir Arthur Conan Doyle upon its original publication in 1928.

Another anomalous photograph spooked the readers of the *Lancashire Evening Post* (03 December 2009) when it speculated on a sinister photograph taken during a birthday party, apparently depicting a wraith behind two smiling women at the Red Lion in Wheelton. The figure appears terrifying at first glance: a woman wrapped in a white winding sheet or shroud, with the hood displaying a shadowy cavity where the face ought to be. Worse, the figure's torso seems to be smeared with blood! However, an expert suggested plausible reasons for the image, and it is a fundamentally strange contradiction that even when we have 'proof' of the paranormal we are still not sure of its reality. The *Post* had scooped another ghostly image in January 2008, when it reported the terror of a couple of 'orb spotters' – that is to say, non-professional ghost hunters – who encountered a ghost in an old graveyard. Orbs are controversial; they crop up on many photographs (I have myself snapped them at 'haunted' sites in Norfolk and Cheddar), and to some they represent the *soul* of a long-deceased person,

as opposed to its ghost. To others they represent the first manifestations of 'new' ghosts, and to yet others they are merely dust particles, reflections, insects and so on. However, the incident that occurred in St Saviour's graveyard, Bamber Bridge, at about 10 p.m., is extremely thought provoking nonetheless. As one of those present was reported by the *Post* as saying, 'We went to the old graveyard. This full figure just stood up in front of us. We managed to get the face, then we just ran. We have a picture of it forming from the first mist. It's like a person climbing out of a grave. Then, in the next picture, it's a full thing ... it's a face. It was too close to us to get the full thing.'

As the pair fled back to their car, they were aware of 'three figures in the mist with orbs around them'. As if a graveyard wasn't unnerving enough, even without the shades of the dead chasing you out the place ...

The Phenomenon of Ghosts

And so it goes on. Currently attracting the attention of ghost hunters and the curious alike, plus much excited blogging and tweeting, is the disused stretch of subterranean railway tunnel ('Miley Tunnel') between the University and St Paul's Road, Preston. Although inaccessible for obvious safety reasons, the entrance to the tunnel is just as you'd expect: a gaping circular brickwork cavity, strewn with gravel, shopping trolleys and other debris, with a grassy railway line disappearing into the gloomy nothingness of the tunnel. Exactly the sort of place where children dare each other to enter, and then get so far before a sudden movement in the gloom forces them to run back out into daylight. The tunnel is allegedly a mile long, hence its nickname, and in places shafts of sunlight filter into the gloom where the brickwork ceiling gives way to immense sturdy overhead beams. Water drips and climbing weeds cling to the walled interior near the parts of the tunnel that catch the sunlight. In this claustrophobic atmosphere, Preston urban legend says that a ghostly little girl wanders about as though lost, and there is also said to be a thin-looking Grey Lady who moves along the tracks. The little girl is believed to be the ghost of fifteen-year-old Margaret Banks, who died in 1866 in unclear circumstances at the station at Deepdale Bridge on Deepdale Road. According to some accounts, she playfully grasped the hand of a passenger on board a train as it left the station, but he held on to her, dragging her along the platform until she slipped beneath the carriage and was killed under the wheels. Although some say in Preston that the passenger was executed for murder, this is not true; the trial, in fact, collapsed. These days, groups of young people, torches in hand, and against all good sense, cautiously make their way into Miley Tunnel to see if they can see these ghosts.

It is clear that the phenomenon of ghosts is a very difficult – nigh impossible – one to categorise definitively, suffice to say that we have certain types of ghosts that can be pigeonholed, if not explained – tape-recording type manifestations and poltergeists, for example. Concerning poltergeists, they do seem to be the modern incarnation of dobbies, or house boggarts, so does this lend the phenomenon a degree of credibility? Or are poltergeists ghosts at all? Some have it that they are residual, psychic energy left behind in a house where terrible or traumatic events occurred, while others say that they are some kind of spiritual manifestation trying to 'get through' to humans in the

only way they are able to, perhaps using susceptible young people as a conduit. Some in fact believe that it is such people themselves (mainly adolescents) who subconsciously create the psychic energy, and it is not a spiritual phenomenon at all, although in some instances we have seen that poltergeist activity is sometimes accompanied by the manifestations of strange phantom figures.

Whatever the explanations are, they are currently, perhaps tantalisingly, out of our sphere of understanding. It may be that these strange and often terrifying manifestations are fleeting glimpses through the gap in the curtain, evidences of another spiritual dimension which the living have hardly begun to explore even barely competently. However, one thing is for sure: such is the Lancashire public's fascination with ghosts of all types that the phenomenon will be studied, reported and speculated on until it is either explained to the amazement of us all as being true, or is finally dismissed as utter, superstitious nonsense. Or perhaps we will never have an explanation!!

As a traditional Colne saying observes, 'All houses wherein men have died are haunted houses.' One is left with the feeling that this chapter could continue indefinitely. But here we must leave the realm of boggarts, ghosts and poltergeists and explore other dimensions of the paranormal in Lancashire: its witches, demons, cryptic creatures of every kind and mysterious airborne phenomena.

Preston: England's newest city is nonetheless an ancient settlement and has many ghosts.

PART II

LANCASHIRE'S MYSTERIOUS REALM

Introduction

In this chapter we explore all outside the realm of ghosts that is mysterious, paranormal and downright inexplicable in the county of Lancashire.

Whatever one makes of the following story, no work of this nature on Lancashire's supernatural heritage (or, indeed, any book on Lancashire history) can ignore the saga of the Pendle Witches, which although well known still deserves a mention due to its utter strangeness and frightening accusations of demonic worship. The story is outlined in a 1613 tract by Thomas Potts, *The Wonderful Discoverie of Witches in the County of Lancaster*, and even today makes for weird and disturbing reading.

It is in the shadow of Pendle Hill that the famous events occurred. Pendle Hill, the western boundary of the Forest of Pendle, is an enormous landmark, extending in a ridge of some 7 miles from north-east to south-west, its highest elevation being 557 metres above sea level. Its sides are verdant, although its summit becomes moor, and it commands excellent views of Lancaster and the Irish Sea. Like many giant hills, approaching bad weather can be read by the envelopment of its summit in grey cloud. On its eastern declivity formerly stood Malkin Tower, the notorious rendezvous for generations of witches, now thankfully long gone, although its legacy is remembered in the name of Malkin Tower Farm. The tower is believed to have been situated on a brow a little elevated above this nineteenth-century farm building. Dobson's *Rambles by the Ribble* (1864) notes of the place, 'The site of the house or cottage is distinctly traceable, and fragments of the plaster are yet to be found embedded in the boundary wall of the field. The old road to *Gisburne* ran almost close to it.' Malkin is believed to have been the old North Country word for 'hare', into which witches were believed to be able to transform. (The tower seen hereabouts today is the later folly, Blacko Tower.)

Out here – in the right conditions – it is easier to believe old stories like the one about the Devil (in his fury) taking a gigantic stride from Hameldon Hill to the ruins of Cragg's Farm near Sabden, leaving the marks of his club-footed presence on one of the stones at Deerstones on Cragg's Dole. His next stride took him to Apronfull Hill, so called in the belief that he carried a number of stones in his apron that he periodically hurled at Clitheroe Castle. One (supposedly) punched the almighty hole that we see in the castle today; some say that the stone actually fell short, landing on the ground just

Hole in Clitheroe Castle.

outside Pendleton – it can still be found bearing his fingerprints. At any rate, his apron strings snapped at this point, and the stones tumbled to the ground where they lie to this day on the hill.

However, it is the Devil's interference in human affairs that has left its lasting mark on the psyche of this part of Lancashire. In the year 1612 twenty persons dwelling in this neighbourhood were committed to Lancaster gaol on the accusation of witchcraft, in two sensational cases that followed hot on the heels of one another. The first incident concerned the arrest of twelve people, all but two of them women. The most notorious of those accused was Elizabeth Southerne, a widow aged eighty or more who commonly went by the name 'Old Demdike' and was believed to have been a witch for decades. Potts tells us that she dwelt in the Forest of Pendle, a vast place fit for her profession, where she brought up her own children, instructed her grandchildren and acted as an infernal agent of the Devil in those parts. Prior to the assizes that autumn, Old Demdike – worn out by age and torment – died in prison following her arrest, and it appears that she was originally committed before some of the others. This is supposed from the fact that others among those arraigned were charged with having been present at a meeting at Malkin Tower on Good Friday, 1612, whereby a plot was entered into to deliver Old Demdike to safety by blowing up Lancaster Castle and assassinating the governor, Mr McCovell.

What had apparently set all this in motion was an incident on 18 March, an unfortunate circumstance that illustrates just how frighteningly quickly events of this nature could slide out of control. On that day Alizon Device, Demdike's granddaughter, had an altercation with a pedlar named John Law on the road near Colne, during

which she cursed him for refusing to give her some pins. Some minutes later Law collapsed, the victim of a stroke that both he and Alizon (apparently) sincerely believed had been brought about by the curse she had uttered. Law lived just long enough to testify against his antagonist in court, with Potts, the clerk, recording that 'his eyes and face (were) deformed, his speech not well to bee understood, his legges starke lame, his body able to indure no travel'.

Some two weeks after Alizon's argument with John Law she found herself dragged before a local magistrate named Roger Nowell, alongside her mother Elizabeth (Old Demdike's daughter) and imbecilic brother James Device. Alizon, in admitting her guilt before Nowell, also implicated others, and while there is suspicion at the ease with which the magistrate obtained these 'confessions', the whole affair began to unravel. Following their arrests, one by one the accused were carted off to Lancaster on a gloomy final journey through the Trough of Bowland.

Of particular interest are the descriptions of the Devil that we are presented with, obtained during the interrogations. According to Dame Demdike's own confession, sometime *c.* 1592 she was coming home from begging when she was confronted near 'unto a Stonepit in Gouldshey' (possibly Faughs Delph quarry) by a spirit or Devil in the likeness of a boy. This personage wore a strange coat, one half of the garment black and the other brown, and he told Demdike to stay where she was, declaring that if she would give him her soul then she could have anything she wished for. The spirit declared his name to be Tibb, and over the next five years or so appeared before Demdike at various times 'about *Day-light* Gate' pestering the old woman and demanding what she would have him do. In the end Tibb appeared 'in the likeness of a browne dogge' and – despite the fact that Demdike was slumbering with an infant in her lap at the time – scrabbled up onto her knee and proceeded to suck blood from under left arm. The old woman woke and yelled, 'Jesus, save my child!' whereupon the strange dog vanished into thin air. Although she spent some eight weeks in a stupefied terror, Demdike gradually took to using the help of Tibb to obtain revenge on the wealthier of her neighbours who refused her beggary or reneged on promises of payment for work.

Typical was the clan's vengeance on a Wheathead miller named Richard Baldwyn, who around Christmas 1611 fell into a row with the women over money, yelling at Old Demdike and her daughter Elizabeth, 'Get out of my ground, whores and witches, I will burn the one of you and hang the other!' Old Demdike, blind by this time and supported by her daughter, had retorted, 'I care not for thee, hang thyself!' When the miller was out of sight, Tibb appeared in the lane, goading the women, 'Revenge thee of him! Revenge thee either of him or his!' One of Baldwyn's children was among the sixteen people that the accused were believed to have murdered through a ritualistic practice of creating clay effigies and then burning, stabbing or destroying these likenesses. The victims consisted of men, women and children, and none were murdered by conventional methods, like stabbing or bludgeoning, but by 'devilish practices and hellish means'.

Allegations such as these horrified and terrified the region at the time, and roused the curiosity of the nation at large. It little needs to be said that these manifestations of Satan must have been sincerely believed in for any of the subsequent trials to have proceeded; truly this was an age when the common people knew that the Devil walked among them. It was simply something that was not questioned.

Ten of those so accused were found guilty. Demdike's poor daughter, Elizabeth Device (also known as 'Young Demdike' and cursed with a facial deformity whereby her left eye stood lower than her right and looked in an opposite direction), and granddaughter Alizon Device were condemned on the evidence of a child, nine years of age – this was Elizabeth's other daughter Jennet, in fact, who thus became a party to the death of her mother and sister. The wretched little girl declared that she had seen a spirit come to her mother in the form of a brown dog called Ball, who promised to kill two persons that Elizabeth Device had sworn against. Potts wrote how the woman impudently denied the accusation of her little girl.

Among the others accused were a second clan of witches, headed by a woman named Anne Whittle, alias 'Chattox', or 'Chatterbox.' Potts graphically describes her as a 'very old, withered, spent and decrepit creature; her sight almost gone'. She was allegedly a dangerous witch of long continuance, always opposite to her rival Old Demdike. Whom one favoured, the other detested, and Chattox was always ready to do harm to her neighbour's property and livestock in the Forest of Pendle. Her lips were forever chattering and talking, but no one could discern what she was saying, nor to whom. It is possible that the two rival clans fell into a bitter spiral of accusation and counter-accusation against each other. Such was their mutual hatred that even with the threat of punishment hanging over their own heads it was more important to see each other doomed than to try and preserve themselves. At any rate, crimes of murder and mischievous evils wrought by enchantments, charms and sorceries were laid at the door of both parties respectively. Again we learn that the Devil himself had tempted Chattox: around 1597 a spirit had appeared unto her in the form of something like 'a Christian man', whom had persuaded her to sell her soul to Satan, and this familiar she named Fancy. Also accused was Old Chattox's daughter, Anne Redferne.

Another of the accused, also tried on the evidence of the little girl, was Alice Nutter of Roughlee Hall, a person of considerable estate and mother to a family. She refused to confess any complicity, and pronounced the highest indignation at the proceedings; there has always been something of a question mark as to where she fitted in to this whole drama. She was described as wealthy, well educated and well connected in the area, yet she met the same fate as the rest, and there have been claims since that someone in authority during this chaotic and highly-charged atmosphere took the opportunity to see to it that she was removed, although for what political reason we shall now never know.

When the proceedings took place, one of the Justices – Sir Edward Bromley – was clearly touched with a certain amount of compassion upon pronouncing the sentences, although this had to be reined in, in view of the seriousness of the accusations. He declared, 'the blood of these innocent children, and others of his Majesty's subjects whom cruelly and barbarously you have murdered and cut off, cries unto the Lord for vengeance'.

Ten of the accused were sentenced to death: Elizabeth Device, her son and daughter, Old Chattox and her daughter, Alice Nutter, Katherine Hewytt (alias 'Mould-heels'), Jane Bulcock and her son, and Isobel Robey. Old Demdike had already died in gaol and Margaret Pearson of Padiham, though acquitted of murder, was sentenced to be pilloried in four market towns. On 20 August 1612 those condemned were marched

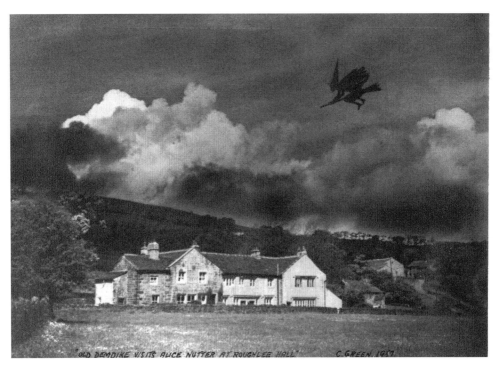

Old Demdike visits Alice Nutter at Roughlee, a depiction *c.* 1957. (Picture courtesy of the Lancashire Record Office.)

through the crowded streets of the assize town, pelted with rubbish and submitted to the catcalls and jeers of the surging crowds, all to be publicly hanged on the gallows about a mile outside the town: three generations of 'witches' executed for the vilification of the public good. As the ten bodies dangled on Gallows Hill, it must have been hoped that the storm clouds over Pendle were clearing.

Three days afterwards eight people from Samlesbury were similarly accused, three of them – Jennet and Ellen Bierly, and Jane Southworth – on the evidence of a young girl named Grace Sowerbutts. However, it was suspected that a Jesuit in the neighbourhood had influenced her in her claims, and thus the case fell apart under cross-examination before the same judge, Bromley. Grace Sowerbutts declared that she had been induced to join the sisterhood, and that their clan was met on occasion by 'four black things going upright and yet not like men in the face'. These strange entities would convey the women across the River Ribble and dance with them, she claimed. According to Grace, the witches had murdered the child of one Thomas Walshman by placing a nail in its navel; after the funeral they had taken spades and dug the corpse up, cannibalising some of the flesh and making an '*unxious* ointment' by boiling the bones. Sir Edward Bromley this time directed the accused to be acquitted: reason, it seems, could prevail, which makes the prior convictions of the previous ten on charges no more or less absurd seem somehow even stranger.

Thomas Potts, as clerk of the court throughout all this, was subsequently directed by Sir Edward Bromley and Sir James Altham to collect and publish the evidence connected

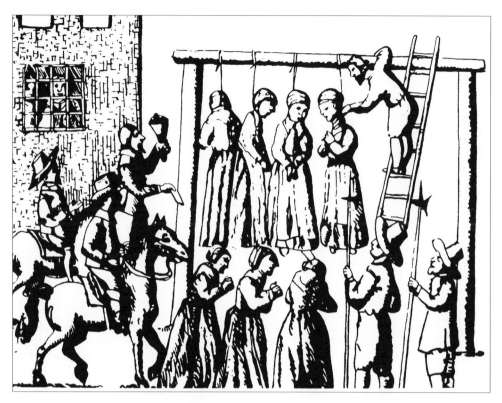

A seventeenth-century depiction of the execution, reproduced at Pendle Heritage Centre.

with the trials. Nowadays, it is difficult to say what the most disturbing dimension of the case is; the fact that a nine-year-old girl could be coaxed into condemning her own family, or the genuine terror of the supernatural that must have saturated the Forest of Pendle at the time. On the face of it the machinations of Satan seem less disturbing in principal than the behaviour of the human beings in this strange drama; but perhaps that was always the Devil's intention? The wretchedness of the accused – born victims – is more tragic than the evil they were supposed to have wrought; the idiotic James Device, for instance, was convicted principally on the evidence of his little sister of bewitching and killing Mrs Ann Towneley with the aid of a spirit familiar called Dandy. His infirmity was so great that he had to be held up in court to hear his sentence.

At any rate, it is an era that in many ways we just cannot understand: as Wallace Notestein observed in *History of English Witchcraft* (1911), 'It is quite impossible to grasp the social conditions, it is impossible to understand the opinions, fears and hopes of the men and women who lived in Elizabethan and Stuart England, without some knowledge of the part played in that age by witchcraft.'

It is often said that the Nutter tomb outside St Mary's, Newchurch in Pendle, belongs to Alice herself, although this is unlikely to be true as witches bodies were buried in unconsecrated ground. However, all seventeenth-century hysteria aside, Lancashire's legacy of witchcraft has left us with some of the most bizarre, surreal and demonically sinister accusations ever marketed as 'fact' before an astonished British public, and

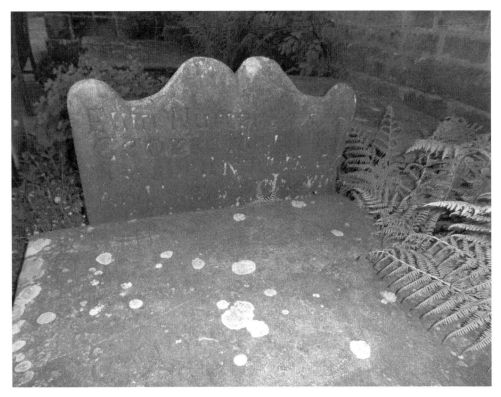

Some say this is Alice Nutter's final resting place.

this chapter is concerned in no small part with the overall weirdness of some of these stories, as well as instances when they say that the Devil himself walked in Lancashire.

It finally remains to be said that outside the arena of ghosts, the realm of the paranormal in modern Lancashire concerns in no small part UFOs, or to be more up to date, Unidentified Aerial Phenomena. But this chapter is also concerned with all the rest – all the mysteries that the cosmic joker has presented us with to keep us on our toes: strange stories of fantastic and mythical creatures, crypto-zoology, the saints whose feet have trod on Lancashire's soil, the gigantic panther-like beasts they say prowl the countryside, and falls of objects and artefacts from the skies … as well as everything phenomenal and inexplicable in between.

Our first segment leads us ever further away from the natural world, into the domain of the supernatural canine Skriker, and the twilight world of demons, witches and creatures that are not supposed to exist. Our second takes us into the realm of everything paranormal outside of human explanation … and even into the realms of beings from other worlds.

Cryptic Creatures of Every Kind

When the Devil Visited Lancashire

To the people of the near past, and undoubtedly in some quarters today, the Devil was very real threat. The Lancashire landscape was conducive to local suppositions that he frequently visited the county, as folklorist James Bowker noted in 1883. He wrote, 'surely it is in a gloomy gorge, through which forked lightenings flash and chase each other, and the thunder rolls and reverberates, or on a dark and lonesome moor, rather than upon the shady side of Pall Mall, one would expect to meet the Evil One.' Satan's influence was seen everywhere; it was well known in Lancashire that he enjoyed playing cards, one allegorical story telling of how oblivious card players would begin to suspect that they were gambling with the Devil himself due to his extraordinary run of good luck. Glimpses of a cloven foot beneath the gaming table would bring a swift end to the night's revelry.

Apparently, at one time the Devil took up residence in the village of Cockerham, terrifying the residents with the clanking of his chains and the awful smells of sulphur and brimstone that leaked into their houses through their windows at night. At length, however, he was tricked by a local schoolmaster, who possessed some knowledge of the art of necromancy and who agreed to trade his soul for Cockerham's freedom – on condition that Satan perform one task. This was to twist a rope made of sand and then wash it in the River Cocker without losing a single grain. 'Old Scrat' rose to the challenge, but found that the 'sand rope' disintegrated when he tried to wash it, and uttering a roar of rage he (in one stride) crossed Broad Fleet and Pilling Moss. To this day, they say that the Devil has not returned to Cockerham.

He wasn't always bested though. Bowker's *Goblin Tales of Lancashire* (1883) tells the story of a 'cunning man', or wizard, named Old Jeremiah, who lived in a cottage down a lane near Clitheroe, of whom it was said had entered into a pact with the Devil. Upon Jeremiah's death there were rumours that Satan had claimed him – passing labourers had found his cottage a burnt-out shell one morning, and the old wizard simply missing.

In the nineteenth century, according to Harland and Wilkinson, the possibility of conjuring up the Devil in order to sell one's soul for temporary gain was still a current

Foulridge Written Spell, protection against the Devil. (Copy in Pendle Heritage Centre.)

and popular fancy, it being believed that to recite the Lord's Prayer backwards was the most effective way to raise Satan from the depths of hell. A story current in Blackburn told how a pair of threshers had succeeded in raising him through the floor of their barn. Surprised and then terrified by their success, they bashed him over the head with flails until he had disappeared. There is a similar story said to have happened at Burnley Grammar School (presumably the original in the churchyard of St Peter's, as the story was current before the Bank Parade school buildings opened in the 1870s). Here the Devil was bashed and hit by boys armed with pokers and tongs as his head and shoulders materialised through a flagstone. This flagstone bore a strange, scorch-like black mark and was pointed out as evidence of the encounter until repairs were made in the mid-nineteenth century; the floor was boarded over and the flagstone disappeared. A third story says that the Devil was raised at Clitheroe Grammar School, when it was under the tutorage of the Revd Thomas Wilson between 1775 and 1813. A thunderous storm prompted the Reverend to hurry to the school on the suspicion that the students had been up to something; the boys had in fact raised the Devil, and – now terrified – were unable to get rid of him. Wilson defied the Devil to 'knit knote out of a strike of sand' (tie a knot with a handful of sand), which his Satanic majesty proved unable to. The storm abated and the Devil evaporated with a flash of fire and brimstone through a hearthstone that shattered into pieces, leaving the angry headmaster threatening to thrash the boys to identify the culprits. The hearthstone, whenever replaced, would shatter into pieces again, unaccountably.

Could any of this have a basis in fact? According to folklorist Jessica Lofthouse, in Holme Chapel churchyard could be found the grave of a man called Johnny o' the' Pastures, whom the people of Cliviger and Worsthorne believed had been a wizard. It was speculated that he had sold his soul to the Ould Lad – the Devil, who had appeared in the form of a dog on a path between Foxstones and Crow Holes. On the day this person died, there raged the worst storm in living memory. At one time tales like this would have made people shudder and cross themselves as they heard them.

Pendle Heritage Centre at Barrowford displays a singular example of a written spell or charm, found at Daubers in Foulridge in 1929 and dating to the seventeenth century. Cabbalistic and ciphered, part of it reads, '(If) any demon resides in or disturbs this person or this place or this beast, I adjure thee in the name of the Father, the Son and the Holy Ghost (to depart) without any disturbance, trouble or tumult whatsoever.' I can only wonder if this charm worked. As they say, the greatest trick the Devil has pulled lately is convincing the world he doesn't exist ... Perhaps not so very long ago he really did sit in the rocky eminence atop Blindhurst Fell called Nick's Chair, looking out across the panorama of the county and whiling away his time, wondering how he could bring Lancashire's people to ruination.

How Nicholas Gosford Outwitted the Devil

Cyrus Redding's 1842 *Itinerary* of the county notes that till lately there had stood by the Ribble, near Brungerley Bridge, a public house bearing a sign depicting the Devil riding a horse. Redding was told this by an eighty-year-old man who recalled seeing the pub in his younger days, and also the reason for the curious pub sign. According to the old man there had a long time ago lived in the vicinity of Clitheroe a tailor called Nicholas Gosford, an honest man but a little too fond of the ale. As a consequence his business did not do as well as it ought to have done, and he frequently found himself short on funds. One night at an inn he heard from a traveller of an incantation that would raise the Devil, although at the price of one's own soul, and so in desperation he waited for an opportune moment for his wife to leave the house so he could try this ritual.

Amazingly the rite worked, and Gosford found himself looking at the 'auld 'un' in his own home, accompanied by two imps. At first, his utter fear compelled him to deny that he wanted anything, but the Devil's rage terrified him even more and so he caved in and declared, 'Make me rich, my lord.' The devil complied and bellowed, 'I will give you three wishes, which must be the first that either you or your wife make after you meet; but for this you must give me your soul at the end of twenty years!' Nicholas was then tortured by the imps into signing a contract with his own blood.

The story enters the realms of farce; Nicholas kept his dreadful secret, and therefore when his wife idly stated, 'I wish we had a nice backstone of our own, for I can bake much better cakes than I can buy', of course this came true. Nicholas flew into a rage and wished that the stone oven would be smashed into a thousand pieces – this happened before their eyes. The following day Nicholas accidentally wished for some warm water to help him shave, and of course this was granted and there were no more wishes left.

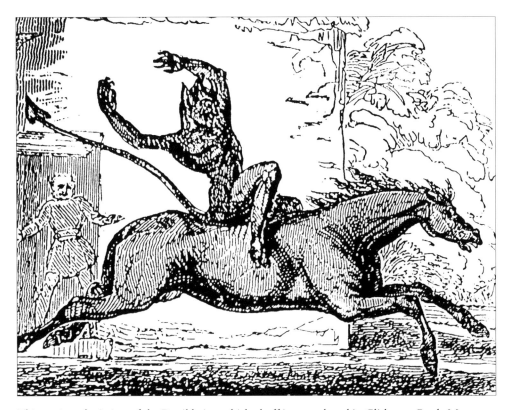

This ancient depiction of the Devil being whisked off is reproduced in Clitheroe Castle Museum.

Of course, there was no hiding from his wife what had happened now, so they took their problem to the Hermit of Pendle, a wise man who Nicholas had once saved from drowning. His only advice was to live as decent a life as possible in the hope of being spared, and to this end Nicholas set his mind to raising a family and being a good husband. Twenty years later the Devil appeared in the shop, waved the bond in Nicholas's face and demanded his soul.

Nicholas very quickly stated that he had been cheated, and the Devil relented, granting the tailor an extra wish. Nicholas shouted, 'My lord, I take thee at thy word. I therefore wish that thou wert riding into Hell upon yonder dun horse, and never be able to return to earth again to plague either me or any other poor mortal!' An invisible power seized the Devil; he dropped the bond, roared so loud that they heard it in Colne, and with the swiftness of the wind both horse and Devil were gone.

In thanks for his escape, Nichols Gosford opened the tavern, and had the sign made, and many people came from all around to meet the man who had outwitted the Devil. The pub was called the *Dule upo' Dun*, and although it had long ceased to exist by the time Lancashire traveller William Dobson passed this way *c.* 1864, he noted, 'The inn and the sign remained for some centuries; the legend will no doubt last for many a century longer.'

Of Witches and Witchcraft

Although the true age of witchcraft in Lancashire is long gone, and despite the discrediting of the phenomenon by later writers, its legacy will always be with us. Although the scourge of witchcraft cannot really be defined as a 'paranormal' phenomenon, the tales told of these dark days are of a sinister and terrifying nature to the ears of the modern reader. No true look at superstition and the supernatural in the county – or, in fact, any history of the county – can ignore the strange and unearthly events that plagued Lancashire in those troubled times, nor ignore the utter weirdness of the demonic accusations that held the county in such terror.

Nor should it be thought that witchcraft concerned only women. The Tudor and Stuart eras were strange times, when wizards, conjurers and wise men were the first resort in a supernatural crisis, not the last, with their power revered and feared in equal measures. A great sensation was occasioned in Lancashire in 1594, on account of an alleged instance of demoniacal possession among the household of Mr Nicholas Starkie, at Cleworth in the parish of Leigh. Ultimately the scapegoat who suffered punishment for the family's torment was a conjurer called John Hartley. Hartley was initially recruited to assist the bedevilled family, and sought to relieve them by various charms and the drawing of a magical circle with four crosses near Starkie's seat at Huntroyde, in the parish of Whalley. Unfortunately, Hartley's presence made no difference; in fact things got worse, and the troubled family were forced to consult Dr Dee, the Warden of Manchester College. Dee suggested that the house required exorcism by Godly priests, and that Hartley was at best a fraudulent opportunist and at worst in league with Satan himself. In the end, Hartley was committed to Lancaster Castle, where upon the evidence of Starkie and his household he was convicted of witchcraft. As he stood on the scaffold he cried out his innocence, but when the rope around his neck snapped and the wretched man was hoisted up a second time, he finally admitted his guilt in plaguing the family before being dispatched. Even now, many of the elements in this story do not make much sense to the modern reader, but nonetheless, some of the demonic agents that plagued the unhappy Starkie family are nightmarishly disturbing in their description – a feature that came to define many of the later allegations of witchcraft. For instance, a thirty-three-year-old visitor from Salford, Margaret Byrom, during a visit, fell in with the general pandemonium of convulsions, violently chattering teeth and weird outcries that were afflicting the family. She claimed to have become possessed by something in the likeness of a cow, that resided in her gut on the left side, and which she 'felt' had its head and nose hammered full of nails; this accounted for the pain that made her shriek aloud when it moved around inside her body. On another occasion, in Hartley's presence, she was terrified by the materialisation of a gigantic black hound, which ran at her with a powerful whipping tail, a long chain and a drooling, snarling mouth. Upon Hartley's incarceration, ministers got all seven who were 'possessed' in one chamber and performed an exorcism, whereupon the afflicted saw with terror the demons that had taken control of them depart their person: Starkie saw an aggressive looking hunchback, while others resembled an urchin and a dark, hideous looking man, with shoulders higher than his head. Many of those tormented bled plentifully from the mouth and nose upon the spirits departing them.

The eye of God at Newchurch: keeping an eye on Pendle's witches.

The great and the noble were not spared the plague of witchcraft, even in the tumultuous years leading up to the English Civil War. A wizard named Utley was hanged at Lancaster around 1630 for having bewitched to death Richard, the son of Ralph Assheton, Esq., of Downham, and Lord of Middleton. (This family seems to have been uniquely unlucky; one 'Richard Assheton, son of Richard Assheton, Esq., of Downham' is also listed among the victims of the Pendle witches.) And it is also highly likely that entirely human tragedies were blamed in some way on a witch's curse, or perhaps divine judgement on the sins of an evil community; thus we learn of a 'prodigious monster' with two bodies joined to one back born at Adlington on 17 April 1613.

As late as the early 1700s the scourge of witchcraft was taken credulously; one Katherine Walkden of Atherton was examined as a suspected witch at Hulton Hall, where her 'Devil's teat' proved her guilt. However, she perished in Lancaster gaol before her trial. A certain Dr Webster, in a 1673 piece entitled *Display of Witchcraft*, notes that he knew of two supposed witches that had been executed at Lancaster in the last eighteen years. His attitude, despite the times, appears generally enlightened; he wrote that these two witches denied any covenant with the Devil, and that in some instances people 'were brought to such confessions by force, fraud, or cunning persuasion and allurement'. However, despite the first appearances of sympathy towards those so charged, the phenomenon of witchcraft was a very long time dying out in Lancashire.

The Improbable Tale of Giles Robinson

An Illustrated Itinerary of the County of Lancaster (1842) describes the striking scenery encountered on the journey between Todmorden and Burnley: 'In travelling through this most picturesque vale, we met at every bend of the hills new groups and combinations of sublime or pleasing objects. Sometimes the mountains closed in and seemed to intercept our passage ... The most imposing of all was the mountain termed "The Eagle's Crag", which rose almost perpendicularly above us, clothed in vegetation.' It was here in 1633, according to the *Itinerary*, that more dramatic developments involving witchcraft were played out. The gist of the events follows these lines – although this version is drawn more from local colouring than the authentic history of the case.

A shocking story told by Giles Robinson, a Pendle farmer, was that as he rode his horse on the road to Burnley on All Saints Day a flash of lightning alerted him to the presence of a notorious local witch called 'Loynd Wife', whom he glimpsed sitting astride the Eagle's Crag. It began to rain heavily, and thunder boomed through and over the mountains, and suddenly a huge black cat with blazing eyes appeared next to him. It said, 'Thou cursed my mistress two days ago, she will meet thee at Malkin Tower.' The creature then flew up the mountainside and alighted on Loynd's shoulders: a blast of flame shot from the 'eagle's' beak and both she and her familiar flew off and over the horizon in the direction of Pendle Forest.

Robinson some time afterwards went to the magistrates and explained that his son, Ned, had subsequently undergone a truly bizarre and outrageous kidnapping by a coven of witches that inhabited a new house called Hoarestones, high up in the mountains. The boy was abducted while picking berries by a witch called Moll Dickenson (and a companion), who deceived him into the forest in the guise of two greyhounds wearing gold collars. One of the greyhounds then transformed into a white mare and Ned found himself galloping to Hoarestones on this beast, sat in the saddle behind Moll and clinging on for dear life. Upon reaching the house, the boy saw in terror that it was literally infested with witches and demonic figures reining in fiery horses. In the barn the young lad was forced to watch a ritual – it being the Witches' Sabbath – whereby the crones, led by Loynd, mixed ingredients in a boiling, flaming cauldron; the blood of a bat, the 'libbard's bane', juice from a toad, oil from an adder and three ounces of flesh 'from the red-hair'd wench'. Mixing the potion produced silent phantasms of Ned's father, Giles Robinson, and his mother, and it was clear what the end was – murder of the pair by witchcraft.

Ned, however, managed to dart away during the ritual, scrambling down the mountain and outrunning the group of witches, led by Loynd, who were pursuing him. He was eventually saved by two horsemen who forced the troop of old hags back while they got the boy to safety. Giles' accusations led to the arrest of eighteen people, seventeen of whom were sentenced to death. However, in an unusual example of mercy the judge took it upon himself to grant the 'witches' a reprieve, and referred the case to the king in council. Four who appeared principally guilty were interviewed by the Bishop of Chester, and thence transported to London where the king's physician undertook an examination, and King Charles I himself came to see them.

A Satanic gathering in Pendle: a seventeenth-century illustration, reproduced at the Heritage Centre.

The case, it seems, collapsed in confusion, with there being suspicions that Giles Robinson was in some sort of financial trouble, and somehow blamed those he accused; possibly he genuinely believed that he had been 'overlooked' by one of his rivals and 'Loynd Wife' was the agent who had been employed to cast a spell on him. The boy Ned had been coerced into providing false testimony, in the investigator's opinion, although the whole thing was confused by a worthless, but full, confession by one of the accused called Margaret Johnson – although she was the only one to confess. The *Itinerary* observes of this, 'So small is the worth of confessions of guilt, when the mind is full of false notions, the imagination morbid, and the passions in a flame'.

A fuller, more historically faithful, version of this strange saga can be found in Harland and Wilkinson's *Lancashire Folk-lore* (1867), and the examination records provide an interesting depiction of the Devil who came to Margaret Johnson. In around 1625 she had been at home in Marsden, when she had suddenly found herself confronted by 'a spirit or devil in the proportion or similitude of a man, apparelled in a suit of black, tied about with silk points' who told her his name was Mamilian.

The excitement that the events whipped up at the time can be judged from the writing of Sir William Pelham. In a letter dated 16 May 1634 he wrote,

The greatest news from the county is of a huge pack of witches, which are lately discovered in Lancashire, whereof, 'tis said, 19 are condemned, and that there are at

least 60 already discovered, and yet daily there are more revealed: there are divers of them of good ability, and they have done much harm. I hear it is suspected that they had a hand in raising the great storm, wherein his Majesty (Charles I) was in so great danger at sea in Scotland.

The Birth of a Monster

A tract dated 3 March 1646 entitled *A Declaration of a Strange and Wonderfull Monster* described how a gentlewoman in Kirkham had given birth to a monstrous child, without a head and neck, although with its face embedded in its own chest. The title page of the pamphlet depicted the headless child stood with its arms akimbo and its legs being rubbed by an affectionate cat. To the left sat a woman, possibly the midwife, with another cat in her lap, while a third cat lay at her feet. The mother was depicted in bed to the right, with two other women shown in the room, while a monk advanced upon the group bearing a cross.

The implication is that the woman brought about the birth of this nightmarish creature herself somehow, as a supernatural judgement on her religious and political beliefs; it was even subtitled 'Strange Signs From Heaven'. However, the pamphlet is a clear piece of parliamentarian propaganda, given that the nation was at war with itself when this horrific event is supposed to have happened. For the woman is declared to be 'Mrs Haughton, a *Popish* gentlewoman' who had yelled during childbirth that she would rather give birth to a headless child than bear a child under a parliamentary dictatorship. Perhaps the inclusion of the cats in the woodcut is also meant to imply a link to witchcraft, being superfluous to the illustration as they are. However, one can only wonder at the types of minds that concocted this type of thing to fight the propaganda war during England's civil conflict; unless, Heaven forbid, the pamphlet actually recorded a true instance of the birth of such a child. The minister of the parish, among others, attested to the reality of the incident.

The Persistence of Belief in Witchcraft

The fear of witchcraft was a long time dying out. The compilers of *Lancashire Folk-Lore* (1867) noted how there was a farmhouse on the road between Blackburn and Burnley 'with whose thrifty matron no one will yet dare to quarrel'. It was believed locally that this formidable woman had been present at the dying breath of another witch, and had accepted the witch's familiar spirit into her own person as it left the dead woman's lips.

Be that as it may, there were nineteenth-century methods to employ as antidotes by those who believed they had been bewitched, or were suffering the 'evil eye'. In Burnley it was the practice to assault the person suspected of witchcraft and draw blood from above the mouth. Spitting three times in the person's face, turning a live coal on the fire, nailing horseshoes to doorframes and carefully placing sprigs from the wicken tree were also powerful and magical anti-witch remedies. *Lancashire Folk-Lore* even

makes an allusion to a ritualistic practice known as 'burning the witch', or 'killing the witch'. One of the contributors was told that although this secret and mystical rite did not involve murder, the sorcery employed had the same effect: one victim (a male wizard from Rossendale) had died recently having been suspected of the mysterious teleportation of a horse from a field into a locked and bolted stable.

'Burning the witch' may have involved employing a so-called 'witch-killer', usually a man versed in the arts of astrology, necromancy, fortune-telling … in short, a person not that different from a witch, but not so maliciously evil, and sought out in the interests of putting things right again. In fact, the ritual – involving the sacrifice of a chicken and the making of a cake containing the urine of those bewitched – had drawn the Rossendale wizard irresistibly to the cottage where it was being performed. To admit him would break the spell, so those assembled let the old man freeze to death in the atrocious weather on the moors. Folklorist T. T. Wilkinson makes it clear that even by the mid-nineteenth century the fear of witchcraft still held a shocking grip over people in the borough of Pendle: even the wives of clergymen were known to consult these 'wise-men'.

That a sincere belief in witchcraft persisted for at least 200 years beyond the scandal of the Pendle Witches is evidenced by a report in the *Lancaster Gazette* of 19 May 1810. A farmer had lately seen a number of his cattle die of distemper in the field some 2 miles shy of Burton-in-Kendal. His neighbours persuaded him that he was 'bewitched', and so he consulted a cunning woman, who told him that the only way to break the spell was to burn a calf alive. On the 11 May this farmer – who genuinely must have believed he had been cursed – burnt a fine heifer calf on an adjacent moss with the assistance of two other men and a servant woman.

So, then, although there are numerous anecdotes, collected by nineteenth-century writers concerning the resident village 'witch' that illustrate just how seriously the threat was still taken, this folklore is backed up by actual documented accounts in newspapers and periodicals that describe the culmination of some petty grudge blamed on 'witchcraft' ending up in a violent assault or a criminal charge.

Overall, the phenomenon of witchcraft is very intangible, difficult to categorise definitively and encompassing a variety of different eras and dimensions, with everything from actual documented cases to misunderstood wise women and superstitious folklore falling under the umbrella term of 'witchcraft'. Until relatively recent times, there must have been innumerable instances of slashing, stabbing and pricking of 'witches', as 'blooding the witch' was thought to deprive them of their power. As in neighbouring counties, these practices continued to manifest until frighteningly recently, almost certainly well into the twentieth century. It has to be wondered to what extent this ingrained belief in the evil, supernatural power of witches still exists in the Lancashire of today, in its dark corners and out of the way villages.

Mythical Creatures of a Bygone Era

In many ways the stories from times long ago depict Lancashire as an almost Tolkien-esque land of fairytale sprites, ghouls, demonic agents and mythical creatures. Of course, Lancashire had its giants in the past: north of Bolton, on blustery Turton

Moor, there can still be sought out the Hanging Stones, one of which also went by the dual name of the Giant's Stone. One Mr Rasbotham, an eighteenth-century county magistrate, wrote in 1776 that the stone had gained this name because of the belief that long ago it was lobbed by a giant from a vantage point on Winter Hill on the opposite range of mountains and the stone bore the impressions of the giant's fingers. At Martin Mere, there are weirder stories that a freshwater mermaid inhabited this vast wetland near Burscough Bridge during the reign of King Charles II. The creature – a spiteful human-hating mermaid called Oneida, who spoke in murmuring tones – is noted in Roby's *Popular Traditions of Lancashire* (1843), although he remarks the 'tradition' might have something to do with a canoe that was found on the mere 'some years ago'. At any rate, the legend was a diehard one. An 1877 study of Lancashire's coastal south-west refers to the fact that 'Many legends still linger in regard to Martin Mere amongst the inhabitants of the district, who believe that it was inhabited by a mermaid, seen only a short time before the lake was drained.'

On the western edge of Longridge can be found an ancient house bearing the name Old Rib Farm. The place bears a date on its doorway of 1616, and there are yet traces of its old moat. But the most remarkable curiosity to grace the exterior stonework of this farmstead is the 'dun cow rib' – said to be the relic of a monstrous animal that once roamed the area.

The story behind this beast is that in olden times it inhabited the area, and was a real, horned bovine animal of utterly colossal size. However, it was quite docile and would allow itself to be milked, its sustenance providing an inexhaustible supply of milk for the farmers of the neighbourhood. She would often be found on the summit of Parlick, drinking from Chipping Brook. People came to believe that the cow was possessed of magical or supernatural powers, but in the end a witch from Pendle played a trick on it and used a sieve rather than a pail to milk the animal dry. In the end the exhausted animal collapsed and died, or as others say, it died in its anger at being outwitted.

Another such relic existed at nearby Grimsargh Hall Farm, the 'old rib' being displayed over the front door of this house dating back to 1773. Although in all likelihood these are whalebones, it is unclear how they came so far inland and there are stories from many other parts of Britain concerning other 'dun cows'. While in reality the creature is mythical, it is tempting to idly speculate that the stories are based on memories of some long-extinct breed of wild cattle (probably aurochs), or a prehistoric species of gigantic bovine animal that had continued to live on in pockets dotted around the British Isles. Whatever she was, the dun cow was supposedly buried at Cow Hill, west of Grimsargh.

Of all Lancashire's mythical creatures, one stands out for being recorded as a 'real' phenomenon of the times. In 1597 natural historian John Gerarde wrote – in all seriousness and in complete credulity – of the 'tree-geese', a mollusc that developed into a bird, and which inhabited the waters off Lancashire. The creatures inhabited many parts of the British Isles, but were especially evident in the vicinity of Foulney and Piel Island. Here, in the froth and spume that washed over the broken pieces of shipwrecked vessels and rotten tree trunks cast up on the wharfs and sandbanks of Morecambe Bay, there were to be found the breeding grounds of this peculiar type of shellfish. Not unlike a mussel, only whiter and with a sharper-pointed shell, within this there floated a long, whitish strand, like silk, at the end of which could be found an

organic mass. Ultimately the shell would open and produce first the legs of the bird; then the body would force the shell mouth open wider, until the beak and head were out and the strange bird thrashed in the coastal shallows. In time, it sprouted black and white feathers and grew to a size bigger than a mallard, with black legs and a bill. As fantastic as this sounds, Gerarde wrote, 'the people of Lancashire call (this bird) by no other name than the tree-goose; which place aforesaid, and all parts adjacent, do so much abound therewith, that one of the best may be brought for threepence.'

However, if these sorts of creatures be mythical, then what do we make of the strange beasts glimpsed these days? Things that aren't supposed to exist are still frequently reported, as we shall see.

Monstrous Serpentine Creatures

There is a story that speaks of a gigantic conger eel, or immense snake-like worm, inhabiting the waters of Marton Mere near Staining some 1,200 years ago. This monstrosity sluggishly lounged in the marshes of the mere's edges, eating livestock and unwary villagers, until a priest managed to induce it to eat a cake concealing a sturdy crucifix. The slimy creature choked to death on this meal and the metaphor of the power of faith no doubt impressed – and frightened – the people of the Fylde long ago.

Of course, the region also had its dragons, the most famous being the dragon of Unsworth. Unsworth is now a residential area on the southern fringes of Bury, Greater Manchester, but at one time was a distinct Lancashire hamlet, or village. Harland and Wilkinson's *Lancashire Legends, Traditions, Pageants and Sports* (1873) noted that in the days when Thomas Unsworth was the owner of the 'principal mansion' here, the surrounding countryside was terrorized by a serpentine monster that ate women and children, and whose scaly hide was so tough that bullets made no impact. Unsworth therefore contrived to load his rifle with a dagger, and fired at the creature's neck when it raised its head. The lineal descendents of the dragon-slayer were, at least in 1842, residing in a farmstead at Goshen, Bury, where there could be observed a stout table carved by the very weapon that had killed the creature, immediately after the event. A number of carvings in possession of the family were said to depict the monster, one resembling 'a serpent in folds with stings at the ends of the tongue and tail'.

There are other stories of dragons in neighbouring counties. However, perhaps diarist Samuel Pepys, in his entry for 4 February 1661, observes the weirdest serpentine mystery. He wrote that at Westminster Hall, London, he dined with a learned man called Mr Templer, who told him that in 'the waste places of Lancashire' serpents (probably meaning snakes) grew to an immense size and lived on a diet of larks. These creatures would stealthily position themselves underneath, mouth uppermost, and 'eject poison upon the bird'. Paralysed, or rendered immobile in an unclear way, the bird would drop out of the sky to be snapped up in the jaws of these monstrous creatures. By 'waste places', it is assumed Lancashire's remote, uninhabited and inhospitable areas were meant.

A strange story was reported in *Dodsley's Annual Register Vol 4* (1760) as occurring on 15 April 1759: 'Two large sea monsters were seen in the river Ribble, in Preston, Lancashire, on which some men went out in boats, with pitchforks, and killed one of

Depiction of a dragon-slaying, Whalley church.

them, which weighed between 6 and 700 weight, and had teats, which they squeezed milk out of; and they said it was the sweetest milk they ever tasted.'

There have recently been bizarre echoes of these themes at Martin Mere. Rumours of a gigantic 'something' living in the lake were first voiced in 1998, the subject quickly becoming a talking point among visitors and the people living near the 380-acre reserve, which regularly attracts Whooper and Bewick's swans. The so-called 'Monster of the Mere' made national headlines following a report in the *Liverpool Echo* (14 February 2002) that drew on the claims of witnesses who saw a powerful living creature drag a fully grown swan beneath the waterline of this 20-acre lake on 7 February. The thing, whatever it was, scattered the other swans, and had apparently been panicking and disrupting their colonies for weeks. The reserve's manager told the newspaper that four years earlier he had witnessed a monstrous creature the size of a small car circling just below the water line, and the supposition is that this monster of the deep might be a Wels catfish of truly gargantuan proportions.

The Living Water

In *Choice Notes From: Folklore* (1859), a correspondent from Lancashire – one P. P. – noted that there was scarcely a dell, stream, road or bridge in his neighbourhood that did not harbour a boggart of some kind, although one entity stands out as particularly

curious. P. P. wrote, 'Wells, ponds, gates, &c., often have this bad repute ... (there is) a column of white foam like a large sugarloaf in the midst of a pond' that was reckoned to be some sort of bizarre spectre, although exactly what was being suggested is impossible to say now. An entity made of the water, perhaps? Maybe it was linked to the 'water spirit' that folklorist James Bowker noted could be heard in the swollen depths of the River Ribble, calling for its next victim.

The association between water and fantastical creatures is common one in Lancashire. As late as 1988 Preston historian Norman Darwen observed, 'I can remember as a child that there was a story that the area around Ladywell Street was haunted by a horrible monster!' This was in the vicinity of a long-vanished spring called Our Lady's Well that might have been beneath Ladywell House, as well as a long since disappeared canal.

Belief in the Little People

Although the definitions of Lancashire's various sprites and boggarts are often blurred, there are examples of fairy lore in the county: evidences of elemental 'little people', as opposed to spectres and ghosts. They perhaps deserve more consideration as a 'real' phenomenon (i.e. having an origin in something natural such as the *ignis fatuus* rather than being an invention) based on the inescapable fact that in Lancashire, as in most other parts of Britain, these elementals were sincerely believed in. Roby is among the first to record a legend in the area concerning interaction between humans and what might be broadly termed 'the little people' – goblins, fairies, pixies and sprites; although the story he relates is an old one indeed, found in many places across Britain. Put simply, he retells the legend of how, when 'the chapel of St. Chadde' was built on (what is now) Sparrow Hill, Rochdale, it was positioned here due to the supernatural transportation of stones and building materials during the night from the original site. This supposedly occurred during the reign of William the Conqueror, and was blamed locally on fairies. Robertson's *Rochdale Past and Present* (1876) adds the detail;'The site ultimately adopted, under such supernatural pressure, led, of course, to the formation of the celebrated church steps; to ascend which is always considered a necessary piece of work to be performed by all visitors to our good old town. To come to Rochdale and not mount the steps is considered a breach of good manners.' We have already seen similar stories elsewhere, where the agent responsible for the incident was considered demonical instead.

Many places bear names indicating some kind of association with the little people: for instance, there is a copse designated Fairy Glen that enshrouds Sprodley Brook near Dangerous Corner, Appley Bridge. At Warton Crag, Warton, where at one time a seat called the Bride's Chair was resorted to by the maidens of the parish on the day of their marriage, there could also be found a fissure cave on the eastern side of Warton Crag called the Fairy Hole. Here, dwarfish spirits called elves and fairies were wont to resort at one time; the Warton historian John Lucas recorded in the early eighteenth century that local people talked of 'little men' dancing around piles of gold and silver here.

There was also a Fairies Well near Blackpool that people made pilgrimages to, where they filled vessels with its purifying water. This is the cold spring between Staining

and Hardhorn. There is a famous story that one lady, collecting water there for her daughter's bad eye, was confronted by a handsome little man dressed in green who presented her with a bottle of ointment. This, he told her in answer to her puzzlement, was for her daughter. However, the mother being cautious, tested the ointment on one of her own eyes first, and, finding that it did her no harm, used it on her daughter. Presently, she was at market in Preston one day when to her astonishment she saw the little man dressed in green. He was in the act of stealing corn from a stall, and when the woman spoke to him he flew into a rage and lashed out at her, blinding her in the eye she had anointed. Of course, the ointment (being fairy ointment) had been magic, allowing her to see the otherwise invisible fairy: the story shows the little people could be exceptionally malicious as well as generous. Writer Kathleen Eyre was told by an eighty-nine-year-old Staining resident in 1964 that the Fairies' Well was still there, although on farmlands, up High Cross Way. Her informant commented, 'They used to say the fairies came there and washed their clothes by moonlight.' Elsewhere, we learn from the *Gentleman's Magazine Vol. 161* that Robin Hood's Well, near Pleasant View Farm, Haslingden, was 'surrounded by places that have been long occupied by fairies'.

Throughout the county there were many legends told of the 'feeorin', as they were sometimes known. At Bolton-by-Bowland William Pudsay, a godson of Queen Elizabeth I, chanced upon fairies by the banks of the Ribble. They presented him with a magical silver bit for his horse and explained to him where he should mine to find more silver deposits. Pudsay mined this silver and used it to mint his own coinage; when officials went to arrest him at Bolton Hall, he mounted his steed and, thundering off, made a 90-foot leap down Rainsber Scar before launching his horse (the magic bit between its teeth) across the Ribble to safely escape his pursuers. He rode on to London where he received a pardon from her majesty, and ever afterwards the spot of this dramatic jump was referred to as 'Pudsay's Leap'.

Fairies are said to have exhibited themselves in military formation on the mountain slopes when civil conflict threatened the county – it being believed that this spectacle was seen regularly at the time of the 1745/46 rebellion. Perhaps the most familiar legend is the one of the Goblin Funeral. North-east of Burnley can be found the dangerously derelict ruins of Extwistle Hall, a four-storey sixteenth-century manor house. The hall long remained the property and residence of the Parker family, but even by 1830 it was a noted ruin, a gazetteer of Lancashire describing it as 'a lofty pile, commanding an extensive prospect; it is now in a state of dilapidation.' Its decay was perhaps seen as symptomatic of the decline of the Parker family, whose own demise was apparently foreshadowed by a strange supernatural event. According to the well known story, Captain Robert Parker withdrew his support for the first Jacobite Rebellion in 1715 upon seeing a singular sight one evening near the small bridge over Swinden Water. This consisted of a silent funeral cortege being borne by fairies, or goblins, or some otherworldly sprite. When he caught sight of the small coffin Parker saw it was inscribed with his own name: Captain Robert Parker. He took this as an omen that he would die if he joined the rebellion, and so abstained. However, it appeared that this was not the message; it was in actual fact a portent of doom for the entire family and their residence. The Parkers ceased to reside at Extwistle after Captain Robert Parker received terrible injuries in an explosion of gunpowder on 18 March 1718; he died the following 21 April.

Bowker's *Goblin Tales of Lancashire* (1883) tells of a similar tradition in Penwortham. At the churchyard of St Mary, near Church Wood, two rustics beheld a fairy funeral. The elves were habited in black and held their caps in their hands. They chanted a mournful song as they bore a tiny black coffin, the inmate of which bore a striking resemblance to one of those watching. The man who it resembled reached out and touched the coffin; whereupon the cortege immediately vanished. About a month later he fell from a stack and died of his injuries.

Also according to Bowker, one Rueben Oswaldwistle would lay claim to having rescued a little fellow called Moonbeam, a servant at the Fairy King's court whom the king was considering having executed during a royal banquet. The lucky Oswaldwistle was privileged to see the fairy 'court proceedings' while lounging about on the banks of the Ribble near Ribbleton Moor. He claimed to have brought his fist down on the head of the Fairy King, and at once the whole scene being played out in the grass before him evaporated. Moonbeam who, when first seen by the human, was moaning to a fellow fairy about the king's intention, is described in the manner of a traditional pixie, or elf, rather than the winged sprite that today's generation might identify with. Moonbeam is described as 'about a span high', clad in green and wearing a red cap, struggling to carry a flat-topped mushroom that was far too heavy to the king's banqueting table.

Goblin Tales of Lancashire also has a (presumably) contemporary story of a man explaining that he saw a female 'feeorin' while ploughing land at the Fylde. The fairy was extremely pretty, but in a state of distress, having appeared from nowhere, and crying, 'I've brokken me speet!' The ploughman took the spade and mended it for her, whereupon she presented him with 'a hanful o' brass' and simply vanished in the blink of an eye.

Another undated, although probably contemporary, story told how two good-for-nothing poachers who lived in Hoghton had one night placed their sacks over the entrance to rabbit's burrows and flushed what they thought were two rabbits into them. Tying up the sack mouths, they slung their catches over their shoulders, when all of a sudden a little voice emanated from one sack, 'Dick, wheer art ta?' A voice piped out from the other sack, 'In a sack, on a back, riding up Hoghton brow!'

After this these gadabouts took respectable jobs as weavers, much to the shock of the people of Hoghton, who forced them to explain their transformation, and in doing so learned of the strange story. (The earliest written versions of this story allege the captured fairies were taken at 'Barley brow', near Newchurch in Pendle.)

Although these legends might reinforce the modern belief that 'fairies' were merely elements of a folk story, hagstones found over barns in places such as Bashall Eaves and Chatburn prove there was a genuine wariness of the otherworldly little people. Hagstones were ugly charms used to prevent horses being ridden by fairies (or else 'hags'), it being believed that horses found in an agitated and sweating state in the morning had been ridden by fairies overnight. Harland and Wilkinson's *Lancashire Legends* (1873) notes further evidence in the shape of a contemporary belief that fairies would come into the house in the night and substitute one of their own imps for a newborn child. The book observes, 'A person now living in Burnley firmly believed that her withered, consumptive child was a changeling. She told the writer it would not live long; and when it died, she said, "the fairies had got their own".'

Hagstone, found at Bashall
Eaves and depicted in
Clitheroe Museum.

Antique tobacco pipes found in the corners of new ploughed fields were believed to have originally belonged to fairies; they gambolled on grassy meads at 'dewy eve', and were still occasionally glimpsed as late as the mid-1800s. Circles of fungus were common in Goosnargh, and were observed to be 'Fairy Rings'. At Hothersall Hall, by the Ribble, it used to be the practice to tie a length of red worsted thread around the cow's tails prior to sending them out into the fields in springtime; this (somehow) warded off potential attention by fairies. Cattle, sheep and horses still grace the land around Hothersall to this day, and I wonder at what point this tradition stopped.

Some believed that those born at midnight were possessed of a magical ability to see the fairies. Although it was thought necessary by others that, in order to see them, you had to prepare yourself with four-leaf clovers and other charms, one had been spotted *c.* 1860 near the ancient encampment on Mellor Moor, north of Mellor itself. The report on the incident can be found in the Lancashire Historic Society's *Transactions Vol. 11–12* (1859). The diminutive fellow had seemed to be a 'dwarf-like man' attired in full hunting costume with top boots and spurs. He wore a green jacket and 'red hairy cap', and carried a hunting whip, running all the while briskly over the moor before leaping over a low stone wall and being lost to sight. *Transactions*' correspondent describes the person who saw this strange sight as 'a near relative of my own, not more imbued with superstition than the majority'. Mellor Moor is, incidentally, reputed to house an 'underground city' in the vicinity of the Roman earthwork there.

Such creatures are not supposed to exist in this day and age; therefore, it may surprise some to know that, as antiquated as the belief in the little people is, the notion of their existence still greatly fascinates. The *Daily Mail* of 20 October 2010 carried a remarkable report averring that, according to a survey called the *Supernatural Angel Report* (a collation of data from police reports over the last twenty-five years) there had been an astonishing forty-four sightings of fairies in the woodland around Croston.

Particularly prominent was a sprite named 'Shrewfoot', who was considered a very benevolent member of its race: 'It is a very protective entity and is reported to have saved at least one pedestrian who was in danger on the adjacent road from a speeding lorry.' The *Chorley Guardian* reinforced this belief a week later in an interview with a sixty-seven-year-old Croston man who had occasionally spotted 'little, glinting sparkly things' like illuminated little spirits about 30 cm high in the grounds of St Michael's Church, Croston. This strange spectacle could be seen at about five o'clock in the morning from the vantage point of his back garden, and the implementation of three medieval figurines carved from tree trunks and placed in the church grounds about 18 months earlier seemed to have encouraged the sprite's appearances; the witness remarked, 'It only lasts a few minutes and then they just disappear. You blink and they're gone.'

Old Trash

In Charlotte Brontë's *Jane Eyre* (1847) there is a reference to one of the most famous supernatural creatures in Lancashire: the 'spirit called a "Gytrash"; which, in the form of horse, mule or large dog, haunted solitary ways, and sometimes came upon belated travellers'.

Across the region in general, there has since time immemorial been stories about this fearsome black supernatural hound (or hounds), which are depicted in *Lancashire Folk-lore* (1867) as 'great big dhogs wi' great glarin' een (eyes), as big as tay-cups'. The creature went by many names in Lancashire; in Formby, Merseyside, it was known as 'Old Trash', supposedly after the noise its feet made as it loped along the sand dunes of Mad Wharf. Perhaps the best description of this ethereal, canine harbinger of death is that provided by T. T. Wilkinson in a speech given 5 January 1860, and transcribed in *Transactions of the Historic Society of Lancashire and Cheshire Vol. 12*:

> The Barguest, or Barnghaist, of the Tuetons, is also reported to be a frequent visitor to Lancashire. The appearance of this sprite is considered as a certain death-sign, and has obtained the local names of 'Trash' and 'Skriker'. He generally appears to one of the family from which death is about to select his victim, and is more or less visible according to the distance of the event. I have met with persons to whom the barguest has assumed the form of a white cow or a horse; but on most occasions 'Trash' is described as having the appearance of a large dog, with very broad feet, shaggy hair, drooping ears, and eyes 'as large as saucers'. When walking, his feet make a loud splashing noise, like old shoes on a miry road, and hence the name of Trash. The appellation Skriker has reference to the screams uttered by the sprite, which are frequently heard when the animal is invisible. When followed by any individual, he begins to walk backwards, with his eyes fixed full on his pursuer, and vanishes on the slightest momentary inattention. Occasionally he plunges into a pool of water, and at other times he sinks at the feet of the person to whom he appears with a loud splashing noise, as if a heavy stone were thrown into the miry road. Some are reported to have attempted to strike him with any weapon they had at hand, but there

Old Trash himself.

was no substance to receive the blows, although the Skriker kept his ground. He is said to frequent the neighbourhood of Burnley at present, and is mostly seen in Godly Lane (Ormerod Road) and about the Parochial Church; but he by no means confines his visits to the churchyard.

Sometimes the clanking of chains also marked this creature's appearance.

An embellished version of the appearance of Skriker – or Shrieker – is told in Bowker's *Goblin Tales of Lancashire* (1883). Here, this monstrous, gliding creature is described as 'a hideous figure with black shaggy hide, and huge eyes closely resembling orbs of fire'. On a December night many years previously it had pursued a young man named Adam between Chipping and Thornley Hall, by the banks of the Hodder north of Longridge. Here, it is described as an 'Ambassador of Death', the animal's feet making no paw prints in the snow, as it chased the young man all the way to his cottage door; in his terror, he struck out at it but his hand passed through thin air. Three days after his encounter, Adam's eldest son was brought home drowned, and his wife died a few weeks later from a fever. Bowker relates that this man became insane and imbecilic after these events, continuously retracing the journey he had taken on that strange night, hoping to encounter Skriker once again: he never did.

In 1872 the folklorist Charles Harwick recited a rare instance that he had recently heard of the spectre hound apparently attacking someone. The incident had occurred *c.* 1825, when a Manchester tradesman named Drabble had encountered the 'black headless dog-fiend' not far from 'the-then Collegiate Church'. It had leapt on him and placed its front paws on his back shoulders and all but run him home. Drabble had been so terrified that he had thrown himself under his bedclothes still wearing his

filthy garments. Although the episode, if true, might appear to the less than credulous modern reader to be a bluff designed to cover up some misdemeanour, there was a strange sequel. For 'this particular dog-boggart' was exorcised and buried 'under the dry arch of the old bridge across the Irwell' for 999 years.

A contribution to *Notes And Queries* in 1869 tells us that this creature also went by the name of Padfoot, and was once seen along the border of Yorkshire and Lancashire. The spectator was safe, however, upon gaining the Lancashire side since 'boggarts never trespass on each other's domains'.

Bentley's *Portrait of Wycoller* (1975) notes that in the Forest of Trawden locals 'feared to meet (Guytrash) in the lonely lane leading down from Height Laithe to the hall, up the Dean towards Parson Lee, and in the countless field-paths that led from farm to farm and cottage to cottage'. At Coppull, the dog goes by the name of 'Pongi', and is said to be as big as a calf, with great blazing eyes. Locally they reckon that he lopes about Hic Bibi Well and Bucknow Brook, and to see him is either portentous of one's own death or a warning of some imminent catastrophe. But whatever terminology he goes under, the monstrous black dog of Lancashire can pop up anywhere: in Clitheroe, for instance, Old Trash stalked Lowergate and Wellgate to Wells House, according to folklorist Vera Winterbottom in 1962.

According to ghost hunter Peter Underwood's *This Haunted Isle* (1984), a creature of this type was purportedly seen in 1962, by two inquisitive local reporters and a photographer who had taken it upon themselves to camp out on Halloween in the very hope of spotting Skriker. Believe it or not, silhouetted by the moonlight they saw a 'huge dark shape' that loped and circled atop a Formby sand dune – but which had vanished when they raced to the summit to see what it was! So perhaps these sinister animals, far from being a superstitious relic harking back to Nordic times, are – Heaven forbid – real … and out there.

Lancashire Vampires

It is possible that some considered the afore-mentioned phantom horseman of Rivington Pike something else entirely, for an article in an 1885 copy of *Household Words: Volume 8* (a periodical edited by Charles Dickens) suggests the creature that haunted the exposed summit was in actual fact a vampire. According to the titillating story, it was

> generally believed that the summit is tenanted by a demon in human form, a vampire doomed to wander on Rivington Pike till the Judgement Day. But, once in every three years, he must resign the body in which he dwells, and find another; and to accomplish this he seeks to lure unwary travellers up the hill that he may murder them. Hence it is considered unsafe to venture on Rivington Pike after dark, for seven nights from the eve of New Year, that being the period chosen by the vampire for the accomplishment of his evil design. Once a too-daring traveller encountered the demon on the last night of December, and escaped unhurt to relate the adventure.

A rather more modern case of vampirism has made headlines on and off since 1993, when a bizarre urban legend became known: made all the weirder for originating in Peru, but concerning a Blackburn woman, Sarah Roberts. The sequence of events in 1993 caused a minor sensation in the tabloids, as well as being repeated in such magazines as *Fortean Times*, and is now, oddly, one of Lancashire's best known legends.

Although from Lancashire, Sarah Ellen Roberts' tomb is in the coastal Peruvian town of Pisco, and declares, 'In memory of Sarah Ellen, beloved wife of J. P. Roberts of Blackburn, England. Born March 6, 1872, and died June 9, 1913'. According to an article in the *Weekly World News* of 21 May 2002, drawing upon Peruvian folklore, Sarah had been the wife of a Blackburn sea captain, and although not an old woman, she looked suspiciously young enough for the people in her home town of Blackburn to blame her youthful beauty on the mysterious slaying of two children who were found deathly-white and with bite marks on their throats. An incensed mob grabbed her, and thrust her into a lead lined coffin, hammering the lid down and dooming both her (and a pet cat interred with her) to an agonisingly slow death from suffocation. As the nails were being hammered home, Sarah screamed from her confinement that in eighty years time her master – the Prince of Darkness himself – would help her rise like a revenant in order to wreak her revenge.

After pondering this, the people of Blackburn dug up the dead woman's coffin and handed it over to her grieving husband, Captain John Roberts, telling him to take the remains away from Lancashire's shores on his next voyage. This he did, his travels ultimately leading him to a small fishing port in Peru, where a hefty bribe ensured the authorities in Pisco interred Sarah in the local cemetery. Roberts left Peru in his vessel and sailed into oblivion; he was never seen again.

Over the years, and throughout the generations, a rumour grew up among the people of Pisco (as it developed into Peru's largest port) to the effect that an evil-looking woman in tattered clothing drifted about their cemetery, glaring madly with blazing red eyes. This was the ghost of Sarah, they whispered, who had in life been the 'third bride of Dracula'. Flash forward to 1993, and the port town of 100,000 was in uproar and genuine panic as the eightieth anniversary of Sarah's death approached. This was incensed when a spontaneous crack appeared in Sarah's headstone, and on the anniversary itself 1,000 people swarmed to the Pisco cemetery gates armed with holy water, crucifixes, stakes, mallets, white flower petals and garlic, and accompanied by shamans and even a Voodoo priestess from Brazil. According to lore, this woman performed a strange incantation as thunder flashed in the sky: the earth of the grave heaved, and a bluish mist began to materialise from the ground itself. But whatever it was the priestess chanted, the spell worked. A terrific scream rent the night air and the misty form evaporated above the grave.

Such is the stuff of modern folklore. Sarah Roberts was certainly a real person, although in all likelihood she was a cotton weaver who probably died on ship while crossing the Atlantic – for her brother-in-law had previously moved to Lima, Peru, to establish a cotton mill. The docking of the ship at Pisco with a dead Englishwoman on board seems to have been the basis for an enduring urban myth; or she may have died in other, unclear, circumstances in Peru itself, perhaps succumbing to

illness. Local historians have established that John Roberts, far from disappearing, returned to Lancashire and became a grocer: he died in 1925, and was buried in the old Blackburn cemetery. But the myth persists: the *Daily Mail* (22 July 2009), in reporting that a Peruvian playwright was adapting the legend for the stage, reported the belief that '(Sarah) had apparently been seen biting the neck of a child and sucking its blood, and her merchant husband John witnessed her pouring blood over ice cream before eating it.' It also observed how the legend was still being fed by other strange incidents, such as Sarah's coffin being left undamaged during a devastating 2007 earthquake that killed hundreds and unearthed or destroyed many tombs in the graveyard at Pisco.

The story is a remarkable one, and very famous in southern Peru, where the curious make trips to Pisco to see Sarah's inscribed tombstone for themselves. To confuse the picture, but perhaps in doing so earning this Blackburn emigrant some justice, Sarah is revered in some quarters as a saint following the 'miraculous' preservation of her coffin during the earthquake.

Another strange story was reported in the *Daily Mirror* (8 April 2005): that the seaside town of Lytham St Anne's was rife with rumours of vampire-style attacks perpetrated by a well-dressed man with short black hair. This person was said to chat to women in French before pinning their arms and then biting their necks. He had struck twice, first attacking a café waitress; at the time of writing I am not aware 'Le Fang' (as the media dubbed him) was ever caught. The whole affair has the feel of a modern urban legend about it, along the lines of the phantom social worker scares, or stories about child abductors dressed as clowns, whereby suspected wrongdoers are reported in a general climate of fear … but no arrests are ever made, and the affair is never really properly explained. Nonetheless, I wonder how the vague story of Le Fang will be misremembered in Lytham St Anne's folklore in years to come.

Hairy Hominids

The most intriguing thing about the paranormal in Lancashire is that however strange a story is, there is always one stranger, however vague. At the time of writing (2011) there is a kind of urban legend concerning some sort of canine-type creature, baring fangs, that moves alternately from a four-legged walk to a two-legged upright posture like a man. This 'thing' was supposedly seen howling repeatedly one night about five years ago by a number of people in Blackpool, it predictably being supposed to be a werewolf, although – surely? – it must have been someone in fancy dress playing some sort of trick, Blackpool being the party town that it is.

But surely the most amazing allegation is that some sort of Bigfoot type creature, or possibly even a small clan of them, inhabits the blustery slopes of Longridge Fell in central Lancashire.

The stories that a huge, hairy 'something' lurks on this dominating landmark with its woodland-covered flanks seem to have begun in earnest with a letter to the Bigfoot Field Researchers Organization in the USA. In this correspondence, a resident of the Ribble Valley claimed that on one occasion in November 2002 she, and others, had

encountered a creature 7- or 8-foot tall with matted, tan hair all over its body after they had parked at Turner Fold and taken themselves off hiking into the dense woodland of the fell. The letter to the BFRO described the creature as looking like a living 'giant haystack', accompanied by an infant of the same species that appeared to be trying to hide. Both were seen among the trees from about 20 feet, in the late afternoon, and as the party made their way back to the car, a couple of stones were tossed at them from deep within the trees. Whooping cries and calls were also heard.

A few days later the witness returned, and with her children heard strange growling noises at the exact same spot on the fell … this caused them to cease searching for the 'haystack' in nervous uncertainty.

Bigfoot in Lancashire? It is a weird allegation, considered intriguing enough to draw a team of crypto-zoologists to Longridge, as reported in the *Lancashire Evening Post* (3 September 2003) and despite its unlikeliness there are rumours in county urban legend that these 'things' might have been there since at least the late 1980s.

'It Had a Face, Almost Human-Like'

The *Big Cats in Britain* website promotes itself thus; 'We are an investigative group made up of a network of researchers across the country. We gather evidence and information with the aim of discovering exactly what species of big cats are roaming the British countryside and how they came to be here.' However, a report sent to the organisers in April 2010, and circulated to the BCIB's membership in a newsletter article headlined 'Things that go bump in the night' concerned something far stranger than even an out of place panther.

The incident occurred just before midnight on 19 March 2010, in the presence of a couple parked at Fairhaven Lake, a saltwater lake on the coast next to Stanner Bank in Granny's Bay at Lytham St Anne's. The moonless night was still and tranquil but for the lapping of the tide against the sea wall. The couple were on the point of observing that it was unusual hear the tide so close by when their attention was drawn to a strange creature on all fours crawling in front of the car.

At first they thought it a fox, and then a dog, but when it hopped once they began to consider it might be a kangaroo, or wallaby. When the husband turned on the headlights to illuminate it, however, they realized it was none of these.

The crawling creature was about the same size as a medium-sized dog, except that its hind legs seemed to be noticeably elongated. Its limbs appeared gnarled, knotted and twisted, like misplaced muscles, and it was a brownish colour, totally without hair, tail or ears. It looked up squinting at the car as soon as the headlights illuminated it, and snarled at the occupants; the letter to the BCIB further explains, 'It had a face, almost human-like but deformed in a way. It was eating something which we couldn't see. It did not look happy, we did notice that; it looked very sad, miserable and evil.' In summing it up, the correspondent wrote, 'in my mind, (it was) a sort of medieval-ish creature, best described as "Gollum"', the pitiable half-human monstrosity from *Lord of the Rings*. When it eventually moved away toward the seafront path, it did so in a slithering, twisting crawl unlike the movement of any animal.

Significantly, the atmosphere at the time of this weird encounter had become 'thick and strange', possibly the so-called 'Oz factor' that often accompanies paranormal experiences. Whether this 'Gollum' has any connection with the Beast of Green Drive remains to be explained.

The Beast of Green Drive

Many will doubtless remember the stir caused in Lytham St Anne's a few years back by the so-called 'Beast': even the national newspapers found it intriguing. Over a number of weeks in the spring of 2005 dog walkers, ramblers and residents claimed encounters with a strange creature that defies absolute categorisation, in the vicinity of Green Drive, a beauty spot north of Lytham famous for its golf course and just east of Lytham Hall.

A composite picture of the Beast of Lytham illustrates that witnesses were clearly seeing something out of the ordinary. It was big – about the size of a Labrador or a Collie – but it resembled no dog. Light-coloured and in description more like a hare, it possessed a large mouth, a lolloping and loping gait, long sticking up ears, and snarled at a man playing bowls near Green Drive on one occasion.

There were many theories put forward at the time: a muntjac deer, a lost greyhound, a wallaby or some other exotic creature that had escaped from Southport Zoo before it had closed years earlier. The man who had been spooked by the creature's snarling commented, 'It was like a monster out of *Dr Who* and it needs tracking down.'

The mystery was thought solved when the *Lytham St Anne's Express* reported on 4 September 2007 that the 'beast' had been caught in a house in North Houses Lane and killed by the RSPCA. The paper reported that 'the elderly creature, widely thought to be the half-dog half-cat beast that has been spotted numerous times in Lytham and St Anne's, was captured' and 'was believed to be the beast after previous suspicions that a rare cat was behind the myths'. It was, in fact, an ancient, mangy and decrepit fox. However, nothing is straightforward in the world of the paranormal, and within fourteen months another (supposedly) emaciated red fox was being spotted in the region, with the *Express* commenting, 'Many of us thought that we had heard the last of (the Beast) when an emaciated fox, suspected of being the beast, was caught last year and put to sleep by the RSPCA. But more recent sightings have fuelled speculation that the creature is alive and well.'

Mangy fox or not, the original reports from 2005 do suggest something weird, and at the time of writing the riddle of this creature – destined to enter folklore, whatever it is – is still a talking point here in Lytham.

The Alien Zoo

In many ways, Old Trash and the Beast of Lytham are compatible with that most modern of mystery animals, the fabled (and seemingly of flesh and blood) black panther that is held to prowl the Lancashire countryside. This creature (or perhaps it might be more accurate to use the plural creatures) seems almost supernatural in its ability to

All-Night Hunt for Mystery Dogs

SHEEP, GEESE AND DUCKS KILLED

Blackpool Police Join Search of Lanes and Fields

FARMERS' LOSSES

Armed with sticks, farmers in the Anchorsholme district have been waiting up all night watching their fields for two mystery dogs which have during the past few weeks attacked sheep, geese and ducks on a wholesale scale.

Several sheep have been found killed, and many others have been seriously injured, their fleeces torn from their backs.

So alarmed have farmers been about the losses to their flocks that they have called in the services of the Blackpool police to help them to search for the dogs.

Police officers have this week roamed miles round the countryside, searching fields, lanes and farmyards in the dark with motor-car headlamps and torches, but have failed to find the dogs. The police are now remaining up all night with the farmers.

On two or three occasions farmers have been aroused from their beds by the barking of dogs, have hurriedly dressed, and gone into the fields to hunt for them.

AVOIDED CAPTURE

The dogs have occasionally been seen, but have always managed to elude capture.

One is described as a big brown dog

The dogs never attack singly. They are always together.

All the attacks have been made during the night, making it extremely difficult to catch them.

The district affected is Robins-lane and White Carr-lane, Anchorsholme.

Three farmers have reported sheep losses, while others have had geese and ducks killed.

POLICE WARNING

It is thought that the dogs belong to people in the Anchorsholme district, and through "The Evening Gazette" the police have issued the following warning:

In consequence of the damage done by dogs to sheep . . . owners are requested to keep their dogs under proper control, at all times, but more particularly during the hours between sunset and sunrise.

The provisions of the Dogs Act, 1871 and 1906, will be strictly enforced.

Hunt for 'mystery dogs' decimating livestock in Anchorsholme, December 1936.

avoid detection, and is modern folklore in the making, having been a favourite with the local media for years.

The Forest of Rossendale and 'The Valley', geographically north of Rawtenstall, has for years now been reputed to harbour at least one of these gigantic panther-like animals. Many people may remember the stir caused by the so-called 'Rossendale Lion', the original large prowling feline of these parts, that although seldom glimpsed was nonetheless blamed for decimating livestock around Hawthorn Farm, Whitewell Bottom. This was in the mid-1980s, and at the time the savage attacks on sheep led to posses of farmers and police scouring the high and wild moorland; some thought the culprit might be a mountain lion, but lately (early 2009) this creature – or another one like it – has once again caught the imagination of the people here in the Borough of Rossendale. For they say that a black panther-type creature has been spotted near more mauled sheep carcasses, and huge paw prints have been left in the snow.

This mysterious animal has earned the distinct name of the Huttock Top Beast. On 30 July 2009 the *Lancashire Evening Post* reported the latest sighting of another gigantic feline-type beast in a different part of the county: this time by a twenty-three-year-old who saw a 'really big, black cat which I can only describe as a panther' at Cinnamon Hill, Walton-le-Dale, near (appropriately enough) Dog Kennel Wood.

The traditional picture painted of these animals is that they are large ('as big as an Alsatian' is often the standard phrase, together with, 'It definitely wasn't a large

domestic cat'), with short, shiny black hair and a small panther-like head. It might be seen moving stealthily on its muscular haunches through a field or across the brow of a moorland hill, and its thick powerful tail usually catches the attention of the witness. Perhaps an atypical sighting is the one made by a thirty-four-year-old train driver along his usual route between Barrow-in-Furness and Preston. As the *Post* (24 July 2008) reported the witness as saying, 'It was about 8.30 pm and I was three miles outside Preston heading towards Lancaster and this thing was crossing the track about 100 metres away. At first I thought it was a fox, but you can tell a fox a mile off and it was three or four times bigger than a normal cat. It was black and feline and moved like a cat. It looked just like a puma. I've never seen anything like it except in the zoo.'

The traditional description of the fabled 'black panther or puma' is not always what the witnesses describe, however, which further confuses the entire picture of just what it is people might be seeing. Some beasts are described as 'lynx-like', and derive substantially from the popular panther myth; the *Lancashire Telegraph* (18 March 2010), for instance, reported that 'in Hoddlesden a pale brown creature with a white, spotted face and a dark ringed tail was spotted a couple of years ago'. That these feline creatures appear to take on many guises is evident, if the report in the *Post* (30 July 2009) is anything to go by; for among its recent archives it listed the sighting of what appeared to be two melanin leopards seen at the corner of Gib Lane, Hoghton, in 2008, as well as a large yellowish cat similar in appearance to a cougar and as big as a sheep that was witnessed in the Mere Brow and Holmeswood region north of Ormskirk in May 2008.

In the mid-1990s one of the earliest animals of this description was labelled the 'Padiham Panther' by the local press. Having first been spotted on multiple occasions in September 1995, it dropped off the radar; but this particular animal was declared by the *Burnley Express* (21 September 2007) to have returned after being spotted twice in woods behind the industrial park on the western edge of Padiham. It was described as lynx-like, 4 to 5 feet long, black and agile like a domestic cat. But this could just as easily be an offspring of the original, given that in their natural habitat panthers, at least, live more or less twelve years.

Whatever they are, these beasts have a number of traits that make them appear almost paranormal, not least in the observation that sometimes it is only a single paw-print that is observed in their wake, rather than the true walking pattern of tracks that would very quickly identify the beast beyond reasonable doubt. It is almost as if some supernatural creature has left some tantalising, accidental evidence of its incorporeal existence. But there is a wealth of sincere, credible correspondence in the various regional newspapers (not to mention urban legend by word of mouth) to suggest that people are at least seeing something they cannot identify; who knows, maybe you will be driving along a poorly lit road somewhere away from a large town, and your car headlights will simply fall on the shiny black coat, muscular haunches and yellow eyes of one of these creatures looking right back at you ... as if it were the most natural thing in the world!

That Lancashire's darkest corners were once home to some remarkable animals is evident from its folklore; the second dean of Whalley earned the name 'Cutwulph' for having cut off the tail of a wolf while hunting in the Forest of Rossendale during the reign of King Cnut. And quite apart from the fascinating deposits of fossilised relics from another era (hippo, rhino and elephant remains are displayed in Clitheroe

Museum), there are occasional, inexplicable modern reports of out of place wildlife turning up in the county. For example, a fisherman named Burrow caught a swordfish in his haul off Heysham in Morecambe Bay on 1 August 1824. In 1981 there was some excited comment among readers of *Fortean Times* after a correspondent (*FT32*, summer 1980) claimed to have seen an 8-foot tall kangaroo in a wooded area near Freshfield, Formby, in the summer of 1967. Of the animal's size, the correspondent wrote, 'This is not a wild estimate. The creature was fingering leaves and branches with its paws and seemed totally undisturbed – its coat was a rich rusty brown colour.' This strange animal quickly disappeared into the undergrowth. A very rare giant leatherback turtle, as big as a man, was spotted feeding on jellyfish off the coast of Cleveleys on 7 June 2010. And on 28 November 2006 a seal pup was found by the side of a country lane near Capernwray; a puzzled RSPCA officer told the *Lancaster Guardian*, 'We can't understand how he got there. He was found in the middle of a farming community, nowhere near the sea.'

Most perplexing is the brief, enigmatic entry in the correspondence of the Tennyson family, in which 'Thy loving mother' Emily Sellwood (Alfred, Lord Tennyson's wife) writes to her son Hallam Tennyson on 21 October 1870, 'I will add any news that may be in the papers today. At present I do not remember anything fresh in any way except the discovery of a kind of crocodile in a Lancashire cave, a beast four or five feet long. It was killed.'

The Reasoning Faculty of Animals

One of the county's most famous traditions is recorded in 1860 in *Notes and Queries* as being 'often heard in South Lancashire'. Nowadays it is associated with Burnley, and tells how one evening a gentleman was sitting cosily in his parlour, reading, when his meditations were interrupted by the appearance of a cat that came down the chimney and announced, 'Tell Dildrum Doldrum's dead!' before running out. The man was naturally started by the incident, and when shortly afterwards his wife entered he related what had happened. Their own cat, which had sauntered in with its mistress, exclaimed, 'Is Doldrum dead?' and immediately rushed up the chimney, never more to be heard from. The periodical notes, 'Of course there were numberless conjectures upon such a remarkable event, but the general opinion appears to be that Doldrum had been King of Catland, and that Dildrum was the next heir.'

Tales of the animal world always amuse us, even if they are examples of odd animal behaviour rather than true paranormal mysteries; although some of them are nothing if not singularly strange. It is said that in the time of King Henry VIII, the rare and wild milk-white cattle kept in the Lord's Park at Whalley Abbey were brought (upon the dissolution) to Gisburn Park by the Assheton family – using the power of music. Who could fail to have their fascination peaked by the instance of a large polecat (a vicious and wild carnivorous mammal later hunted to extinction in England) pathetically scratching at the door of a man named Taylor in Carnforth on 4 August 1810, in a bid to be allowed shelter from a tremendous thunderstorm outside? Upon allowing the animal in, the polecat dried itself by the fire and then leapt upon Taylor's knee when the astonished man sat down, docilely letting itself be manhandled into a cage.

The *Sporting Magazine* of 1807 observes that a pregnant hare was lately shot in Garstang, and when opened three live ones were found in her: these were presented to a cat that had just been deprived of her kittens, and – remarkably – the cat chose to 'adopt' the little animals in place of her lost offspring. In December 1809 it was reported that a goose laid seven eggs within a fortnight at Garstang, this somehow being read as a comment on the mildness of the season. On 9 December 1826 a remarkable white hare, shot in Bleasdale, was sent to a taxidermist in Lancaster to be stuffed.

Stranger are the evidences that some animals on occasion displayed an almost human-like intelligence. The long-demolished Buckley Hall, on the northern fringes of Rochdale and the Lancashire border, had a curious tradition concerning an animal, in this case a greyhound. This dog had accompanied one of the Buckley family on a journey to London, but in Cheapside it was startled by the fall of a heavy package and bolted off. The poor animal was found dead from exhaustion at five o'clock the following morning on the threshold of Buckley Hall – having run 196 miles in sixteen hours.

In May 1826 there was a strange instance of a homing horse. Two years earlier, the mare had been stolen from the stable of a Mr Salthouse, of Scotforth, being passed through several owners before being sold in Yorkshire for 30 guineas to a man from Preston. This man, in collecting the animal, fell asleep on its back during the journey, and – strange to relate – the horse somehow navigated its way back to Scotforth and to the very stable door from where it had been previously stolen. The man on its back was still asleep, probably drunk, when the mare arrived at its former home and presented itself before its utterly astonished original owner.

Perhaps the most astonishing animal curiosity is noted in a letter submitted to *Notes and Queries* in 1861 concerning an 'east Lancashire' man who traced the source of a mysterious bird-like whistling to an outer wall: shining a bull's eye lantern on the spot, he saw the culprit was 'a small mouse of light grey colour … moving its mouth and throat somewhat like a bird when singing'.

A singing mouse? Wonders will never cease. But apart from the evidences of (presumably) freak examples of human-like traits, there are instances that suggest sometimes animals possess a heightened perception, or extrasensory perception almost paranormal in nature. The Victorian folklorist James Bowker observed that there were few superstitions in Lancashire as powerful as the belief that dogs were possessed of the ability to foretell death and disaster. Despite the tendency of the educated to scoff at this, he recalled a peculiar incident when he had been attending a party at a house in an upmarket London square. The after dinner conversation in the drawing room was interrupted by the singular sight of a lone dog that had positioned itself in the roadway outside the window. It began howling dismally, ignoring the pedestrians and horses, and the attempts by coachmen to shoo it away. Eventually it finished its plaintive howl 'with three peculiar yelps', and then turned from the window (all inside were by now looking out at the creature) and ran off. The hostess and owner of the house was a north county lady, who was visibly shaken by this; and although the other guests laughed at the suggestion the animal was an ill-omen, Bowker recorded, 'A few days after … I was informed that on the evening of the dinner-party the brother of the hostess had died in north Lancashire.'

Footsteps Ever Further into the Unknown

Astral Projection, or a Lancashire Doppelgänger

If 'ghosts' are a mere supernatural tape-recording of an event that has somehow saturated itself into the soil, bricks or mortar around the site where it happened, as some subscribers to the Stone Tapes theory believe, then how does the phenomenon 'know' to appear only upon the death of the subject – thus giving the impression that it is somehow at the same time the embodiment of the 'spirit' of the late person? Surely if ghosts were merely supernatural 'recordings' then might we not, on occasion, see them played back before the subject was actually dead? This is what makes appearances of ghosts of still living people so fascinating, adding as it does another dimension to the already multilayered mystery of what ghosts might actually be.

Ernest Bennett's *Apparitions and Haunted Houses: a Survey of Evidence* (1939) cites just such a strange occurrence. Upon his return from the Foreign Service in 1911, Brigadier-General Swabey was posted to Preston, and with his family took up residence in a small house in what was (at the time) Cadley Bank. The place was in actual fact the property of a Mrs Smith, but she had been forced to take herself to Blackpool, where she lay bedridden and all business was done through an agent.

Before long, Swabey contacted the agent to ask for permission to chop down one of the garden trees, although a few days later all thoughts of gardening were forgotten when Mrs Swabey gave birth to a son.

Early one morning the nurse, having brought Mrs Swabey her newborn, shortly thereafter brought seven-year-old Patricia into the room and announced, 'I found Miss Pat terribly frightened, and I can't make out what frightened her.'

The little girl stammered to her mother, 'An old witch woman came into the nursery, looked into (the) baby's cot, and then went out … She went out at the door like a candle, and that was what frightened me!'

The little girl was good at drawing, and so drew what she had seen: an old lady in profile, wearing a peculiar mob cap with purple ribbons hanging on each side, and a grey shawl about her shoulders. A few days later the vicar's wife came to call, and when told the story and shown the little girl's picture she declared that it bore a striking resemblance to old Mrs Smith – currently bedridden in Blackpool. The vicar's wife

managed to procure for the Swabey family a photograph of the old woman, and all agreed that it must have been her: the one problem being that Mrs Smith was incapable of travelling anywhere and had not left the seaside town!

So what could have happened? No one in the family knew what Mrs Swabey looked like, so the little girl could not have drawn her from memory. The only solution was that when Mrs Smith had been informed the family wished to chop down the garden tree, she had become so distressed and agitated that she had somehow telepathically projected herself back to her beloved old residence. Either that or it was a ghost, although a rare instance of a 'tape-recording' type ghost, which displayed itself before its living counterpart had actually died.

The Flying Youth

Of human enigmas, John Aubrey's *Brief Lives* (1694) alludes to a remarkable story told to him by Sir Jonas Moore concerning an instance of a human being flying in the county. Aubrey penned,

> I remember Sir Jonas told us that a Jesuit (I think 'twas Grenbergerus, of the Roman College) found out a way of flying, and that he made a youth perform it. Mr Gascoigne taught an Irish boy the way, and he flew over a river in Lancashire (or thereabout), but when he was up in the air, the people gave a shout, whereat the boy being frightened, he fell down on the other side of the river, and broke his legs, and when he came to himself, he said that he thought the people had seen some strange apparition, which fancy amazed him. This was in 1635, and he spoke (about) it in the Royal Society, upon the account of the flying at Paris two years since.

Little more are we told of this enigmatic marvel, and it is unclear whether it is being suggested that those involved were practising necromancers or whether the boy was strapped to some sort of contraption ... or whether there was, in theory, a way for a human to fly like a bird.

The story is reminiscent of a perplexing modern incident stated (in a letter to the National UFO Research Centre in Seattle, USA) to have occurred near Barnoldswick in mid-July 2003. A middle-aged couple, both teachers, testified that they saw very definitely on a summer's evening a figure dressed in black overall-type clothing fall from the clear blue sky as though by parachute; this person appeared to be descending behind a row of houses, into a meadow – but he levelled off some 15 feet above the ground and then (despite the evening being windless) accelerated off northwards, sweeping into the distance at about 50 mph until lost to sight. The figure wore no visible means of propulsion: no backpack or parachute, although he may have worn some sort of black helmet. He made this amazing manoeuvre in complete silence. There was no suggestion of any UFO, or 'bright lights' anywhere in the vicinity at the time.

Fires from Nowhere

The most unnerving of all unexplained phenomena are the fires from nowhere – cases of spontaneous combustion. Newspapers in London reported in March 1926 that inexplicable small fires were breaking out at Closes Hall, the residence of Captain B. Heaton on Stump Cross Lane, Fooden Moor, north of Bolton-by-Bowland. In various places the woodwork under the roof had simultaneously burst into flame, in a part of the building so inaccessible that the firemen had to hack their way in. The blame was tentatively placed on sparks from the kitchen stove, although that explanation was highly unlikely in the mind of Charles Fort, the chronicler of all things out of place: 'Maybe it is strange that sparks from a kitchen stove should simultaneously ignite remote parts of a house, distances apart.'

A melancholy incident in Chorley on 4 March 1980 initially bore all the hallmarks of spontaneous human combustion; firemen attending a blaze found, in a smoky back sitting room, the severely burned body of an elderly lady. So severely burned was she that parts of the body had almost been vaporized to ash, but the blaze that had consumed her had left the legs from the knees downwards virtually untouched. That the victim's head had been near the iron grate of the fireplace was suggestive, but there was no evidence of any fire damage to the walls or the ceiling, and what caused the combustion was unclear. Nonetheless, a verdict of 'Accidental Death' was recorded at Chorley Magistrates Court, it being surmised that the victim had fallen head first into the coal fire, the fire in the grate having extinguished itself somehow after consuming the top half of the body.

Strange Rain

On occasion the skies above Lancashire can sometimes throw things at us that we can only marvel at. Sometimes, the weather has been so extreme that we can only wonder how we might deal with it in our own age: for instance, the tremendous storm of thunder, lightning and hail that pounded the county on 5 July 1836. The Heavens appeared in a permanent state of illumination, and fields of wheat were entirely destroyed by hail, or masses of ice, measuring 6 inches in circumference and weighing from 1 to 1½ ounces. Thousands of squares of glass were smashed at Claughton Hall alone.

However, the methods by which some things fall from the sky can be inexplicable. During the night of 8 November 1984 a couple in East Crescent, Accrington, were woken by a thunderous, prolonged noise on their roof, which lasted for about an hour. When it was over, the couple found that their back garden was ankle-deep in apples: and best quality Coxes and Bramleys at that. Some 300 had fallen on their property, and also on the hedges, paths and gardens of neighbours. The oft-repeated explanation for this type of fantastical rain is that it was whipped up by a whirlwind and deposited on an unsuspecting community from the Heavens, although such a whirlwind would in itself have to be phenomenal, if it only sucked up one particular type of thing! I am tempted to suggest that – if such things can really be – they are deposited instead from some sort of vortex, although goodness knows how such circumstances are created.

Wonders of the Natural World, Cosmic and Closer to Home

Wherever one lives in Lancashire, and in whatever era, there is – and always will be – a fascination with Heavenly oddities: one can only wonder what the appearance of three suns in the sky on 28 February 1648 portended to the people of a bygone age who observed it from vantage points across the county. The awe with which previous generations held the night sky is evident in local folk belief: farmers predicted fair weather or poor depending upon whether the new moon 'lies on her back' or 'stands upright', according to *Lancashire Folk-Lore* (1867). It was also exceptionally unlucky for anyone to look at the new moon for the first time through a windowpane.

1814 was an intriguing (and perhaps a little worrying) year for local students of astronomical phenomena. The year had been an exceptionally cold one, with heavy snow in the early months and severe frost being reported as late as 7 June, a circumstance that badly damaged the region's agricultural pastures. Perhaps more hardship was predicted when, on 4 September at about 3 a.m., a ball of fire was seen to pass over Thurnham in the direction of Ashton Hall; a train of light followed it, like the tail of a comet. The *Lancaster Gazette* reported that six days later a 'singular phenomenon' followed on the heels of this, when at around 8 p.m. 'a bright bow, similar to, but much larger and more brilliant than a lunar rainbow, extended from the West across the meridian to the N.E. by E. It afterwards moved to the S. of E., crossing the Milky Way, which was not near so bright as the bow.' This cosmic wonder itself preceded the appearance in the Heavens, two hours later, of the *Aurora Borealis*, or Northern Lights, an extremely rare spectacle at this latitude. One can only observe that – if we didn't know better – one phenomenon actually seemed to herald the appearance of the next.

A series of earthquakes that rattled the north of England and southern Scotland on the night of 17 March 1871 appeared to coincide exactly with a meteor shower witnessed from various French towns and cities. Six earth tremors in Manchester at 7 p.m. appeared to herald the event; the luminous phenomena in France occurred some four hours later, accompanied by a series of shocks felt virtually everywhere in Lancashire north of the Mersey. Three days later, as reported in the *London Times*, these atmospheric anomalies continued with booming noises as of a number of field guns being fired in the distance, and pale lightning flashes being witnessed in the skies above the region of Lancashire affected by the tremors.

Less cosmic, and closer to the grounded existence of the typical Lancastrian, Richard Cookson's *Goosnargh Past and Present* (1887) noted that Inglewhite, north of Goosnargh, might have earned its name by the repeated appearances of will-o-the-wisps. 'Ingle' was another denomination for 'fire', with the area having a reputation for these mysterious ghostly lights. Cookson wrote, 'Inglewhite was once famous for the *ignisfatuus*, a moving whitish fire vulgarly called "Will-with-the-Wisp" and "Jack-with-the-Lantern" ... the cause of this phenomenon has not been satisfactorily proved.' Cookson also makes the tantalising observation that, 'There are many well authenticated accounts of live toads having been found in solid rocks and boulder stones in this neighbourhood, remarkable phenomena that I dare not pronounce upon.'

This was a mystery that caused much contention in Victorian Britain, and across the county's natural landscape in general there are examples of other incidents that

do not appear to make sense in any kind of rational, conventional way. For instance, the *Sunday Express* (24 August 1919) reported a perplexing enigma. Near Ormskirk, there had been a field of wheat that (following a drought) had fully died off in 1918 – and from which there was consequently nothing worth harvesting. However, the following year, the field was found to have spontaneously produced a new crop of wheat – and not just odd seedlings that might have conceivably sprouted, but 'one of the best crops of vigorous, young wheat in West Lancashire, for the season'. Farmers and agriculturalists were at a loss to explain how this could have happened in a barren field.

To this type of bemusing – yet natural – curiosity we might add the mystery of the crop circle, which has an earlier precedent than average in Lancashire: in June 1947 a single circle was found amid a field of potatoes near Pilling.

What, to this day, continues to flatten crops of wheat, corn and barley into perfectly circular shapes in fields up and down the British Isles has long been the subject of speculation. Sometimes 'hoax' is labelled at crop circles, the irony being that the more mundane the design (some patterns are incredibly complicated and intricate) the more likely it is to be a genuine mystery. The Pilling incident is featured in researcher Colin Andrew's *Circles Phenomenon Research (CPR) Newsletter No.3* (April 1991), the circle having been found in a field near Eskham House by a former employee. The witness, John Salisbury, a noted local archaeologist and antiquarian in his later years, described it thus; 'I could see it was a huge circle, almost 50 yards in diameter, with all the plants swirled in a clockwise direction and almost as though they had been plaited. There was no other damage in the field, no sign of tracks or anything ... the edge of the circle was so well defined that one plant was normal, and the next one to it completely flat.' Eerily, Mr Salisbury observed,

> Standing in the middle of the circle and trying to take it all in, I remember a sudden sense of panic and to get out of it as quickly as I could. It just seemed as though something had come down and gone straight up again ... There is something else I would like to mention, seven or eight years later on the same field and not far from the crop circle location, I ploughed up a number of stone age hammer and axe heads which are still in my possession.

Could there have been some sort of link between the circle and this last observation? The supposition is that such circles are a natural phenomenon, although the least likely explanation – that circles such as the one at Pilling are caused by UFOs landing – will always be the one that excites the popular press looking for a connection to the paranormal. However, the Pilling incident does give food for thought, in view of the sensible observations made by Mr Salisbury.

In many ways, this is a good point to move on. Here we depart earthly mysteries and head ever further into the unknown. All the cosmic and atmospheric oddities in the known sphere would pale into insignificance if just one of the following tales genuinely concerns what is implied – visitations to Lancashire by people and 'things' from other worlds and other universes.

UFO Valley

It is official: Lancashire is a 'UFO hotspot'. According to the *Sun* on 12 February 2010, the 'sleepy pocket of Lancs' that is Rossendale and Bacup has clocked up the highest number of UFO sightings in the country – forty-four since 1977 to be precise. Also published in the newspaper was a curious photograph of the latest sighting, taken with a mobile phone camera and depicting nothing so much as an oval, saucer shaped silvery object apparently hovering near Stacksteads, glinting sunlight giving the object a 'polished' metallic appearance. It hovered for under a minute and then shot off at an amazing speed. Over the past thirty years, sightings such as this have earned the area the dual nicknames of 'UFO Valley' or 'UFO Alley'.

However, although the Forest of Rossendale is now world-famous in UFO circles, the phenomenon in the Valley is an old one indeed. The *Sunday Express* (29 October 1967) reported the story of a policeman in the station at Bacup who was alerted to some sort of atmospheric disturbance outside that interfered with the short wave radio and made it crackle. It was 4 a.m., and to his amazement the officer, PC Earnshaw, saw the cause some 250 feet up: a glowing, metallic-looking cigar-shaped object, about 50 feet long and sailing through the night sky with a whirring noise. Portholes were visible along its side.

In fact, the region in general boasts an exceptionally impressive and thought-provoking history of encounters with, or observations of, Unidentified Aerial Phenomena (UAP). Strange things seen in the skies above Lancashire have perplexed man's imagination for generations; what, for instance, could have been the 'absolutely black, spindle-shaped object' that was observed from Manchester to be crossing the sun on 10 October 1914? The *English Mechanic* reported, 'Its extraordinarily clear-cut outline was surrounded by a kind of halo, giving the impression of a ship, plowing her way through the sea, throwing up white-foamed waves with her prow.'

The following is a brief history of Unidentified Aerial Phenomena in our region – and, just possibly, a glimpse at a revelation: that we might not be alone in this universe, and may even be being monitored by higher beings.

A Short History of Lancashire UFOs

There is still a great deal of fascination with the story of the so-called 'Wardle Thing', despite the matter being largely explained. The *Rochdale Observer* was the first newspaper of many to cover an incident on the night of 15 February 1957 when a nineteen-year-old girl, Gwyneth Fitton, spotted a 'big round object which glowed white. Underneath there was another one like it, which changed from white to red.' The sighting was made as she walked to her home in 'Wood End-lane', high in the blustery cold of the Pennies at Wardle. The night was clear, however, and when Gwyneth alerted her mother, Dorothy Fitton, the older woman saw 'the thing gliding towards me just higher than the rooftops'. She shouted, 'Good God! They're here!' as the object hovered, and then took off again over the moors. The matter ultimately reached the House of Commons, when Mr J. A. Leavey, the Conservative MP who represented Heywood and

Royton, demanded of the Air Ministry what they knew of the 'thing'; parliamentary Undersecretary Charles Orr-Ewing rose from the Government front bench and replied (to huge laughter), 'This object did not emanate from outer space but from a laundry in Rochdale!' Apparently, an amateur meteorologist and radio ham, thirty-five-year-old Neil Robinson, had rigged two small hydrogen balloons illuminated with a flashlight bulb, and sent them up as a means of tracing air currents. He said, 'I never thought my little tests would be raised in Parliament!'

Somehow it almost goes without saying that Pendle Hill has connections with UFOs. Jenny Randles, the world renowned authority on Unidentified Aerial Phenomena (who was born in the Rossendale Valley), notes a credible case in *The UFO Conspiracy: The First Forty Years* (1993). This incident concerns a sighting made by a night shift factory worker, Brian Grimshaw, and a colleague, who were driving to work through the nearly deserted streets of Nelson at just after 3 a.m. on 9 March 1977. Both very clearly saw a light appear over brooding Pendle Hill, which revealed itself to be a dark cigar-shaped (or oval) object that flashed different colours on its underside and floated through the sky towards them. As it hovered over them their car engine and lights simply cut out, and – panic rising – both men felt a strange tingling sensation while an electromagnetic humming noise, like rushing wind, filled their ears. Then, as suddenly as it had arrived, the object simply drifted away southwards, and the car's engine sprang back into life; the feeling of oppression lifted as well, although the two men experienced pounding headaches when they subsequently arrived at the textile mill. The case is a famous one in UFO folklore generally, coming as it did on the back of dozens of sightings of strange aerial phenomena in all corners of Lancashire: for weeks there had been reports of weird orange, red or yellow lights being seen all over the county, even menacing the telecommunication masts on Winter Hill, although often the spectacle changed shape, moved differently or otherwise varied in its appearance depending on who saw it and when seen. In one instance an entire coach party at Barnoldswick marvelled at one sky borne display. Television and radio reception was reportedly affected throughout the area, and the mystery behind the wave of sightings is unexplained, although some lean towards a natural phenomenon that we do not yet understand. Yet of the Nelson encounter, Ms Randles wrote, 'Brian Grimshaw struck me as one of the least likely people I have ever met to have invented his story.'

The last week of February 1979 saw another cluster of sightings in this region, centred around what seemed to be a fast moving orange blob in the sky, seen independently in the early hours from places as diverse as Scarisbrick, Wigan, Blackpool and Ormskirk. The most amazing reports came from Stacksteads, in the Rossendale Valley, where a man spotted an orange glow crossing the sky from a bedroom window at about 2 a.m., presenting a carousel-type appearance with blue and red colours or lights being visible. Its bizarre movements – halting, changing direction – arrested the witness's attention, and the thing appeared to be about 600 feet in the air, and moving at 80 mph, before appearing to descend into Lee Mill Quarry. Upon rushing to the quarry, the witness found two figures pointing flashlights about in the darkness; these turned out to be police officers who had struggled up the moors in the gloom to investigate a strange orange glow they had seen.

This very same witness claimed other encounters, a rare privilege indeed if true. Having regularly taken to hiking the hills with a professional photographer in the

hope of photographing the 'UFO' that everyone was talking about, he encountered the thing itself, or another like it. An enormous 'craft' suddenly appeared in the sky just feet from the men; lights shone from it and there were huge jet black triangle shapes visible beneath it, the whole thing having apparently simply 'fallen' from the sky to loom menacingly over the petrified witnesses. The experience was accompanied by a piercing howl, and although the terrified photographer took some twelve shots of this monstrous craft, none came out – all images having been wiped from the negative somehow. After this, the thing just simply moved away across the Valley. This encounter had occurred at about 2.30 a.m. on 19 May 1979. Curiously, an interview in the *Lancashire Telegraph* (17 February 2010) makes it clear this witness was the father of the man who took the photograph referred to earlier as being published in the *Sun* – either credible UFO sightings run in the family or the thing of 1979, whatever it was, hasn't yet departed the Valley.

The late 1970s were the time when this area began to earn the nickname 'UFO Valley', and the moniker has stuck to this day. But perhaps one nineteen-year-old youth was lucky enough to catch sight of the occupants of these 'crafts', if that is truly what they were. While camping with a friend in July 1977, he spotted a strange celestial figure standing not 100 yards from him as he collected water from the edge of Clowbridge Reservoir in the small hours. Perhaps reassured by the rifle he carried, the youth observed this being to be at least 8-foot tall, dressed in a white robe and sporting a beard and bushy hair. This figure merely stood staring out across the water, and seemed oblivious to the startled witness – only appearing to vanish when the youth yelled to wake his friend up. The story was featured in Issue 43 of a sadly missed and sober periodical, *Northern UFO News* (edited by Jenny Randles), which catalogued such weirdness in the north of Britain. Although the figure's appearance was akin to a phantom, the implication is that it appeared something apart from a 'ghost', and there are other instances of phantasms that cannot be easily pigeonholed, as we shall see.

Joseph's Robots

What of the occupants of these strange craft? A few miles east of Rossendale, at around 5.15 a.m. on 29 November 1980 a police constable observed what he initially thought a bus in Burnley Road, west of Todmorden (near to the Lancashire border). Much has been written about this particular case; how the good officer realised the 'bus' was in fact floating several feet off the ground, presenting a blurry oval with its bottom half spinning and its top domed; how rows of darkened windows, or perhaps panelling, were also partly visible in the early morning gloom; and how the nearby trees shook with the force of this object's vibration. In a frantic attempt to contact his station, the officer found neither his car radio nor his personal walkie-talkie set would work, and as he attempted to sketch the thing (he had by now pulled over) a blinding burst of light filled his vision; and the next thing he recalled was driving on as normal further up Burnley Road. Following some indecision, the officer filed a report after it emerged that a brilliant white object had been seen by others at around the same time, namely a driver further west at Cliviger and a patrol of brother officers in Halifax.

Site of the officer's encounter on Burnley Road.

A hypnotic regression session was arranged in August 1981, prompted by suggestions that the officer was missing some 15 minutes that could not be accounted for between his sighting and arriving back at the police station. This proved traumatic, as reported in the *Sunday Mirror* (21 September 1981) by two journalists, John Sheard and Stewart Bonney, who saw the subsequent video of the regression. During the session the PC spoke of a shining white light that blinded him, and when he came round he was in a room on a table. A 6-foot tall, bearded and skull-capped figure wearing black and white was beside him.

The regression session became increasingly disturbing, with the subject becoming progressively more agitated. The *Mirror* subsequently reported that the officer became gripped with terror, and reported him as yelling, 'They're horrible ... small, three to four feet, like five-year-old lads. There are eight of them. He's touching me. He's feeling at my clothes. They have hands and heads like a lamp. They keep touching me ... they are making noises ... Joseph, I know him as Joseph. He has told me not to be frightened.' And then, 'They are robots, they're not humans, they're robots. They're his. They're Joseph's robots. There's a bloody dog ... it's horrible. About the size of an Alsatian.'

The hypnotic session ended here, the hypnotist bringing it to a conclusion in order to deliver the patient from further distress. The hypnotist was quoted as saying, 'This is quite the most mysterious thing I have ever witnessed.' A second session with a different psychiatrist also failed to resolve the matter; this time, the subject spoke of

being examined by a machine, and when prompted for further information he said, 'I haven't to answer that, I haven't to tell you. Each time I think about it I get a pain.'

What happened to this unfortunate police constable has, in the popular press and on paranormal TV shows, prompted much comment, some of it rational (that he suffered some kind of trance-like altered state of consciousness), and some of it sensationalist – such as the implication that the officer's abduction was linked to the mysterious slaying of Zigmund Adamski. This missing fifty-six-year-old miner's body, suffering strange burns from a corrosive substance, had been found dumped on top of a pile of coal in a Todmorden yard that June as though dropped out of a vortex. The police constable in question, who the whole UFO mystery revolves around, had been one of the first officers on the scene at the time. What most researchers do not doubt is that the officer experienced something – although whether it was a psychological or extraterrestrial or natural phenomenon has not been resolved to everyone's satisfaction.

Earlier that year, according to researcher/journalists Phillip Mantle and Carl Nagaitis in 1998's *Without Consent* (a giant tome exploring the phenomenon of alien abduction) a truck driver had had a similar experience west of Todmorden, at the point where the A646 crosses the railway line in the middle of bleak Heald Moor. This had occurred in January 1980, when his headlamps had fallen on a group of men in unfamiliar dark or silvery grey uniforms inspecting a large, dark, oval-shaped metallic-looking object in the road that beamed points of red light out from three places. Unsure what to do, his confusion was made worse by his headlamps suddenly cutting out, and then a blackout. When he came to, he found he was a substantial distance further up the road. The headlights were working normally; but three hours had passed since he had encountered the object on the road.

Creatures from the Spaces Between Space

Occasionally, the occupants of these strange craft appear to manifest themselves, often confusing the entire picture of just what we might be dealing with; *Northern UFO News* (Issue 58), for instance, notes that in August 1967 an eighteen-year-old man walking along the seafront in Heysham in the small hours observed a glowing white light shoot between two clouds, making a humming noise. He then – briefly – glimpsed before him a figure like a man that just as quickly vanished again.

This illustrates that in some instances there are seen phantasms that appear to be something more than a 'mere' ghost to the observer. In 2009 Janet Wood was told a strange story that she has kindly passed to me, concerning a young woman who saw something – it defies identification – in the grounds of Towneley Hall, south-east of Burnley in the early 1970s. The 'thing' appears to have been some sort of ghost, but for my part seems to resemble no known ghost I have ever heard of, and is more akin to some kind of science fiction entity from another dimension. The witness and two of her friends were stood talking about nothing in the dusk of a summer day's end, in the vicinity of the old bandstand near the miniature golf course, when their attention was drawn to something approaching towards their left. They all saw a light-grey figure with a clearly definable chest and head moving towards them. However, this thing, whatever

it was, was 10-foot tall, and of such an unnatural appearance that it sent them all fleeing out of the park, whereupon they did not stop until they reached the main road.

The story is reminiscent of other spectral phantasms that appear something distinct again from a ghost. Maybe a North Shore mother of two unwittingly photographed one of them. On 3 November 2009 the *Blackpool Evening Gazette* reported how the woman had been attending a party in the Spanish Hall, Winter Gardens, Blackpool, and taking photographs. One, when downloaded onto the PC, showed a 'cloaked figure with deep set eyes in a ghostly pale face'. The strange entity appeared to be floating near the glass windows of the ceiling, and – even stranger – *wings* could be distinguished when the image was zoomed in on.

But perhaps the most unnerving of these types of phantasms – part ghost, part *Dr Who* alien – is the one reported by a correspondent to *Fortean Times 168*. In 1981, aged eleven, he and some other children had been playing a hide-and-seek type game in the semi-rural part of Lancaster between the Lune and the Lancaster Canal. One of their number went home mid-game, apparently abandoning the childish fun, and so the group went to call on her. They found the girl trembling and terrified, having gone home after seeing something singularly inexplicable. As she walked across a road near the housing estate, she had seen a field nearby, inhabited by a few chickens and an ancient donkey. A hedge bordered it, and from this materialised a figure, walking towards her. This figure was 'about 7ft (2.1m) tall, black from head to toe, and with pointed ears!' It emerged from the hedge and walked, ghost-like, through a wire fence that acted as a boundary. At this, the child had run as fast as she could for home, and even months later she would refuse to go anywhere near the sinister field.

If such things be real, and where there is no suggestion of UFOs, where could such things come from? Could they be inter-dimensional – beings from the spaces between space?

Credible Witnesses

To return to UFOs, perhaps the 'reality' of the phenomenon is best illustrated by reliable testimony from credible witnesses. The region's most baffling and important UFO story concerns an incident at 6.48 p.m. on 6 January 1995. This was when the Captain and First Officer of flight 5061, a Boeing 737 with sixty passengers, saw a triangular UFO approach the plane at high speed, at about 4,000 feet and some 8 miles south-east of Manchester Airport. The First Officer automatically ducked, fearing a collision, although the strange craft passed silently along the starboard side in the opposite direction. The Captain was able to see it himself for about 2 seconds through the Boeing's windows, and thought he could detect a number of small white lights; his companion thought the craft had a dark stripe down its side. Questioned separately, the two witnesses agreed on the shape, colour and size of the craft – comparable in dimensions to a small jet – although they disagreed on its lighting. Nothing had been visible on radar, but both the flight officers were certain the thing that had almost crashed into them that evening had been unidentifiable and not a balloon or a military stealth aircraft.

One has to assume two experienced pilots would recognise the object if it were something familiar, and would not be given to flights of fancy, as it were, in view of

Manchester Airport: An incoming plane was 'buzzed' by a UFO.

their responsible position; to invent such a claim might have ramifications on their jobs – especially when the national press got hold of the story.

There will always be, of course, an alternative explanation posited by someone in cases like this. However, credible witness testimony does not have to come from uniformed 'authority figures'; the *Burnley Express* (2 November 2010) published a letter from a former Padiham resident enquiring of the newspaper's readership whether anyone else had seen the singular sight in the skies that he, and a friend, had witnessed around January 1983. What they had both seen, for some five minutes, had been an object about as big as a small bus, travelling around 200 feet up between Pendle Hill and Burnley. Its appearance presented a big, rusty cigar-shaped object with flames and black smoke billowing from its tail end, and – it being mid-afternoon – a number of other children stopped playing on the hill to watch this strange thing fly at about 50 mph in the sunshine, heading in the direction of Burnley. The correspondent's choice of words ('At that time there were no camera phones to take pictures, as this would have been the best shot ever taken of a UFO. This event has haunted me for years and I reported it to Padiham police at the time. What I could not understand was how could this thing exist in the modern world?') is strangely compelling, and I can only wonder at what this object might have been. A misperception of an elaborate firework? A missile or rocket mistakenly fired over land? A failing aeroplane of terrestrial origins? Or could it have been – as the witness appears convinced it was – a UFO of some sort? Until an adequate explanation is brought forward that convinces everyone, witnesses like this have to be assumed to be capable of relating correctly what they saw with their own eyes.

A UFO looked like it was in trouble over Burnley in 1983.

A Continuing Phenomenon

There is an intriguing report in the *Craven Herald* (30 May 1998) in which the claims of a Barnoldswick man are put forward; among them that balls of light were visible in the fields beyond his house (appearing and disappearing near an underground reservoir), and that 'he has also experienced what he can only describe as three to four foot "beings" in his house which have the ability to paralyse him'. During one of these episodes he awoke with a shiny bead-like object partially embedded in his scalp. This would appear to be a failed extraterrestrial 'implant' scenario, with one element of the mysterious artefact allegedly defying identification, according to a representative of a local UFO research organisation at the time.

Outlandish claims such as this appear to have dwindled drastically in the post *X-Files* era, but that is not to suggest that the truth isn't still 'out there'. Winter Hill, 1,496 feet high on Rivington Moor in the blustery West Pennines, seems to be a place, like Rossendale, that habitually attracts UFOs, and has done for decades: with one particularly famous case being the so-called 'Winter Hill Incident' of 13 November 1999. This involved an erratically moving bright white light that hovered over fields and a farmstead on the edge of Winter Hill, chasing a late-working farm labourer and scattering the cattle in the fields. The incident was reported to both the police and the Manchester Aerial Phenomena Investigation Team (MAPIT) at the time. (Full details of the official investigation into this strange episode, including the labourer's original frightened call to

Morecambe Bay: Many inexplicable lights seem to depart Lancashire from these shores.

MAPIT, can be viewed on their website.) On 17 May 2006 the *Lancashire Evening Post* published an intriguing photograph (taken in 1996) of what looks like a silvery, metallic speedboat cruising in the sky between the Pike and the mast, the snow-covered moor beneath clearly visible in the daylight. The *Post* also commented, 'Bright green lights above the M6 and a moon-like object hovering in the Preston skies are just two of the "UFO" sightings to have been reported in Lancashire.'

As this suggests, there is a wealth of information concerning calls and sightings logged by the Ministry of Defence that have recently been made public under the Freedom of Information Act (2005) and via the National Archives. In fact a quick look at the recently released MoD archives reveals what a fabulous wealth of strange phenomena has been observed in Lancashire's skies, quite apart from the ordinarily commonplace (in UFO terms) miscellaneous silvery metallic discs, jumping stars, pulsating bright lights, hovering triangles and orange globes that are frequently observed. Some reports do stand out as being particularly strange, even in a field that, by its very nature, is concerned with the weird. For instance, a number of witnesses reported what was (presumably) the same sky-borne spectacle at around 7 p.m. on 1 March 2001. When it passed over Fleetwood, it was observed to be an 'unconventional silent craft' with four red lights that swept low over the witnesses' house, before shooting in a vague westerly direction over Morecambe Bay where it was reported as *five flying orange lights*.

Worryingly, sometimes these objects – whatever they are – seem to descend from the Heavens to the ground. From Tarleton, a village situated in the marshlands by the

River Asland (or Douglas), a flashing, pulsating blue and red light was seen, which next changed colour to orange and descended towards the ground. This occurred at about 9 p.m. on 14 January 2001. The aforementioned 'bright green lights' noted in the *Evening Post* were, in fact, a singular light, about the size of a traffic light (seen from the M6) that broke up when it came near the earth seven miles outside of Lancaster.

These last surely have some kind of natural explanation? After all, meteorites have in the past soared out of the Heavens and thumped to earth, such as the small one that (accompanied by a sudden illumination flashing in the early evening darkness) whistled into a field at Appley Bridge on 13 October 1914. In truth it is almost a hopeless endeavour to try and make sense of the decades of strange phenomena seen in our skies, given the full diversity of sightings and experiences. It must mean either an amazing array of different craft and creatures are scouting earth, and as such they are already here, or there is an endless list of misperception, folly, fabrication and natural phenomena that we do not yet have an explanation for. The MoD archives document a number of latter-day reports concerning orange globes flying over the county, which must surely be misinterpretations of Chinese sky lanterns. However, many witnesses have to be considered capable of relating correctly what they thought they saw – or actually did see – in the skies above Lancashire, and as such in Unidentified Aerial Phenomena we have a mystery, or multiple mysteries, that may be a long time dying out.

At its most extreme, the UFO mystery is a world of inexplicability, where close encounters are often experienced in a kind of *Alice In Wonderland* surrealism; how on earth do we explain such dream-like experiences as the one publicly released to the National Archives by the MoD in October 2008, and later featured in the *Wigan Observer* (23 October 2008)? The sighting concerned a woman driving with her mother from Southport to Manchester, along the East Lancashire Road via Wigan. The allegation seemingly makes no sense in any kind of rational way: their progress was almost drawn to a halt as they dawdled behind a very old-fashioned looking car in the road being driven by a tall and stocky man wearing a 'strange German-type hat'. Leaning out of the window to see what the hold-up was, the woman saw a gigantic craft, twice the size of a double-decker bus on its side, lit up with dazzling lights and domed, that floated some 30 feet above the road. In her letter to the MoD, the woman claimed they had lost 55 minutes that she could not account for, during a journey that took at least three times longer than it ought to have.

Until we know more, we can only ponder the riddles of the latest MoD releases, culled from the National Archives by the local media and presented to an ever fascinated public. Lately, the *Burnley Citizen* (19 August 2009) told its readership, 'Contained in 4,000 pages of declassified Ministry of Defence documents are three cases of curious happenings over the skies of Colne and Burnley. A copper gold triangle moving at right angles caught the eye of a Colne resident on 18 October 1994.'

And so it continues. There are more things in Heaven and Earth, as they say. One can only wonder what other marvellous tales might yet emerge into the glare of publicity. Most of all one wonders if we are, indeed, alone.

Afterword

There is so much that we have had to leave unexplored. Quite naturally there is a wealth of stories concerning miraculous phenomena, which – whether true or not – is testament to the depth of faith in Lancashire. White doves were generally held to be omens of the recovery of someone suffering a serious illness, and in some cases they were even believed to be angels who had shown themselves in readiness for helping the soul of a dying person into Heaven.

At Bryn Hall, once the seat of the Gerard family but now demolished, there was a Roman Catholic chapel; and a priest who continued here long after the family had departed had in his custody a saintly relic called 'The Dead Man's Hand'. Preserved with great care in a white silk bag, it was resorted to by many diseased persons, and wonderful cures are believed to have been wrought by this grim remnant. It was said of this hand that it belonged to Father Arrowsmith, who had been put to death at Lancaster for his religion in the reign of King Charles I. (Bryn Hall was situated in Bryn Park, Ashton-in-Makerfield, in the Metropolitan Borough of Wigan.) Elsewhere, at St James' Church in Brindle, east of Leyland, there is a 'footprint in stone': a small indentation in the wall of the eastern gable of the chancel, just above a stone coffin, where a Catholic stamped his foot during some heated religious debate.

It was at Pendle Hill that George Fox, the founder of the Quaker movement, experienced something akin to a vision in 1652. His diary records,

> As we travelled, we came near a very great high hill, called Pendle-hill, and I was moved of the Lord to go up to the top of it; which I did with much ado, it was so very steep and high. When I was come to the top, I saw the sea bordering upon Lancashire. From the top of this hill the Lord let me see in what places he had a great people to be gathered. As I went down I found a spring of water in the side of the hill, with which I refreshed myself; having eaten and drunk but little several days before.

His diary entries for the year 1666 also make it clear that Fox believed he was under divine protection, with those that persecuted him frequently dying young or suffering disaster and misfortune. He wrote that 'Hunter, the gaoler of Lancaster, who was very wicked to me while I was his prisoner, was cut off in his young days. The under-sheriff

Human-sized tombs at St Patrick's chapel, Heysham: a cliff-edge site of devotion.

Pendle Hill illuminated; a view from Colne.

Stonyhurst College near Hurst Green has, in its collections, a thorn said to have been part of the crown of thorns that adorned Jesus' head.

who carried me from Lancaster prison towards Scarborough, lived not long after ... when I came into (the north) country again, most of those that dwelt in Lancashire (who had persecuted Fox) were dead, and others ruined in their estates ... the Lord had executed his judgements upon many of them.' If his diary is to be believed, then Fox's tormentors did indeed appear to suffer divine persecution on a grand scale, with Fox being further protected from attempts on his life and the fury of the natural elements while travelling.

These days a popular site of pilgrimage is the shrine to Our Lady and the Holy Well at Ladyewell House, at the end of Fernyhalgh Lane, Preston. *Notes and Queries* observed in 1861 that there was preserved here an ancient gilt chalice with the inscription *Dosius Maguire, Rex Fermannae fieri me fecit, anno 1525*. Could this mysterious 'Maguire' have been the very merchant who, according to legend, had made a vow (while in danger of being shipwrecked in the Irish Sea) to build a chapel if his life should be preserved? The man was accordingly spared and supernaturally directed to build a chapel where he found a crab-tree bearing fruit without cores, and under it a spring. This he found at Fernyhalgh, and although his chapel was pulled down during the suppression of the chantries, another – St Mary's – was built in its stead in the years 1684/85. Today people bring bottles to fill with the well's water. The shrine was almost destroyed in February 2011 when a mysterious fire broke out in the shop here (the cause is at the time of writing unclear). However, many will no doubt view its preservation – perhaps justifiably – as something of a 'miracle'.

The fact that so many anecdotes with strange and paranormal themes failed to die out is no doubt in part due to the Lancashire people themselves, who were clearly fond of lively, imaginative storytelling, as many of their other twice told (and non-religious) tales indicate. *The Transactions Of The Folklore Society Vol. XXIII* (1911) makes reference to a classic Victorian urban legend as having happened in the county. The circumstantial story concerned a 'worm with legs' (i.e. a newt or a lizard) that had crawled down the throat of a man sleeping in a field. Not knowing why he felt so ill, the man consulted a local 'wise-man' who told him to not drink anything for two days. The man was thereafter taken to a stream and his head held near the water; the thirsty 'worm' darted up and out of his throat, being caught on a flitch of cooked bacon. Its claws stuck in the bacon, and the wise man hurled the little creature and the meat into the stream. In some versions, the lizard tried to scurry back down the afflicted man's throat, but was caught and killed by the wise man. The editor of the periodical remarked, 'I heard (the) story told among my mother's relatives as happening in Lancashire.'

The beautiful, rugged and windy landscape of Lancashire quite naturally lent itself to many an eerie tale. Numerous of the blocks of millstone grit that adorn the summit of Boulsworth, about 7 miles from Burnley, have earned strange names: the Abbot Stone, the Little Chair Stones, the Weather Stones, the Joiners' Stones, the Buttock Stone etc. Of these, the most intriguing are the Lad Law, the ancient British terminology *Llad* suggestive of ritual human sacrifice being practised here. John Bentley's *Portrait of Wycoller* (1975) relates the ghoulish story that at one time a seated human skeleton was found, propped against this rock. The remains belonged to a traveller lost on the moor, and it was said that the very rock bore the impression of his body; although Bentley noted, 'There is no trace today!'

However, at the same time Lancashire's people were once genuinely and fearfully superstitious of almost everything around them. Among the strangest of these superstitions was the belief on the Lancashire Moors that plovers, a species of wading bird, were possessed by trapped souls, and that people who heard the cries of these birds were sure to be overtaken by ill luck. To see seven together was a portent of misfortune, and it was thought that these birds were doomed to fly in the sky forever, being cursed as they were. I can only wonder whether such observations were not merely a case of rustic philosophy, but actually based on something that had been witnessed to occur on numerous occasions, so crafting the composite of a sincerely held belief. Typically, colliery explosions accompanied the appearance of the portentous 'Seven Whistlers'.

Everything out of the ordinary – or even the ordinary itself – had some sort of portentous meaning, and some superstitious rituals stand out as charming and potentially disturbing in equal measures. For example, it was believed a Lancashire lass could conjure up the ghost of her future husband by scattering ashes on All Hallows Eve (these would spell one or more letter of her future husband's name), and then throwing hempseed over her shoulder. She could then expect to see the wraith of her future spouse following her. On the fast of St Agnes she could light a candle called a 'pig-tail', and in the shadowy gloom of her surroundings she would glimpse the ghost of her future husband passing by her. Personally, I cannot help but wonder what these rituals were based on to have lasted for so long; perhaps our ancestors knew something we don't about the bigger picture affecting life, death and everything in

between. Perhaps the people of our near past simply lived a more grounded existence, maybe more superstitious than their city cousins because of what they had actually seen and knew to be true; privately, they might have pitied the poor city dweller for their dismissal of ghosts and boggarts merely based on their never having seen one.

What all this has left us a great treasure chest of myth, legend, folklore and supernatural stories that we can dip into and perhaps indulge ourselves with the hair-raising question of whether any of it might have had just the tiniest bit of truth in it. While many tales are indicative of the love of strange stories that is so much a part of the Lancashire psyche, many others have that curious ring of truth to them: these days, for example, it is repeated that an ancient prototype tank – the Mk 1 – is actually buried 16 feet beneath the flowerbeds of Victoria Park, Haslingden. This supposedly happened in the years following the First World War, the tank having been positioned in the park as a focal point for war related fundraising and a monument of remembrance; although it seems a strange thing to have done, if we imagine some kind of immense pit being built purely to drive a tank into it and then cover it over with earth.

For myself, it is clear that many of Lancashire's mysterious stories are rooted in real, tangible incidents. Consider the event that occurred at a cotton mill in 'Hodden Bridge, in Lancashire' in 1787. According to a number of periodicals (who probably meant *Hebden Bridge*), this began when a girl put a live mouse in the bosom of a fellow female worker who harboured a congenital phobia of mice. The girl instantly went into violent convulsions that lasted twenty-four hours – by which time three more had started displaying similar symptoms. The next day, six more girls were afflicted, and by the time a physician arrived at the mill, twenty-four people – including a male employee directed to hold the girls down during their fits – were suffering spasms and convulsions so violent it was all that could be done to stop the patients dashing their skulls against the walls. The rumour spread that infected cotton had brought the plague with it, and three more factories, 4 or 5 miles apart, were infected with this mysterious malaise.

Electric shocks employed by the physicians on the patients brought about a gradual end to all this. Surely this would have represented 'demonic possession' 150 years earlier? I happen to believe that even the most outlandish of folkloric stories – even those pertaining to dragon slaying or 'dun cow ribs' – probably had an origin in a factual event, however obscure, and I sincerely believe that to dismiss many of the equivalent, modern paranormal allegations referenced in this book as utter nonsense or a fabrication is not doing the witnesses justice; nor the folk of any other county in the British Isles, all of which have their own ghosts, poltergeists, monstrous black cats and UFOs. In this day and age, that likes to think of itself as less superstitious than previous generations, and lives by the DVD, mobile phone and i-Pod, there are still those that profess in all sincerity to have seen a ghost, a strange beast or a bizarre sky borne object. Then there are those that will tell you that they know for a fact a 'house up the road' had a ghost, ensuring that many of these compelling paranormal stories continue to fascinate generation after generation. Lancashire consistently boasts a number of halls credibly denominated 'the most haunted house in Britain', many having more than one ghost; if 'ghosts' be real, it is only natural that a particular place might house several different spooks. I have heard from so many people in the county who profess to have had a ghostly experience – or to know someone who has – that I cannot help

but think that surely people would not see ghosts unless there were ghosts to see. It would still have to be an incredibly sceptical person who considered everything in this work as fanciful, superstitious nonsense, even in this twenty-first century.

Hopefully, complete scepticism of such oddities will not over take us too soon. In Lancashire, having met and spoken to many of those who have either repeated the old stories of the paranormal, or told me mysterious new ones, I believe this is highly unlikely!

Pendle Hill: this brooding landmark still represents paranormal Lancashire.